The Green Screen Handbook, Second Edition

"Green Screen replacement has been around since last century, and you think we'd have made it completely fool proof by now—but we haven't. The reality is, there are still challenging situations like poor lighting, motion blur, rig removal, and on and on that we have to deal with. I talk to many customers who still have trouble, even on million dollar compositing machines. But when you talk about green screen, one name always comes up, and that's Jeff Foster. Jeff is fearless in his will to take on any project, no matter how good or bad it's been captured. I think his success comes from the fact that he doesn't just get saddled with green screen a couple times a year, he is doing this stuff constantly and it's because of this that he keeps updating his own knowledge and passing it on to us. When I read the latest copy of the Green Screen Handbook, I feel like I'm cramming another 5 years of success into my digital compositing 'holster'!"
—Colin Smith, Adobe Systems, Inc, Sr. Support Specialist

"Ask anyone who works with green screen and compositing on a daily basis and they will tell you that it's way more than just clicking on the green background in your NLE or compositing application. This book has been my go-to source for many years before planning a green screen shoot. Jeff's tips and tricks on lighting, background paint, material choices, codec choices, color space, and much more have helped me countless times. It's a resource that I give my own field team staff as well as recommend to our Creative Cloud Pro Video customers for the best possible keying results in our Adobe Premiere Pro CC and Adobe After Effects CC applications."
—David K Helmly, Adobe Systems, Inc, Sr. Manager
Strategic Development Pro Video/Audio Americas

"The Green Screen Handbook is an indispensable asset to your production and postproduction. Make sure you buy a copy for your studio/field kit and another for your workstation. From proper lighting techniques and matching your subject to the background to choosing the right matte process for your project, it doesn't get any better than the Green Screen Handbook. If you can't have Jeff Foster on set manning your green screens, then the next best thing is to make sure that you and your crew have the Green Screen Handbook locked and loaded."
—Sean Mullen, CEO/Lead Creative, Rampant Design

"When faced with the daunting task of figuring out how best to shoot against a green screen, I went right to Foster's book for a clear and concise breakdown of what I needed to do and just as importantly—why. Jeff's knowledge on the subject runs very deep, but it's his ability to translate that knowledge in an easily digestible way that made all the difference. Now I'm pulling keys with the best of them! Thanks to Jeff!"
—Josh Apter, Owner, Manhattan Edit Workshop

"Walking a tightrope is easy if you know what you're doing, but if you don't then you're going to make a huge mess that someone else has to clean up. Shooting great green screen footage is shockingly similar. I've spent decades learning to walk that rope the hard way{. . .} I wish I'd had this book a long time ago.
This book isn't a safety net. It teaches you how to work without one. This is very, very good, because—in the fast-paced world of production—nets aren't often provided. Unless you're very good at bouncing I strongly suggest you read this book."
—Art Adams, Director of Photography, ProVideoCoalition.com, DVInfo.net

"Knowing the history and various styles of green screen techniques is a powerful asset for any VFX professional in determining how to approach, tackle, and complete green screen composites. Jeff Foster has masterfully gathered this valuable knowledge into one place."
—David Torno, Technical Director, Ghost Town Media

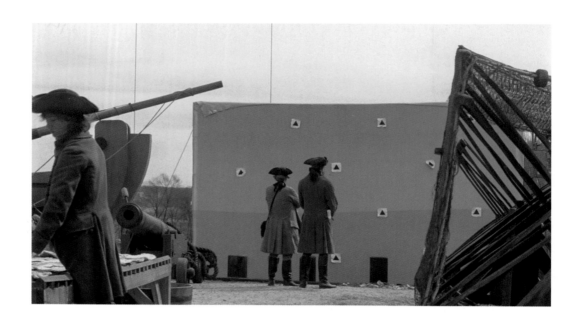

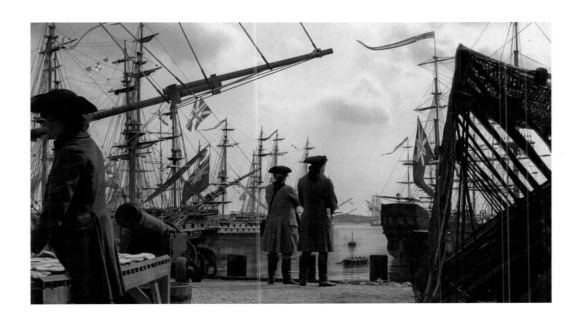

The Green Screen Handbook, Second Edition

Real-World Production Techniques

Jeff Foster

Focal Press
Taylor & Francis Group

NEW YORK AND LONDON

First published 2010 by Sybex, Wiley Publishing, Inc.
This edition published 2015
by Focal Press
70 Blanchard Road, Suite 402, Burlington, MA 01803

Simultaneously published in the UK
by Focal Press
2 Park Square, Milton Park, Abingdon, Oxon OX14 4RN

Focal Press is an imprint of the Taylor & Francis Group, an Informa business

Notices

Knowledge and best practice in this field are constantly changing. As new research and experience broaden our understanding, changes in research methods, professional practices, or medical treatment may become necessary.

Practitioners and researchers must always rely on their own experience and knowledge in evaluating and using any information, methods, compounds, or experiments described herein. In using such information or methods they should be mindful of their own safety and the safety of others, including parties for whom they have a professional responsibility.

Product or corporate names may be trademarks or registered trademarks, and are used only for identification and explanation without intent to infringe.

Library of Congress Cataloging-in-Publication Data
Foster, Jeff.
 The green screen handbook: real-world production techniques / Jeff Foster. — Second edition.
 pages cm
 1. Cinematography—Special effects—Handbooks, manuals, etc. 2. Computer graphics—Handbooks, manuals, etc. 3. Computer animation—Handbooks, manuals, etc. 4. Image processing—Digital techniques—Handbooks, manuals, etc. I. Title.
 TR897.7.F683 2014
 777—dc23
 2014026098

ISBN: 978-1-138-78033-0 (pbk)
ISBN: 978-1-315-77083-3 (ebk)

Typeset in Sabon
by Apex CoVantage, LLC

Technical Editor: Scott Carey

Cover Image: Jeff Varga, Director/Producer *Dead End City*
www.imdb.com/name/nm1008375/

Printed and bound in the United States of America by Sheridan Books, Inc. (a Sheridan Group Company).

Contents

Acknowledgments

I wish to thank the following colleagues, friends, and associates for their help and support in the making of this project—for without it, there would be no book! Scott Carrey, Barry Andersson, Terry Wieser, Michael Micco, Chris and Trish Meyer, Alex Lindsay, Colin Smith, Brian Dodds, Lynne Sauve, Eric Wise, Misty Madden, Kelsea Cire, Michael Anderson, Jim Tierney, Joe Sohm, Douglas Spotted Eagle, Adam Wilt, Per Holmes, Bruce Bicknell, Guy Cochran, Paul Kalbach, Claudia Crask, Steve Forde, Kevin Monahan, Steve Audette, Erik Wesby, Mannie Frances, Blair Collins, Mark Spencer, Marco Solorio, Steve Martin, Todd Kopriva, Michael Coleman, Kanen Flowers and Victor Milt. Many more friends and family that have contributed in many ways that I can't begin to list here—I sincerely thank you all for your help and support.

To the many people whom I've had the privilege to meet while researching, interviewing for, and producing this project: I truly appreciate your input, help, resources, wisdom, and, above all, friendship. Petro Vlahos and Paul Vlahos (Ultimatte), Jonathan Erland (AMPAS), John Galt (Panavision), Jeff Goldman (CafeFX), Mike Bozulich (CafeFX), Sean Marshall (Pete's Dragon), Bob Kertesz, Timothy Hines (Pendragon Pictures), Les Perkins, James Parris, Jeff Varga, Sunit Parekh-Gaihede, Bill Ingram (KSBY TV), Chris Slaughter (CafeFX), Lynne and George Sauve (Ultimatte) and Ron Ungerman (Ultimatte).

I also wish to thank the following corporations, studios, and organizations for their help in providing content, research materials, equipment, and software to produce this project—you really helped make this possible. Panasonic, Adobe, Kino Flo, Reflecmedia, Strata, iStockphoto, Rampant Design Tools, PhotoSpin, Fiilex, Blackmagic Design, Ventura Technology Development Center (TDC), CafeFX, HBO, Disney, Composite Components, Lastolite, Imagineer Systems, Digital Film Tools, Boris FX, RE:Vision Effects, dvGarage, Digital Anarchy, Bogen Imaging USA, Mark Roberts Motion Control, GenusTech, Adorama, VirtualSetWorks.com, Red Giant Software, General Lift, Ultimatte, iMatte, Full Mental Jacket, Academy of Motion Pictures Arts and Sciences (AMPAS), and the Margaret Herrick Library.

Last but certainly not the least, I wish to thank my lovely wife Ellen Johnson for her continued support and also for always being my number one model for many of the examples throughout this book. Having you and our loving dog Halona there not only for your love and support, but also to assist and stand-in when needed or to grab a camera and shoot or adjust a light or haul gear around with me is appreciated more than you'll ever know!

About the Author

Jeff Foster has authored and contributed to several Adobe After Effects and Photoshop tutorial and training how-to books over the years. He's an Adobe Community Professional who has appeared regularly as a featured speaker at conferences such as Photoshop World, Macworld, Adobe MAX, the NAB (National Association of Broadcasters) Postproduction conference, Adobe User Groups, and a regular instructor on creativeLIVE (www.creativelive.com).

Jeff has been producing and training for traditional and digital imaging, photography, illustration, video production, motion graphics, and special effects for more than 25 years. Some of his clients include: Tribune Broadcasting, Motorola, Sanyo, Bio-Rad, McDonnell Douglas, DOW, FAA, USMC, Nestlé, FOX Television, Spike TV, Discovery/TLC, Delux Digital, Cisco Systems, Stanford University Hospital, Universal Studios, and Disney.

He is a contributing staff writer and reviewer for ProVideo Coalition (www.providocoalition.com). You can learn more about his books, video workshops and the on-going blog for the independent filmmaker or film student with current trends and info at: www.PixelPainter.com

With several new productions and projects continually in the works, Jeff is currently operating from his studio in the San Francisco East Bay area in California.

Foreword

I may be biased, given the amount of my career devoted to it, but composite imagery and its enabling technology, traveling matte, are at the core of the art of visual effects. In turn, visual effects are basic to the very philosophic foundation of our art form—motion pictures, which commenced by reveling in the ability to depict the reality of life, such as the simple sneeze of Fred Ott, but then quite quickly set about conjuring not merely what was, but what could be—no matter how farfetched. (Just think, a scant six decades passed between Georges Méliès' *A Trip to the Moon* and Neil Armstrong actually landing on it.)

Film art (as with most art), being interpretive, requires editorializing—lots of editorializing. Include this, discard that, emphasize this, diminish something else. The montage and juxtaposition of images and ideas give voice and vision to a particular perspective and point of view. The process includes the elements that comprise a film's plot, the characters who inhabit that plot, the order of its scenes and shots, and ultimately, the elements that comprise each shot and every image. The great paradox of this art, or any, is that to conjure for you the truth that I desire you to comprehend, I must lie –sometimes outrageously. Thus, the amusing and insightful motto of the USC Film School's Visual Effects Club reads: "Better films through trickery and deceit."

Traveling matte, a magic carpet that can take you anywhere you can imagine, is actually part of the ancient, rich, and honorable heritage of "Natural Magick." We are, of course, the immediate and direct descendants of the "magic lantern." Méliès, recall, was a professional magician of some repute when he took up film. As long ago as 1558, Giambattista Della Porta, in his book *The First Book of Natural Magick: Wherein Are Searched Out the Causes of Things Which Produce Wonderful Effects*, compares and contrasts two sorts of magic: one is infamous, unhappy, foul and wicked, called "sorcery" (or "black"); "The other Magick is natural; which all excellent wise men do admit and embrace, and worship with great applause; neither is there anything more highly esteemed, or better thought of by men of learning." Della Porta teaches essentially the virtue of deceit and trickery in the pursuit of knowledge. Thus, the book that lurks behind this page is going to teach you to lie, to fudge, to shade, to misrepresent, to mislead, to misinform, and to beguile—all in the service of the truth you desire to convey.

To lie successfully you must convince, and to achieve that, you must plot and scheme meticulously, exhaustively, and then perform the artifice with exquisite deftness. All this Jeff Foster will teach you. Note particularly the section called "The Importance of Previsualization and Storyboarding." You will learn also that each element and layer

of a successful composite "deceit" will incorporate the effect of lighting, or perhaps a gentle breeze, in the other elements. For example, a flashing neon sign in a background "plate" will be seen to be reflected on a foreground actor shot on the green screen stage. Such subtleties are time-consuming and difficult to achieve, but, while their effect is subliminal, it is compelling. Failure to comprehend and envision the eventual total composite image is perhaps the single greatest error in a green screen shoot. And this error is not confined to amateurs but committed by many professionals. Traveling matte imagery is employed for a host of viable reasons mostly having to do with such goals as avoiding risk to life, excessive cost of sets or locales, or physical environments that are impractical to create other than as CGI elements. But resorting to green screen simply because one has not yet decided what the shot should look like is appallingly unprofessional. Recall W.C. Fields' retort to a "rube" who asks, "Is this a game of chance?" to be told by Fields, "Not the way I play it, it isn't, no." Chance is so inherently endemic to film making that its planned diminution should be encouraged at every opportunity.

Orson Welles had the unique good fortune to have access to Linwood Dunn, A.S.C., his optical printer, and his formidable skills to help make *Citizen Kane* the classic it is. The fact that today computers are routinely employed in composite imagery does not mean that computers "do it." Very sophisticated software (sometimes including the use of several different programs on a single shot and often including software derived from Petro Vlahos' landmark photochemical process), operated by skilled and knowledgeable people, are required today, just as in the past it took skilled optical camera operators like Lin Dunn to do the same job—and remember, in those days, long before the computer, the optical printer was parallel processing at the speed of light. The real advantage we have today is that far more filmmakers can gain access to, and be empowered by, the kind of image manipulation that was the preserve of the very few at the time of *Citizen Kane*. The open question, of course, is, will that result in films of such brilliance? That, neither Jeff Foster nor I can answer, but, if the spark of such brilliance resides in you, then Jeff and this book could help ignite it.

Jonathan Erland
*President, Composite Components Company and
Award-winning Founding Member at the Academy
of Motion Pictures Arts and Sciences*

Introduction

For several years, a great deal of confusion has surrounded green screen and blue screen production. People tend to ask the same questions regarding lighting, background materials, shooting, and compositing techniques:

- When should I use green or blue screen?
- What kind of materials should I use?
- What can I use to light the green screen?
- What kind of cameras should I use?
- What should I use to composite my green screen footage?
- How do I fix bad green screen shots?

In addition to my many years of experience in blue screen and green screen production, I've done a great deal of research on the topic to dig into the history of compositing, testing products, and running through every kind of workflow and technique I could to answer these questions and more. I've interviewed some of the pioneers in this industry, such as Jonathan Erland, John Galt, and Petro Vlahos, the Academy Award-winning technology inventor who has perfected the traveling matte system several times over (unfortunately, we lost Petro in 2013 at the age of 96). I've also worked with many industry pros who have shot major motion pictures, commercial television producers and editors, and indie filmmakers who are constantly pushing the edge of this technology. Adding that to input from many hardware and software manufacturers, I believe that I have developed the definitive handbook for all phases of green screen and blue screen production—from start to finish.

I sincerely hope that you will find this book not only a useful production guide but also a great resource to return to for years to come. I also want to invite you to contact me with any questions you may have and follow my ongoing blog from my website at www.PixelPainter.com.

Happy compositing! ~ Jeff

Who Should Read This Book

As the title implies, this book is intended for people who need an overview of all aspects of green screen production, as well as a quick-reference guide for students and working professionals getting started in the industry. This book was structured as a textbook, with

quick references at the end of each chapter and a full appendix listing all the resources and manufacturers mentioned in the book. The following people will benefit the most from this book:

- Film and television students needing to learn the history of compositing as well as all phases of studio production and postproduction techniques.
- Experienced videographers and indie filmmakers needing to learn the concepts and process of creating better green screen shots and composites.
- Editors who have been given poor green screen footage and don't know how to make it work.
- Producers, directors, and production leads who need to understand the value of proper lighting, staging, setup, and production as to minimize the necessity of always relying on postproduction to "fix" their sloppy shooting.

For everyone, this book can serve as a go-to guide for quick reference. The chapters cross-reference other chapters where a subject is discussed in more detail and point you to online resources where you can learn more about a product or service that may help you in your own productions. The online resources are available here: www.focalpress.com/cw/foster

The practical application examples and projects in this book may reference certain software applications, but those packages aren't a requirement to gain knowledge of the workflows. You can implement the examples through virtually any complementary compositing software.

If you are teaching courses in green screen technology and are interested in obtaining course curriculum and a course syllabus structured around *The Green Screen Handbook*, please go to www.PixelPainter.com and we will post information as it becomes available.

What You Will Learn

The Green Screen Handbook: Real-World Production Techniques covers the spectrum of green and blue screen production workflows of big studio productions, live TV broadcast, indie filmmakers, and small-budget student projects. Not only does the book cover practical applications of lighting, staging, planning, shooting, and compositing in most any scenario, but it emphasizes the history of compositing and gives an overview of how real-world productions are produced. This will give you the benefit of learning not only the "hows" but also the "whys" of the entire production process. This book should provide creative inspiration and serve as a reference for your productions for years to come.

What You Need

This book covers a lot of different production techniques, exposing you to high-end production studios, cameras, lights, and compositing hardware and software. I don't assume that you have access to these while reading the book; instead, you can use this

book to learn about what is being done in professional environments in the industry. However, for most of the practical application examples and projects in this book, I use the Adobe Creative Suite or Apple Final Cut Pro on standard desktop hardware. The example project files are included on the book's Media Downloads page at www.focalpress.com/cw/foster but aren't always necessary in order to follow along with the chapter contents.

What Is Covered in This Book

The Green Screen Handbook: Real-World Production Techniques is divided into three parts: Exploring the Matting Process, Setting the Scene, and Compositing the Footage. The chapters are in a sequence that supports the resource materials covered in each section but aren't necessarily in any chronological or instructional order. The book can be read from cover to cover, or select topics can be read independently for reference. There are plenty of cross-references in each chapter, should you need more detailed information regarding a process or technology. At the end of each chapter is a quick-reference list of the resources used.

Part I: Exploring the Matte Process
Chapter 1: Mattes and Compositing Defined

Often misrepresented as chroma keying, the *matting* or *traveling matte* process uses a sophisticated series of elements that allows you to make more complex extractions and composites.

Chapter 2: Digital Matting Methods and Tools

This chapter addresses the question, "Why should I used green screen over blue screen?" and what kinds of hardware/software compositors are available today.

Chapter 3: Basic Shooting Setups

The foundational elements for shooting all green screen setups are the materials used and the lighting of the background and the foreground subjects, including how these elements are positioned in relation to each other.

Chapter 4: Basic Compositing Techniques

This chapter introduces you to the various methods of keying and matting with both hardware and software keyers and compositors.

Chapter 5: Simple Setups on a Budget

Don't have the budget for a dedicated green screen studio and professional lighting? This chapter will show you how to still get good results when shooting outdoors or how to build your own studio lights for around $100.

Chapter 6: Green Screens in Live Broadcasts

We've all watched the TV news and seen the large weather maps that the meteorologist stands in front of while delivering the evening's weather forecast. Now, learn how that's done in the real world.

Chapter 7: How the Pros Do It

This chapter gives you a real-world look at a few FX/compositing-heavy productions from HBO's *John Adams* miniseries to successful, innovative and industrious indie filmmakers' home-spun projects.

Part II: Setting the Scene
Chapter 8: Choosing the Right Matting Process for Your Project

This chapter is about understanding the tools and processes before you plan your budget, if possible. Knowing how you'll achieve the results the project calls for will dictate the path you take and what that workflow will entail.

Chapter 9: Proper Lighting Techniques

Nothing wastes more time than shooting a great scene with the wrong lighting for the intended composition. This chapter shows you the proper techniques for lighting your background screen and the subjects.

Chapter 10: Matching Your Subjects to the Background

This chapter introduces some of the basic elements to look out for, including matching lighting angles, compositing tips, and motion tracking.

Chapter 11: Digital Cameras and Camcorders

This chapter covers some of the basics of how digital cameras and camcorders work, and what to watch out for when selecting a camera to use for your green screen work.

Chapter 12: Storyboarding and Directing Your Talent

The better you can communicate your production ideas to your talent and crew, the more successful your project will be, both in front of the green screen and in the postproduction process.

Chapter 13: Interacting with the Background and Objects

With the proper lighting, staging, and prop preparation, you can put your subjects into nearly any virtual world or scene, complete with props and other objects the subjects may come in contact with.

Part III: Compositing the Footage
Chapter 14: Getting a Great Matte

Getting a great matte depends on many production factors: lighting setup, screen background, camera and lens, subject staging, shadows and reflections, and more.

Chapter 15: Color Balancing the Subject and Background

It's not always possible to perfectly match the color temperature of your lighting on the green screen stage and on your background plate, so this chapter gives you postproduction solutions for color corrections and matching plates.

Chapter 16: Fixing Problem Green Screen Shots

The most common problems with poor green screen or blue screen shots result from improper lighting, poor positioning, and the use of backgrounds that are the wrong color. This chapter shows you how to work around most any poorly shot scenario.

Chapter 17: Working with Virtual Sets

Virtual sets are more commonplace in the commercial television and corporate video production landscape, and this chapter shows you how they're created and implemented with green screen shots and live broadcasts.

Chapter 18: Motion Tracking and Matchmoving

This chapter will show you some examples of the hardware used for various motion-control techniques and tracking tips for software trackers, plus a few secrets for faking it visually.

Chapter 19: Complex Composites

Sometimes it's necessary to extract your subject from between two surfaces or have them interact with the surfaces in some manner, retaining the shadows on the surfaces. This chapter will show you some examples of production techniques, including a real-world example from a feature film production.

Appendix A

This appendix is a comprehensive compilation of all the resources used in this book, listed alphabetically, including information resources, manufacturers, studios, and contributors.

Appendix B

Appendix B has details on the contents of the companion website: (www.focalpress.com/cw/foster) which is home to all the demo files, samples, and bonus resources mentioned in the book. It's organized to provide you with video and image examples,

project files, and source materials that will help you follow along with the text. The website content is divided into folders for each chapter.

How to Contact the Author

I welcome feedback from you about this book or about books and/or videos you'd like to see from me in the future. Feel free to contact me at my website at www.PixelPainter.com and check out the ongoing tips, tricks, and reviews on my blog, plus I'll post additional content and updates to the book as the need arises.

PART

Exploring the Matting Process

Before you can understand *how* to shoot and composite green screen, you first need to learn *why* you're doing it. This may seem obvious: you have a certain effect you're trying to achieve or a series of shots that can't be done on location or at the same time. But to achieve good results from your project and save yourself time, money, and frustration, you need to understand what all your options are *before* you dive into a project. When you have an understanding of how green screen is done on all levels you'll have the ability to make the right decision for just about any project you hope to take on.

Mattes and Compositing Defined

Since the beginning of motion *pictures, filmmakers have strived to create a world of fantasy by combining live action and visual effects of some kind. Whether it was Georges Méliès' ground-breaking work in the silent film* A Trip To The Moon *in 1902 or* Walt Disney *creating the early* Alice Comedies *with cartoons composited over film footage in the 1920s or Linwood Dunn and Carroll H. Dunning combining stop-motion miniatures with live footage for the visual effects for* King Kong *in 1933, the quest to bring the worlds of reality and fantasy together continues to evolve. With computer technology pushing the envelope more every year, filmmakers are constantly attempting to outdo their predecessors with more realism and fantastic visual effects.*

Often misrepresented today as chroma keying (which is a process relegated to a video switcher that turns off a specific color value in a video channel), the matting or traveling matte process uses a sophisticated series of elements that allow you to make complex extractions and composites. Although the industry may still refer to a matte as a key or keying, it's rarely suggested that an actual chroma key be used unless it's a crude and simple video production. With software and hardware matting and compositing available today, you'll seldom use such archaic technology.

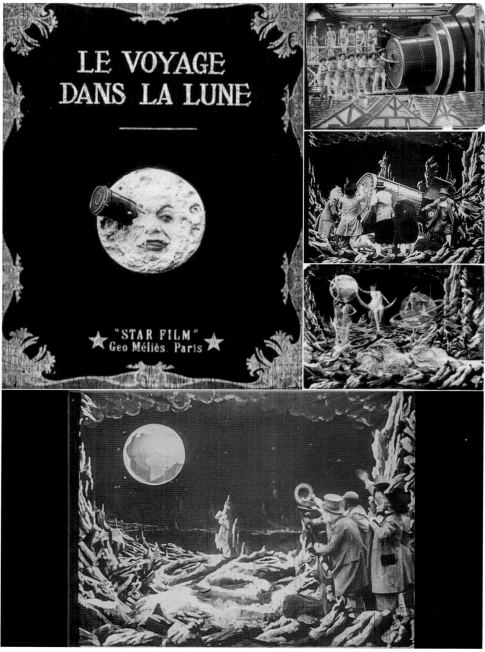

Georges Méliès pioneered early silent movie VFX with elaborate sets, painted mattes, animation and stop-motion in his 1902 film *A Trip To The Moon*

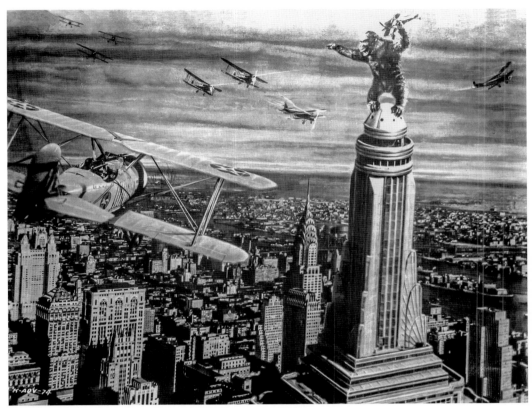

Linwood Dunn was pioneering matte techniques used in RKO Radio Pictures 1933 film *King Kong*

In this opening chapter, I'll share some of the history of compositing and matte-making techniques so you'll better understand where this technology came from and why it's still important today. There could be an entire book written on VFX history, but I'll focus on only the lineage in a specific series of events that lead to modern day mattes and keying.

The Road to the Modern-Day Traveling Matte

Let's start with the earliest compositing techniques. They were developed by Frank Williams, who used a black-backing matting process, which he patented in 1918. The process required the foreground actor to be evenly lit in front of a black background and then copied to high-contrast films, back and forth, until a clear background and a black

silhouette were all that was left on the film. Using a contact print with the silhouette matte film and the intended background footage together, a composite could be created. This process was used in many of the action silent films and continued to be used through the 1930s for the series of *The Invisible Man* features.

The Early Days

In 1933, John P. Fulton used this technique in one of Universal's most timeless and memorable stories, H. G. Wells' *The Invisible Man*. Actor Claude Rains wore black velvet under his clothing and gauze bandages and was shot against a black background, and the composited shots were cleverly created to sell the illusion (see Figure 1.1). It was such a success that several sequels were created in the years following the original; they used the same process, even though more sophisticated techniques had been developed.

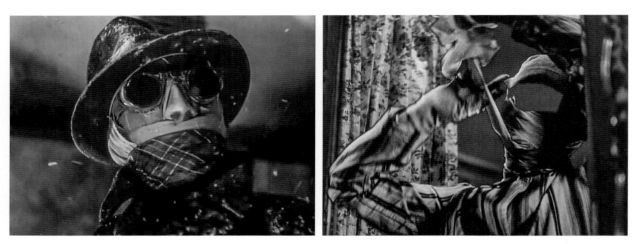

Figure 1.1 *In 1933, John P. Fulton of Universal used effects for* The Invisible Man *that awed audiences for generations as being technologically far ahead of their time*

Walt Disney set out in the 1920s to do a series of cartoons called simply the *Alice Comedies*. These were short films that used footage of a live actress shot against a white background. The film was run through an animation camera a second time to expose the animated characters and backgrounds (see Figure 1.2). Some of the scenes were done frame by frame from a series of stills to get closer interaction with the live actress and the animated characters.

Walt wanted to do something more than just add cartoons to an existing film, as Max Fleischer had done in some earlier films (although Walt invented the rotoscope process along with Max's brother Dave). Disney wanted to put the live actress into an imaginary world, and he created a feature-length film called *Alice's Wonderland*, which was never picked up by a studio. His *Alice Comedies* continued, with various actresses playing the Alice role in these silent films.

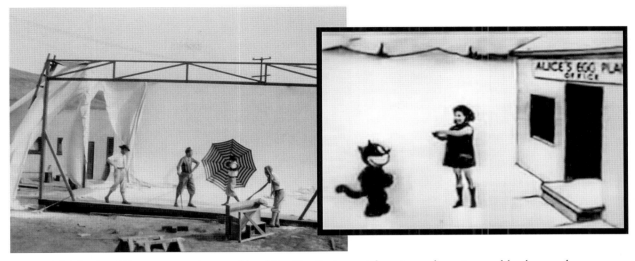

Figure 1.2 *The first Disney composites combined live film footage with cartoon characters and backgrounds*

Walt's top animator working at the Disney studios at the time was Ub Iwerks, who helped solve issues with the multiplane animation cameras to achieve better lighting exposure for the Alice cartoons. Ub was also responsible for helping Walt develop characters such as Oswald the Rabbit and what would eventually become the icon for the Disney empire, Mickey Mouse (see Figure 1.3). He and Disney parted ways for a time due to a dispute over a third-party contract, and Ub ventured out on his own.

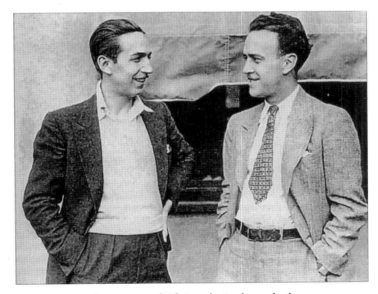

Figure 1.3 *Walt Disney and Ub Iwerks in the early days*

As shown in the documentary *Brazzle Dazzle Effects* on Disney's *Pete's Dragon: High Flying Edition* DVD (http://movies.disney.com/petes-dragon), Ub returned to Disney in 1940 and remained until the end of his career, working in Disney's film technologies processing lab.

In 1944, Disney and Ub developed new ways of mixing animation and live action in color with the feature film *The Three Caballeros*. This fantastic production used several techniques, including clear animation cells composited onto live film footage, rear-screen projection of animation behind live actors and dancers, and a color removal/transfer process. This process wasn't quite as sophisticated as what was to come: it used a dark background that, when duplicated onto black and white negative film, could hold a luminance matte of the actor from the color film; a crude extraction could then be made. Using the optical printers at the time, this footage was combined with animation cells and color overlays to create some fantastic effects never before seen. Several other Disney productions were accomplished with this process, including *Song of the South* and *Fun & Fancy Free*, as well as a number of Disney's television specials.

One of the true pioneers of the optical printer was Linwood Dunn, who joined RKO Pictures in 1929. Dunn worked on developing the first commercial production model of the optical printer, which was used by the armed forces during WWII; he won an Academy Technical Award in 1944 for his design. During his time working at RKO, he created a double-exposure matte process for the musical film *Flying Down to Rio*, which was an effect that was ahead of its time for 1933 (see Figure 1.4). In this film, many of the location scenes were performed and shot in front of a rear-projection screen.

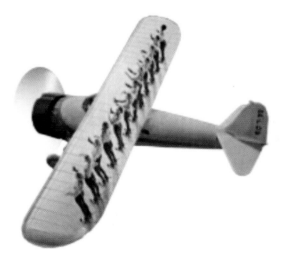 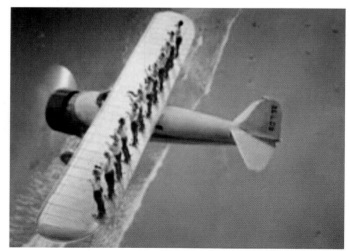

Figure 1.4 *The matte process using the optical printer on the 1933 musical comedy* Flying Down to Rio

The Traveling Matte Is Introduced

Petro Vlahos perfected the traveling matte system while working at the Motion Picture Research Council. This process originally used sodium vapor lighting on a set with the actors well in front of it. Petro's system was different from that of the British, who were forced to use didymium filters on all the lamps (which cost them two stops of light) plus a sodium absorption filter on the camera (resulting in another lost stop of light). This system was cumbersome and costly and produced results that were inferior to Petro's process.

Petro's system involved the use of a multicoated prism in a large Technicolor camera that split off the sodium light from the color film and directed the difference to the black and white film to create the traveling matte. He borrowed sodium vapor streetlights from the Department of Water & Power to light his scene and test his prism and camera process (see Figure 1.5).

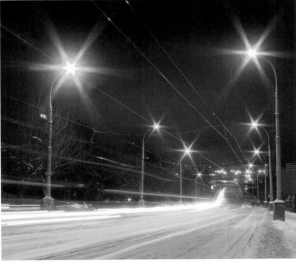

Figure 1.5 Sodium vapor street lights cast a yellow light in a narrow bandwidth

Interestingly, Petro developed his process and patented the technology at the same time the British developed their system, without either entity knowing about the other's developments (see Figure 1.6). Keep in mind that this was well before technology and information were as rapidly globally accessible as they are today.

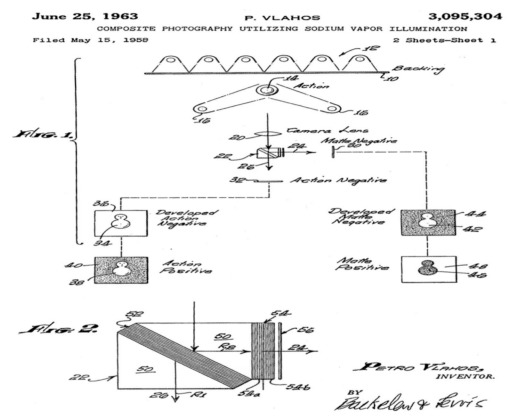

Figure 1.6 *Petro Vlahos' patent for the sodium vapor compositing process*

Upon learning of the British attempts at a sodium vapor lighting system's development, Petro made a trip to England and met with Ub Iwerks of Disney, who bought Petro's multi-coated prism from him in 1959 and started producing films for Disney using this technology. Ub then went on to perfect the camera used to shoot the traveling matte shots for several Disney feature films.

When I interviewed Petro Vlahos in 2009 at age 93 (Figure 1.7), he stated that even though Ub has been mistakenly credited with inventing this process in several instances, and has even received awards for the technology, Ub "took no part in the development, invention, or testing of the system which includes the multi-coated prism, but he did use it and made it popular in several films."

However, Ub Iwerks did perfect the production process using Petro's multi-coated prism in a three-strip Technicolor camera, which was dubbed "Traveling Matte Camera #1." In Figure 1.8, Ub is shown with the camera and the front is opened to reveal the prism, of which only one is to be reported to ever exist—the original that he originally bought from Petro Vlahos.

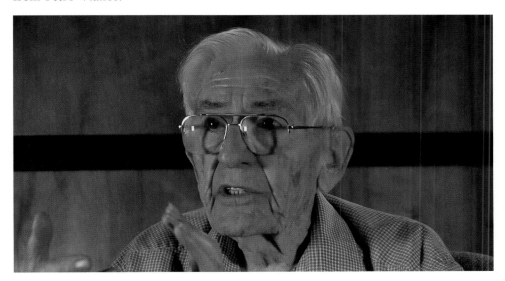

Figure 1.7 *Petro Vlahos at age 93 when I interviewed him*

Some of the earlier Disney films that Iwerks was responsible for, using this process, were *The Absent-Minded Professor*, *The Parent Trap*, *Mary Poppins*, and *Pete's Dragon*. Alfred Hitchcock borrowed Iwerks from Disney to supervise the special effects in his 1963 production of *The Birds*.

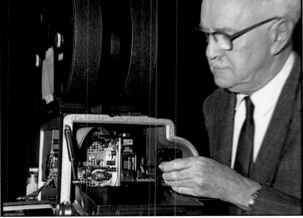

Figure 1.8 *Ub Iwerks with the modified Technicolor camera and Petro Vlahos' multi-coated prism*

Other notable pioneers of the compositing world who used early versions of the traveling matte process were Larry Butler for the 1940 Technicolor feature *The Thief of Bagdad* (SIC) and Arthur Widmere for *The Old Man and the Sea* (1958); see Figure 1.9. Widmere and others tried using ultraviolet lighting to create mattes, with acceptable, but still limited results.

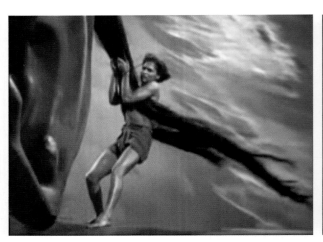 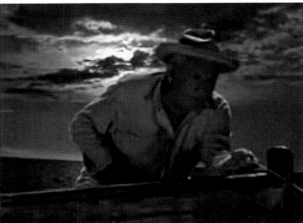

Figure 1.9 *Composited scenes from* The Thief of Bagdad *and* The Old Man and the Sea

But it wasn't until Petro Vlahos was challenged by MGM during the production of *Ben-Hur* that things really started to develop. MGM was shooting *Ben-Hur* in 65mm (then printed on 70mm), so the sodium vapor system Petro had developed wouldn't work—it was designed for 35mm Technicolor cameras.

Vlahos knew about the blue screen process others had been using with limited results (watch *The Ten Commandments* to see some of the major issues for reference); things like hair, smoke, motion blur, and transparency couldn't be properly matted and left a blue glow in these areas. He knew there was a select band in the color spectrum where blue could be split off with good results. He developed and refined the technology and patented the technique known as the Color Difference Traveling Matte System (see Figure 1.10). He won an Academy Technology Award in 1964 for this technology, which made the shooting and compositing of *Ben Hur* possible. All subsequent blue screen and green screen technology has been based on Vlahos' invention.

Vlahos holds several patents for his work in the motion picture industry area over the years, including a matte metering system, a camera flicker metering system, a camera crane motion-control system, a high-grain screen for outdoor drive-in theaters (for which he won a technical Oscar in 1957), a safe pyrotechnics discharge system, a daylight lighting system (which was used in *Ben-Hur*), and a fake blood for filmmaking that was made of tiny red glass beads and cellulose wallpaper paste that wouldn't stain expensive costumes. He has won several awards for his technical achievements, including Oscars, Emmys, and more, and has altered the course of motion picture history through his many accomplishments.

In 1976, Vlahos founded the Ultimatte Corporation (www.ultimatte.com) with a colleague, Bill Gottshalk (cousin of Panavision founder Robert Gottshalk), to create the electronic color difference traveling matte system, commonly known as the Ultimatte. Petro was joined by his son Paul Vlahos, and Ultimatte has led the industry in digital keying and compositing. Their technology in live broadcast keying hardware remains the de facto standard today and is also licensed by their largest competitor, Grass Valley, for use in its hardware systems. Ultimatte's software matte system remains superior to most on the market today.

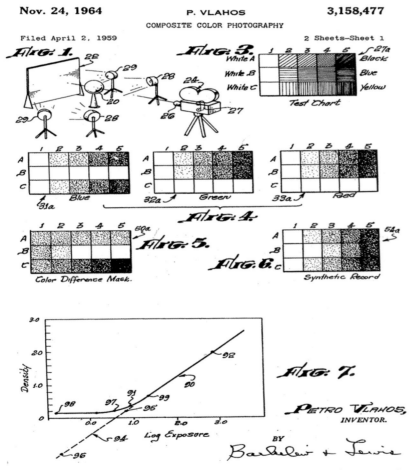

Figure 1.10 *Petro Vlahos' patent for the Color Difference Traveling Matte System*

Ultimatte has a sister company called iMatte (www.imatte.com), run by Paul Vlahos, which develops new technologies for live and video conference presentations and advanced camera technology for mobile devices. Paul has been instrumental in the

development of much of the technology at Ultimatte over the years, holds several patents of his own, and has received awards for his accomplishments.

Ultimatte has been used extensively in broadcast television production since the late 70s. One of the original shows that used it was Carl Sagan's *Cosmos* series for PBS. The composited footage was ahead of its time, which raised the bar for production quality of Dr. Sagan's series. You can find several examples of *Cosmos* on YouTube.

Many variations of this basic traveling matte technology have been explored over the years, as I'll cover in this book. Different ways to light and shoot the screens have been explored, including front projection, rear projection, interior and exterior lighting, film, and hardware and digital compositing—each has made its place in special effects history.

How the Sodium Vapor Traveling Matte Process Works

The term traveling matte simply means a matte that travels with motion picture images from frame to frame. A *fixed matte* stays constant throughout a sequence, as is done with basic garbage matting and the traditional hand-painted matte paintings on glass that the camera shoots through, to the static scene behind the glass.

Pete's Dragon High Flying Edition DVD http://bit.ly/1hqiH9O

As illustrated in the historical documentary produced by Les Perkins, *Brazzle Dazzle Effects* on the *Pete's Dragon High Flying Edition* DVD, the sodium vapor traveling matte process uses sodium light to produce a contrasting matte when exposed through a prism in the camera and onto black and white film. Contrary to popular belief, the sodium system (often mistakenly referred to as a "yellow screen") doesn't have a yellow background; rather, it consists of a white painted background that the sodium lights bounce off and back into the camera. This specific yellow sodium light that has a color temperature of about 1300°F (700°C) splits off to generate the matte on the black and white film stock, but because of its narrow spectral bandwidth, it doesn't affect the rest of the footage on the color film that is exposed. The color film records this portion of the scene as a dark bronze color, since the prism splits off the narrow bandwidth of the yellow sodium vapor light.

There are two film carriers in the camera. The lens in front captures the image, a prism deflects the sodium light frequency off at an angle onto the black and white film, and the color information

The sodium screen as seen on the color film, the B&W matte film and the final composite with animated character in Walt Disney's *Pete's Dragon* © Walt Disney Productions (courtesy of Les Perkins' *Brazzle Dazzle Effects* Featurette on the DVD)

continues straight on through to the color film. In the example illustrated in Figure 1.11, the process that was used in many of the Disney features is shown. The original scene shows the sodium vapor lighting on the background. The color footage of the actors is captured along with the black and white matte footage, which is then processed and inverted to create a void in the background plate. This matte is then masked to incorporate the animated character with the background plate and the animated characters and rotoscoped shadows. The final result may be several duplications of film later.

You can see why this technique was time-consuming and was eventually abandoned for the newer blue screen process and, eventually, the digital compositing that we take for granted today.

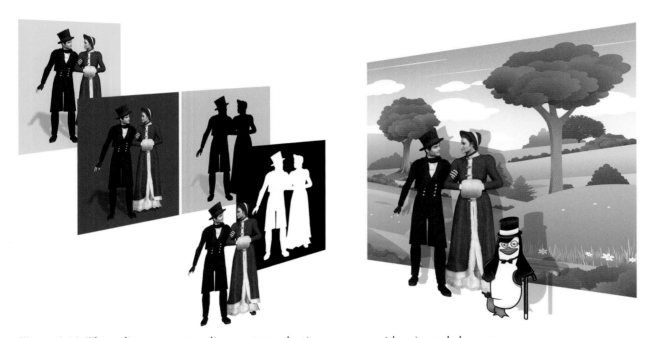

Figure 1.11 *The sodium vapor traveling matte production sequence with animated characters*

You can view my interview with Petro on YouTube at this URL: `http://youtu.be/XwtEW_nRHis`

How the Modern-Day Blue and Green Screen Traveling Matte Process Works

Today's hardware and software compositors can provide real-time results, extracting the background screen from an image and creating the matte without the need for duplication or processing film.

The blue or green screen production process is primarily made up of three elements: the foreground subject, the colored screen background, and the target background that the subject is composited into. Instead of a separate film stock processed at the same time as the original footage to create the traveling matte, the matte is generated from the background color on original film or digital video footage and composited digitally through hardware or a software application as shown in the diagram in Figure 1.12. Variations and combinations of this process are discussed throughout this book, but the process is basically the same using either hardware such as an Ultimatte or a computer software editing/compositing program.

Professional and amateur filmmakers alike can now shoot, extract, and composite scenes with ease, thanks to the technology available for every budget. The only limitation is your imagination and how much time you want to put into the planning, production, and postproduction of your project.

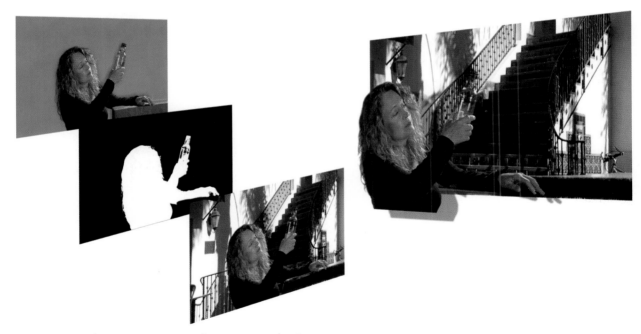

Figure 1.12 *The green screen traveling matte production sequence*

You can read more about how today's studios and indie filmmakers are using this technology in their projects in Chapter 7. As shown in Figure 1.13, the production of HBO's *John Adams* involved a lot of compositing techniques that are much more advanced from the simple sodium vapor process that Petro invented.

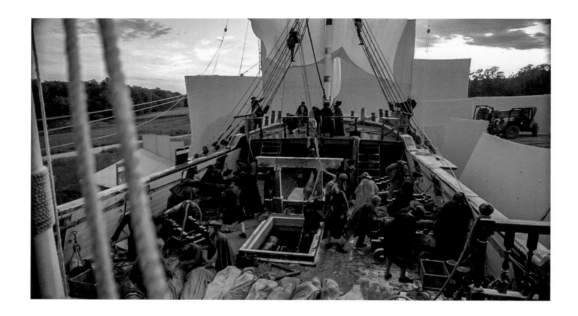

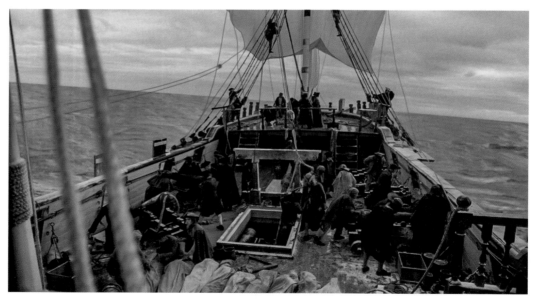

Figure 1.13 *Shooting and compositing green screen on the set of the HBO miniseries* John Adams

Where to Learn More?

Studios and productions mentioned in this chapter:

- **Disney's Pete's Dragon DVD:** http://bit.ly/1hqiH90
- **Les Perkins Productions:** www.lesismoreproductions.com
- **Universal Studios:** www.universalstudios.com
- **RKO Radio Pictures:** www.rko.com
- **MGM:** www.mgm.com
- **Ultimatte Corporation:** www.ultimatte.com
- **iMatte:** www.imatte.com
- **HBO:** www.hbo.com

You can find a complete list of references and suggested continued reading/learning from this chapter in Appendix A.

QUICK LOAD
QUICK SAVE

S M A R T

ultimatte

CHAPTER 2

Digital Matting Methods and Tools

In today's video and film *production market, various matte color options, lighting options, and hardware and software solutions help you create a digital matte. What is the best solution for your particular production? Should you use green or blue? Will your production be composited live or composited in post? Should you use a solid-color background or a reflective screen? Planning ahead and developing your workflow will dictate what your needs are and guide you through your available options. This chapter will help you decide between using a green or blue screen and will explore your options for hardware and software.*

Why Green vs. Blue Screen?

The most common question I've heard asked in the video and film production world is, "Why should I use a green screen instead of a blue screen?" Another common question is, "Why is green the most popular color?" The answers to these questions are often as varied as the people who give them because there are several reasons to choose one color over another. The original process for blue screen compositing, called the *color difference traveling matte composite*, utilized a series of steps in layering and exposing individual frames of film to create a composite, as discussed in Chapter 1. The next logical step for digital compositing production was to simplify and expedite the process of compositing blue screen shots with a combination of hardware and software. The term *blue screen* was the industry standard until more video production started taking off in the late 1990s.

The main reason green is currently the most popular keying color is that the green channel in composite video has the highest luminance value of the three signal colors red, green, and blue (RGB). The green channel in HD digital video has the most samples of the three available channels, so it gives you more data to work with, with the least amount of noise. In today's more advanced HD digital video cameras, this is typically known as 4:2:2. That means there are twice as many green photosites on a Bayer Pattern sensor than there are red or blue (RGB = 4:2:2), as shown in the diagram in Figure 2.1. You can read more about the different camera sensors and digital camcorder technology in Chapter 11.

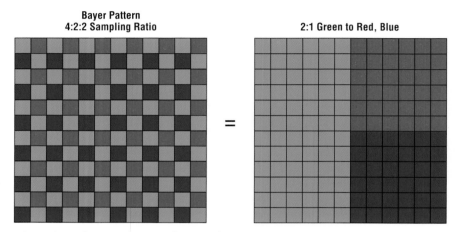

**Bayer Pattern
4:2:2 Sampling Ratio**

2:1 Green to Red, Blue

Figure 2.1 *The Bayer Pattern layout of a 4:2:2 sensor*

Most green screen is shot for video compositing use today, because high-definition cameras are widely used and are readily available to a broader user base. In addition, green is easier to light with tungsten (artificial) lighting, and it requires less light to illuminate it fully—thus costing less in production for lighting and setup.

For simple chroma keys and mattes, it's the easiest to work with for quick and dirty digital video production. Green is also less likely to conflict with your subject's skin tones, clothing, or eye color than blue. An exception of course is if a subject needs to wear green clothing or you're incorporating natural green foliage into your foreground shot.

However, camera sensor technology is getting more and more advanced today and even some prosumer cameras can get a decent green/blue screen shot for general low-budget video work. But I will cover more about cameras, resolution and what sensor/optics combinations still deliver the best results—within a reasonal production budget.

Real-World Examples

As shown in the examples in Figure 2.2, the noise levels of the red and blue channels in the green screen shot are much higher than for the green channel. Combining these three color channels together provides a composite of RGB and gives a color image. When

these channels are separated out independently, you can see the image data contained in that color space. Look at the compression artifacts above the model's head in the red and blue channels. These can cause problems when you're trying to pull a matte from the image or video footage. The original footage was shot with an HD camera with a 4:2:2 sensor.

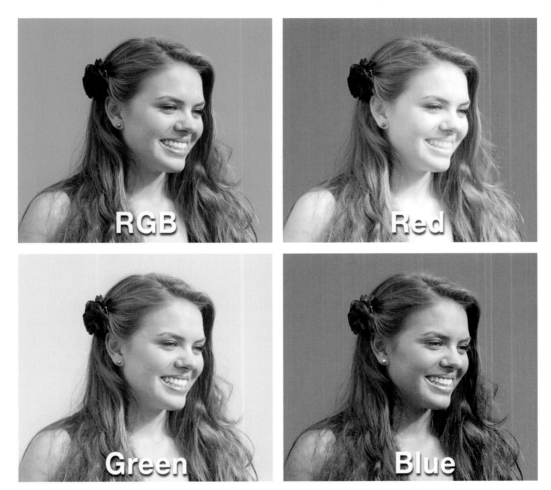

Figure 2.2 *The original green screen image shown in order of its channels: RGB, red, green, blue*

When the channels are compared with a difference matte (green channel minus red channel, minus blue channel), you can see how the blue and red cancel each other out and leave the background black, creating a matte of the background (see Figure 2.3). This series of images is only for illustration purposes; the software used to generate a matte works much more comprehensively.

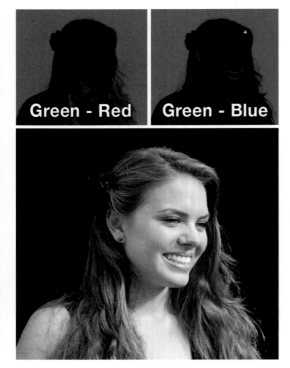

Figure 2.3 *Channels are subtracted (difference) from each other, creating green minus red, green minus blue, and, ultimately, green minus red minus blue to create a matte of the background*

There are still situations where you'll use blue over green. If your subject is a blond (let's say, "unnaturally blond") with fine blowing hair, then to get a decent key against green, your subject's hair will go toward red. A lot of work in matching the foreground color correction to the background composite will be required. A well-lit blue screen background will serve better in this situation.

You may also occasionally prefer blue over green when objects or actors come in contact with the screen, producing unavoidable *spill* when color bounces back off the screen. It's always best to place your subjects far away from the green background to avoid as much of this spill as possible, although the brightness of the background may still bleed over onto smaller subjects with details in the video. This is especially important if you're shooting with standard-definition analog camera equipment that has interlaced even/odd fields to deal with. In compositing, blue spill is less offensive on hair and skin tones, especially in night shots or composites where the scene includes a lot of cool-colored light.

At times, a magenta or red screen is used for difficult-to-light night shots with a lot of foliage and cool color lighting on the foreground subjects and objects; in those cases, you need a contrasting color to pull a tight matte. This is also common practice when shooting spacecraft, monsters, and aliens that may have blue-green textures or metallic surfaces that won't work well with a traditional blue or green background. This practice is used primarily in film and not video, because the color space in RGB doesn't yield as clean a result unless shot with a 4:4:4 camcorder.

In high-resolution still photography, an evenly lit blue screen is the preferred background. The many subtleties in the color range give you a cleaner matte in Adobe Photoshop (www.adobe.com) when you use a software compositor such as Ultimatte's AdvantEdge or Digital Anarchy's Primatte Chromakey, available as a third-party plug-in (covered later in this chapter). Some people prefer to use tricks with white, black, or 40% gray, but it's tough to get details such as fine hair or the transparency of glass and water without the aid of a quality color-difference matte compositor.

Jonathan Erland at the Academy

When I met with award-winning compositing and technology pioneer Jonathan Erland at the Academy of Motion Pictures Arts and Sciences (AMPAS), he showed me his technological testing stage for lighting and backgrounds at the Pickford Center (www.oscars.org/academy/buildings/pickford.html). He dubbed this studio the

Esmeralda stage in honor of the center's namesake, silent film actress Mary Pickford, who played the role in the 1915 feature of the same name. On this stage, Mr. Erland can test for the purest background and lighting combinations while extracting a broad range of foreground colors with various cameras and devices. In Figure 2.4, Mr. Erland describes the various color chips and focus targets placed around the frame of the stage with the green screen background, in addition to the blue and red backgrounds used for testing.

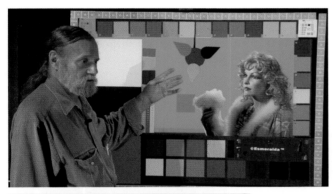

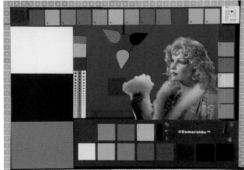

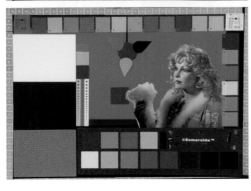

Figure 2.4 *Jonathan Erland describes the* Esmeralda *stage at the Academy of Motion Pictures Arts and Sciences Pickford Center*

The *Esmeralda* stage is constructed with a great deal of depth and detail so cameras and equipment can be calibrated for accurate testing and comparisons. With all spill completely removed from the front face of the stage frame, as well as an isolated and separately lit *Esmeralda* mannequin, the background is approximately 15 feet behind with changeable color backgrounds and filtered lights for complete illumination. The images in Figure 2.5 show the many components of the stage setup.

As Jonathan points out, the key to a great composite is all about the lighting and getting clean information from the background into the compositing software or hardware. Many productions go over budget and time because of poorly shot scenes or because the people involved don't know the basics of getting a clean blue screen or green screen shot. As Alex Lindsay of Pixel Corps (`www.pixelcorps.com`) has said, "With green screen, 80% of your postproduction budget is lost on the set." In other words, a properly planned and correctly shot production will result in less time needed in post to fix things.

Throughout this book, I'll cover production issues that should help you avoid making costly mistakes in planning, staging, lighting, and shooting your shots so the compositing process will go as smoothly as possible.

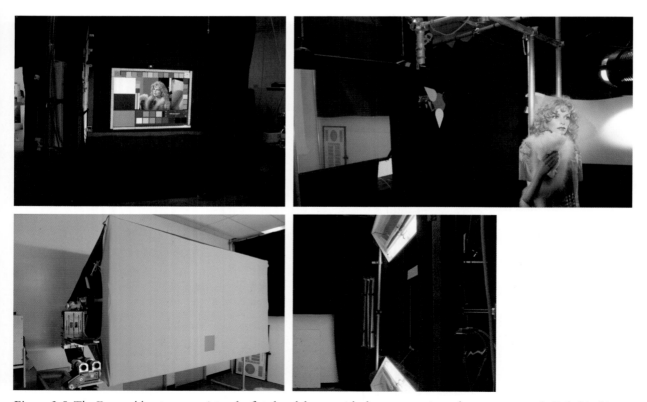

Figure 2.5 *The* Esmeralda *stage consists of a flat-faced frame with the mannequin and props separately lit behind it and the filtered background and color-matched lights approximately 15 feet behind the subject*

Difference Matte vs. Chroma Key

The term *chroma key* is often used loosely to mean anything that refers to pulling a color-difference matte from film or video footage. Even several manufacturers of matte compositing hardware and software still refer to the process as *chroma keying*. Although chroma keyers have evolved to do basic keying quite well, the process refers to switching off certain color pixels in an image or footage. Thus, when selecting a green color from the background in an image layer, the keyer looks for all instances of that green color and switches them off (or makes them transparent), revealing the image or footage below. This often causes artifacts and bleed around the edges of the subject you're trying to key out. Most keyers attempt to minimize this effect by expanding the color range slightly and choking the subject to remove green edges. This approach doesn't work well to retain shadows, reflections, or transparency, nor does it handle spill suppression well.

A good hardware keyer or compositor has the technology to handle spill suppression, transparency, and shadows, including motion blur in the foreground footage. Most software keyers that are included with non-linear editing (NLE) applications such as Final Cut Pro have minimal control over these issues and often rely on a good third-party plug-in to do the compositing.

For comparison, I've illustrated in Figure 2.6 the difference between the results from a basic chroma keyer and a color-difference matte compositor. The first two images are the original green screen footage and the chroma keyed image against the background plate. The third and fourth images represent the matte generated with Keylight in Adobe After Effects and the composited result.

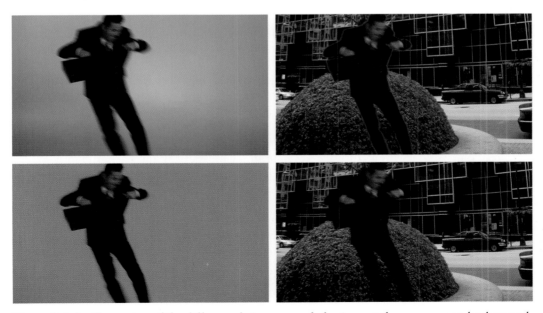

Figure 2.6 *An illustration of the difference between merely keying out the green screen background and using a matte-extraction tool such as Keylight*

Generally, if you only need a crude cutout of your green screen footage to place into a composition or overlay background footage, and you aren't concerned with fine details or transparency issues, a basic keyer may work for you. In most cases, a more sophisticated matte tool will be required. I outline the differences throughout the rest of this chapter.

Hardware Matte Compositors and Chroma Keyers

Whether you're working on a live broadcast with a virtual set such as a TV news set, a network sports desk, or a weather map, or you simply want to record a high-quality composited foreground and background to disc, a hardware keyer or compositor is what you need. Many options are available today for most any budget. From the high-end Ultimatte and Grass Valley compositors and keyers to all-in-one products such as NewTek's TriCaster 8000 to the very budget-conscious VeeScope Live, these options give you greater control and real-time results. I'll only cover a few of the most popular options currently on the market, which I hope will give you an overview of how these products work.

Ultimatte Hardware Compositors

The first and still the best hardware compositor on the market is the Ultimatte system (www.ultimatte.com). This system combines the foreground and background plates through hardware so you can see the results of the composite instantly and make adjustments either in the setup or through the hardware settings. Not only does the hardware key out the background colors, leaving the reflections and shadow details intact, but by using a difference matte, it also compensates for a dirty background matte, footprints, marks on the floor, cables, light stands, and other items that may be in the background.

Hardware modules from Ultimatte range from the high-end Ultimatte 11 HD/SD with the Smart Remote 2 for studio or TV production work to the latest prosumer version, the Ultimatte DV, which is plug-and-play with even lower-end video devices (see Figure 2.7).

The difference between using a hardware compositor like Ultimatte and shooting for later compositing with a software keyer begins with the way the background is lit. With few exceptions, when shooting a scene for postproduction keying, you want the background to be brightly and evenly lit, eliminating all shadows from the foreground subjects if possible. When you're shooting a live-action scene that requires retention of the subject's shadows on the background, you should use the available light with which you're shooting the actor to also light the screen. The hardware, such as an Ultimatte system, can compensate for this and allow finer details in the shadows and hair, as shown in the examples in Figure 2.8.

You'll require proper side-lighting to reduce the blue spill without degrading the lighting on the background or washing out the subject. It's also important to keep the color temperature of all the lights on the set the same. You can learn more about using the Ultimatte hardware system in a live-broadcast TV studio in Chapter 6.

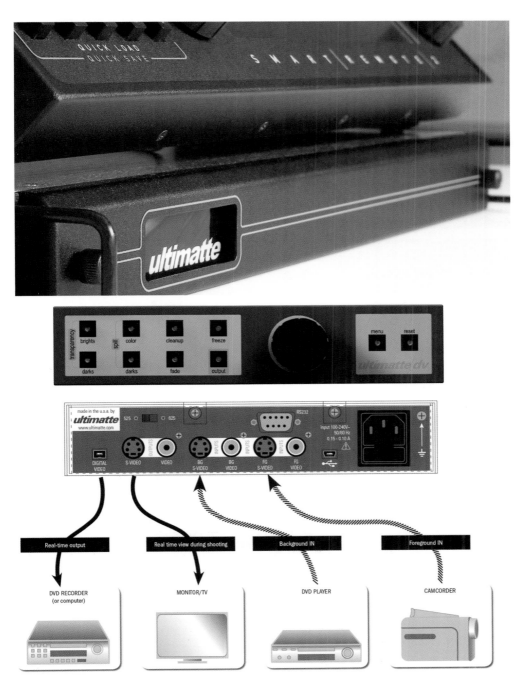

Figure 2.7 *Ultimatte 11 HD/SD with the Smart Remote 2 hardware compositor and the Ultimatte DV workflow*

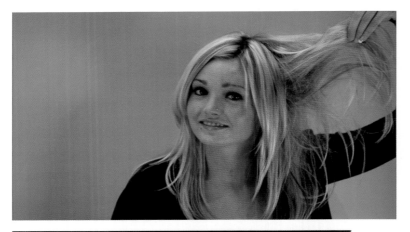

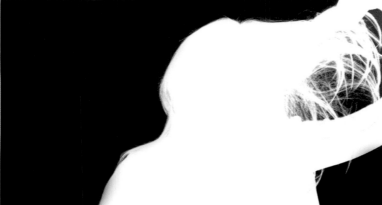

Figure 2.8 *Ultimatte compositors can create a clean matte while handling all the fine details of hair, spill suppression, edge refining, color correction, and foreground/background matching*

Grass Valley Switchers with Chroma Keyer

Many TV studios, colleges, churches, and live production venues use Grass Valley (www.grassvalley.com/products) switchers and hardware that have a built-in chroma keyer. Grass Valley licenses the use of the Ultimatte technology but has developed its own system to produce good results. The keyer is integrated into several configurations and packages, which makes for easy installation, implementation, and training.

These systems are usually installed in a modular configuration with several panels and lined up to create an impressive console. The company also provides several other hardware and software products, as well as digital studio camcorders and robotic cameras, as shown in Figure 2.9.

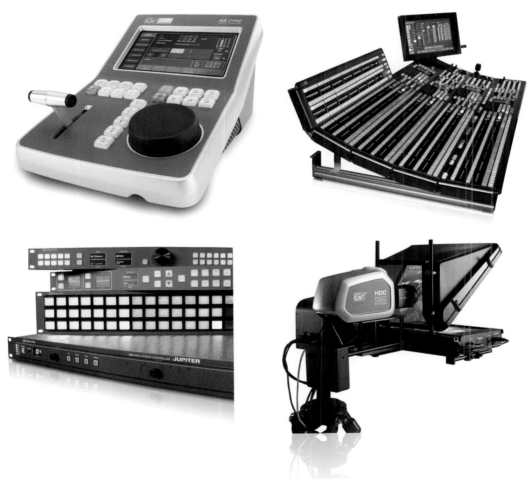

Figure 2.9 *Grass Valley offers integrated hardware and software systems, including controllers and switchers with chroma keyers and robotic studio cameras*

NewTek TriCaster 8000

For smaller studios, mobile production units, and live venues that need real-time switching, compositing, and streaming capabilities with virtual sets incorporated into the workflow, NewTek's TriCaster 8000 (`www.newtek.com/products/tricaster-8000.html`) is the way to go. Utilizing compact hardware and a PC with a software interface (see Figure 2.10), this easy-to-use system gives you multiple-camera control of your green screen shots and incorporates a live virtual set complete with reflections, drop shadows, and inset TV monitors.

You can learn more about NewTek's compositing with virtual set capabilities in Chapter 17.

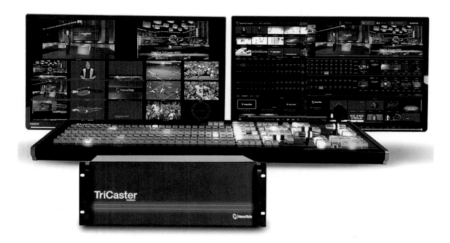

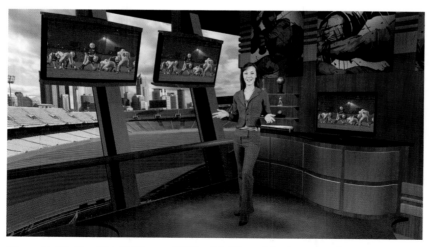

Figure 2.10 NewTek TriCaster 8000 with Virtual Set is a complete system that is both portable and affordable for mobile live productions and small studios

VeeScope LIVE

For the individual shooter, student or small video production department on a budget that wants a very simple setup for capturing and compositing live footage to disc, then VeeScope LIVE (www.dvdxdv.com) may be just for you. As simple as it is to configure and composite, VeeScope LIVE is a sophisticated keyer that works right on your MacBook with a live video feed from your HD Camcorder.

With very little lag in the real time feed, you can monitor and key the green screen foreground plate directly from your camera and preview or record it directly over your looping background video footage or image.

As you will note on the developer's website, they offer several stand-alone products and plug-ins for keying video and photos, plus they even have an iOS App that will produce live keying to your iPad. You can learn more about VeeScope LIVE's compositing capabilities in Chapter 17.

Figure 2.11 *VeeScope LIVE is easy to setup and composite/capture your green screen shots live on the set*

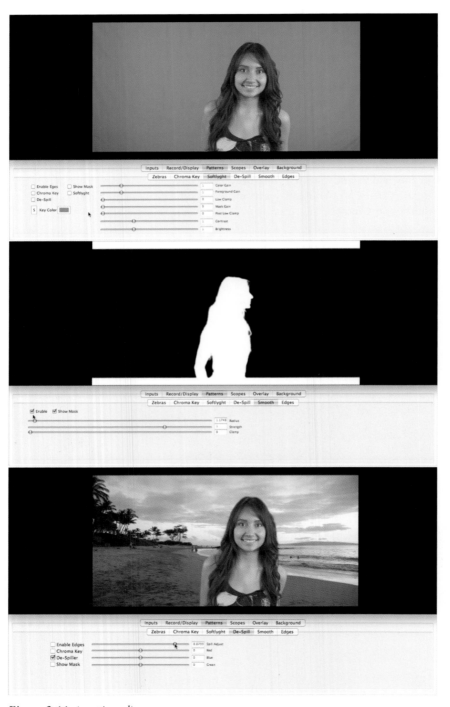

Figure 2.11 *(continued)*

Reflecmedia LiteRing

Another type of hardware keying isn't a compositor like the Ultimatte system; rather, it uses a reflective media background surface and a ring of colored LED lights around the camera's lens. *Reflective media* systems project a low-level but highly directional green or blue LED light that reflects off a background material made up of tiny glass beads; this background reflects only the LED light back into the lens of the camera. This provides a simple and clean key regardless of the surrounding lighting conditions, and it doesn't produce any color spill onto the subject you're shooting.

This footage can then be composited in real time with a low-end Ultimatte hardware solution such as the Ultimatte DV, or the footage can be recorded and composited like standard green screen or blue screen footage with a software keyer in postproduction. Again, the results will be determined by the position of the subject against the backdrop and the intensity of the lighting you use with the ring lights. If you have too much intensity, you'll get a visual spill on the subject due to high-intensity light bouncing back into the lens—similar to shooting a figure against a very bright window or light source pointed directly at the camera.

A few companies manufacture this type of setup, including the Reflecmedia LiteRing (www.reflecmedia.com) combined with its Chromatte backdrop material (see Figure 2.12). Reflecmedia also has a portable pop-out screen product called ChromaFlex that allows you to travel with the system and shoot close-ups for interviews, as I'll show in more detail in subsequent chapters throughout this book.

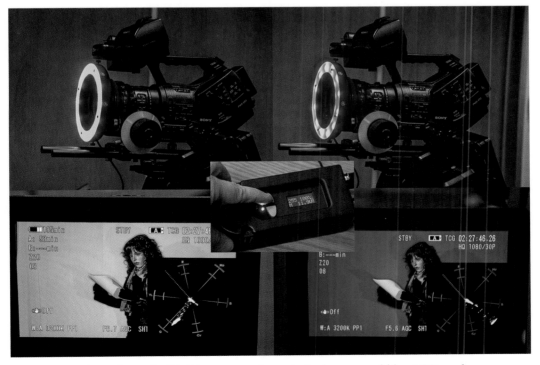

Figure 2.12 *The Reflecmedia LiteRing system shown in both green and blue LED modes*

This system works well for low-light conditions as well, because it doesn't depend on outside light sources for screen illumination. It's also a good choice for quick shots and on-location interviews where you may want to use existing natural light for your subjects but remove the background. The Chromatte backdrop material is very forgiving, and wrinkles aren't an issue. However, you won't get the subtle shadows you get in a true blue screen composite straight from an Ultimatte hardware system and a well-lit blue screen background. Another concern may be subjects wearing glasses or highly reflective adornments such as buttons and jewelry, which may bounce back the LED light. Slightly angling the subject to face at an angle away from the camera helps reduce any issues. A reflective teleprompter won't work with this system; and having an actor stare into the bright LEDs for an extended period may cause discomfort and squinting. In addition, you can't use this system outside in direct sunlight.

I've also found it extremely helpful to use a live software scope such as ScopeBox (www.scopebox.com) to help achieve optimum levels in the green or blue channels while recording with the Reflecmedia system. Seen in Figure 2.13 is a portable setup running ScopeBox on a MacBook Air with a live camera feed through a Thunderbolt connection on a Blackmagic Design UltraStudio 4K (www.blackmagicdesign.com/products/ultrastudiothunderbolt). You can learn more about this in Chapter 9.

Figure 2.13 *Monitoring the Reflecmedia signal with ScopeBox with a Blackmagic Design UltraStudio 4K*

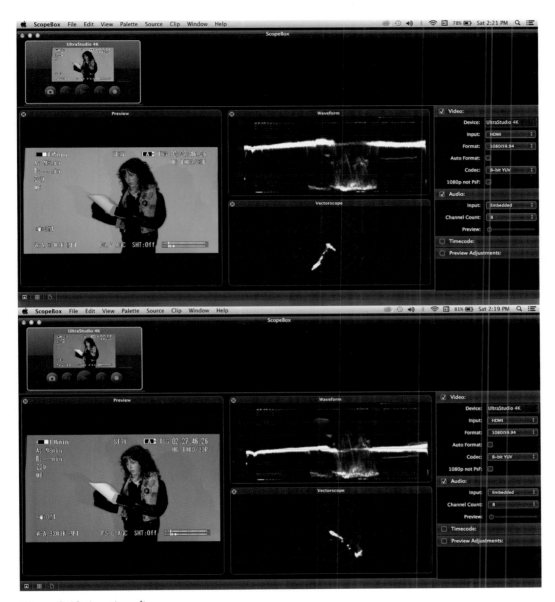

Figure 2.13 *(continued)*

Compositing Software and Plug-ins

When you're matting green and blue screen footage and creating composites, you can either use the capabilities built into major video-editing applications or use a third-party filter. The built-in keyers in most editing software are adequate, but only a few, such as

Keylight in After Effects, Ultra in Premiere Pro and Avid's SpectraMatte, are deemed exceptional. Therefore, you'll achieve the best results by using a third-party keying plug-in, available for the most popular video and image-editing software. Note that the following sections aren't a complete list of all the software or third-party plug-ins available—just the most popular on the market today.

Video- and Image-Compositing Software with Keyers

Major video software applications include some kind of color-keying or chroma keying tools that are built into the software's toolset as effects or plug-ins. If you don't have access or the budget to acquire third-party plug-ins for your compositing project, chances are you may be able to get away with using the built-in tools in your editing software. Let's take a look at some of the options available inside these popular applications.

Final Cut Pro X

Apple's Final Cut Pro X built-in Keyer does a decent job for general composites. I talked with Mark Spencer and Steve Martin from Ripple Training (www.rippletraining.com) about their suggested workflow using this keyer, which they have a project-based step-by-step video produced to explain the process.

They shared some screenshots from their video showing the process in the FCP X UI (Figure 2.14) by selecting the green screen footage and applying the Greenscreen Event, Refining the Key Matte and making the composite.

Avid Media Composer

Avid Media Composer includes an effective chroma keyer called SpectraMatte, which allows you to not only pull a clean key but also change parameters over time with keyframes. This process includes a SpectraGraph visualizer, which shows you the saturation region of the background key color compared to the color range of the entire foreground plate (see Figure 2.15). As expected in high-end keying software, there are advanced matte-processing tools such as matte edge softening, luma controls, and spill suppression.

Adobe Premiere Pro CC with Ultra

Premiere Pro CC uses the Ultra keying effect that Adobe acquired some years ago. It has an amazing algorithm that extracts a clean matte with very little adjustment, provided you start with a clean green screen foreground image.

Simply applying the Ultra Key effect to the foreground plate and selecting the green background with the eyedropper will get you close to an automated final matte.

Adobe After Effects CC with Keylight

Adobe After Effects CC includes the Keylight plug-in for extracting a very good matte. Keylight is a powerful green and blue screen matte-compositing tool with a lot of options and controls usually found only in high-end third-party plug-ins. Keylight was originally an award-winning stand-alone application from the Foundry in the United Kingdom; it

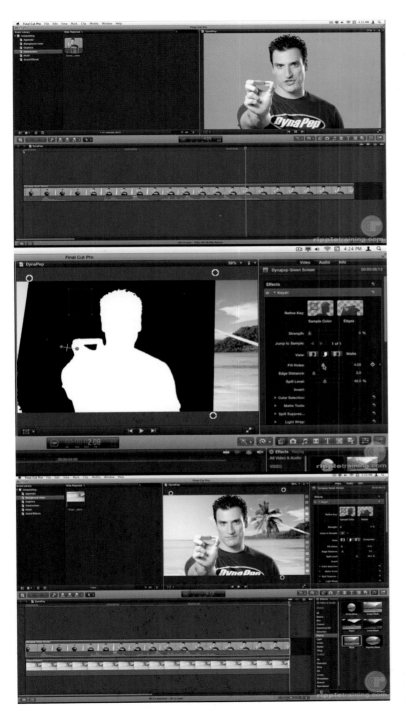

Figure 2.14 *Using the built-in Greenscreen Keyer Event in FCP X*

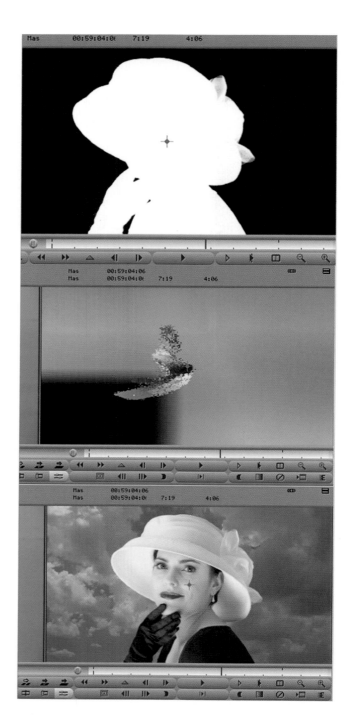

Figure 2.15 *The Avid Media Composer built-in SpectraMatte keyer with the SpectraGraph visualizer*

Figure 2.16 *Applying the Ultra Key effect in Adobe Premiere Pro CC*

was first licensed and included with After Effects 7.0 Professional and has been a forerunner in the professional compositor's toolset for several years.

Some of Keylight's features are the ability to see multiple matte stages and fine-tune the inside/outside matte controls, foreground/background color correction, and edge controls. You can double up the effect on a single piece of footage using both green and blue screen elements to matte out both background and foreground plates. Combined with the latest Key Cleaner and Advanced Spill Suppressor effects in the latest After Effects CC, you can create remarkable composites with detailed edges in just a couple clicks.

Adobe has included an Animation Preset that applies all three effects at once to your green screen layer, with expressions tied together so the adjustments work of each effect applied (see Figure 2.17).

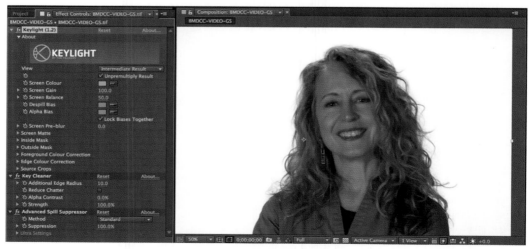

Figure 2.17 After Effects CC with Keylight plus the new Key Cleaner and Advanced Spill Suppressor applied with a simple drag-and-drop Animation Preset

With only a couple of slight adjustments, you can get an amazing composite with great detail and no edge artifacts (Figure 2.18).

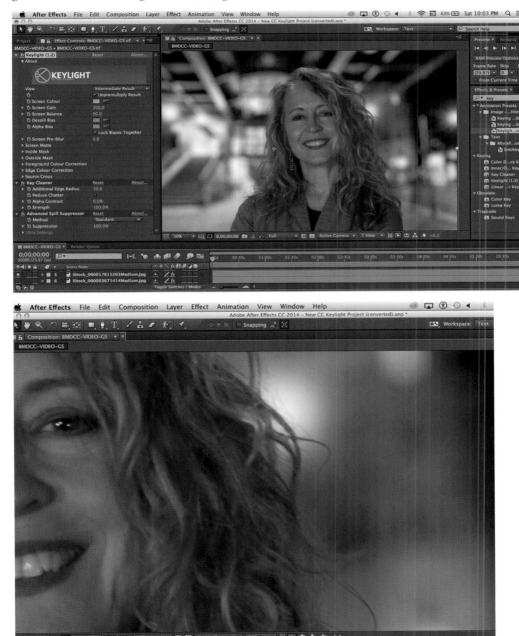

Figure 2.18 *A few adjustments in the effects gives an amazing composite*

After Effects CC is a robust compositing tool, and several third-party plug-ins are available for this application, as are covered later in this chapter and in greater detail in Part III of this book.

Sony Vegas Pro

Not one of the mainstream video editors but still an amazingly powerful tool is Sony's Vegas Pro (www.sonycreativesoftware.com/vegaspro). Since I'm primarily a Mac guy, I've never had the opportunity to work with Vegas Pro personally, but my colleague and fellow author/trainer Douglas Spotted Eagle is a real advocate for the software. He shoots with a lot of Sony gear (as do I) and shares with me how quick and easy it is to use Vegas Pro from almost any Sony file format—even in 4K. You can learn a lot more about editing in Sony Vegas Pro from his video training on the VASST website (www.vasst.com/store/training-dvds.aspx).

Douglas provided me with some examples of the Sony Chroma Keyer built into Vegas Pro. His preferred process is to first get a decent matte with the Chroma Keyer plug-in on the foreground plate, then applies a very slight amount (.002) of Gausian Smart Blur to the mask track and then parents it to the foreground plate track. A little color correction and exposure controls locks in the foreground and background composite quite nicely.

DaVinci Resolve

DaVinci Resolve (www.blackmagicdesign.com/products/davinciresolve) is known more for its amazing color grading capabilities but has also become quite an editing tool in the last few versions. While most editors will still opt to do their composites in After Effects, it is possible to create a matte directly inside Resolve—even if just used as a placeholder in your project. My friend and colleague Barry Andersson (www.barryandersson.com) is a fellow author and filmmaker and admits to using After Effects primarily for his composites, but in a pinch he may do a quick key in Resolve just to save time or use as a placeholder. He provided me with a few examples using DaVinci Resolve shown in Figure 2.20.

You can create a matte by adding a Serial Node and selecting a Corrector to hold out the selected green background to use as a hold-out matte. It's important that your green screen footage has an evenly lit background and that you have very little spill on your subject. This is a pretty hard key but it will work in a pinch with a few corrections.

Third-Party Keying and Compositing Plug-ins

As opposed to the built-in keying tools of the major video software applications, the best selection of compositing applications are third-party plug-ins that specialize in matte-extraction processes. Some are very advanced, whereas others perform only one specific task, but at a budget price.

Figure 2.19 *Sony Vegas Pro compositing with the built-in Chroma Keyer plug-in*

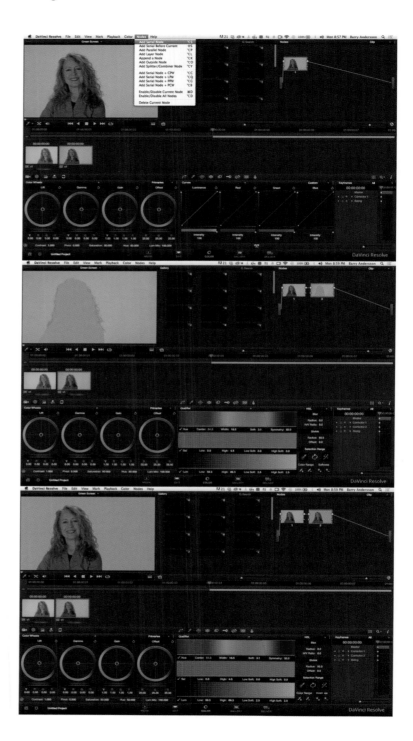

Figure 2.20 Using
DaVinci Resolve to
generate a rough green
screen matte

Primatte Keyer Pro 5.0

A robust keyer plug-in from Red Giant Software
(`www.redgiant.com/products/all/primatte-keyer`), Primatte Keyer Pro 5.0 gets it
right in just a couple of clicks—or with just the one-click Auto Compute option. The
simplicity of the controls doesn't mean this is a prosumer-level software product by any
means. It has features such as de-artifacting, color-correction tools, and cropping controls
for garbage matting. There is also an alpha cleaner that automates the process of
reducing noise while retaining edge details such as hair and transparency. A separate Spill
Killer offers spill suppression for greater control; and Light Wrap lets you fake the
background light spill on the edges of your keyed subject to produce a much more
believable composite, as shown in Figure 2.21. This isn't just a simple plug-in; rather, it's
a complete suite of keying tools.

Figure 2.21 *Primatte Keyer Pro 5.0 is an amazing toolset for the ultimate chroma key compositing*

Primatte Keyer Pro 5.0 works with the following applications:

- Adobe After Effects CC, CS6-CS3
- Apple Final Cut Pro 7, 6
- Apple Motion 4, 3.0.2

dvMatte Pro 3 Studio

Created by the gurus at dvGarage (`www.dvgarage.com`), what started as a simple keyer has evolved to become an impressively powerful piece of software for a small price. Originally, dvMatte (basic) was designed for doing one thing really well: keying standard-definition NTSC DV video footage and compensating for the problems associated with keying interlaced video. Since then, serious features have been added, such as an edge Light Wrap, Color Matching, and a new Screen Fix feature that utilizes a blank frame of the background plate to assure a clean key.

The original dvMatte (basic) was developed for After Effects and can still be purchased with the Composite Toolkit offered at dvGarage's site; however, dvMatte Pro 3 Studio isn't compatible with Adobe products.

dvMatte Pro 3 Studio works with the following applications:

- Final Cut Pro 6 or higher (not FCP X)
- Final Cut Express 4
- Apple Motion 2 or higher

Conduit Suite 2.2

Another sophisticated product from dvGarage, this isn't just another keyer but a complete compositing toolset. It's developed on the Conduit Pixel Engine developed by Lacquer. Conduit fuses the entire compositing process into an efficient GPU program—an optimal way of extracting performance from the video card with renders at full 32-bit.

It includes Conduit Live, which is a stand-alone GPU-powered nodal capture tool that uses the hardware (Mac only) to deliver real-time compositing. You also get the Conduit fxPlug for Final Cut Pro, Conduit After Effects, and Conduit Photoshop (Mac and Windows).

I've discovered through using Conduit After Effects that it has an entirely different approach, which includes its own UI; following a flowchart-based procedure, you can add several processes and effects to a single layer in one intuitive window (see Figure 2.22). This is truly an interactive process that lets you instantly see the effects of each stage in preview without having to wait to render after each adjustment.

Conduit also has its own built-in scope for measuring your signal from the camera live.

Conduit works with the following applications:

- After Effects CS5-CS3 (Mac only)
- Apple Motion 3 or higher
- Final Cut Pro 5.1.4 or higher (not FCP X)

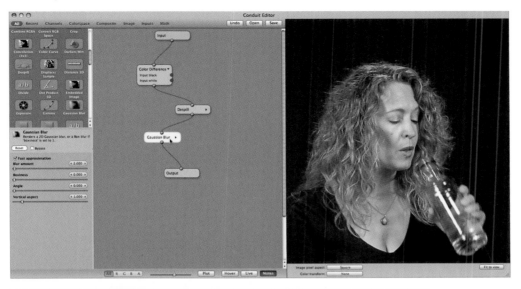

Figure 2.22 *The intuitive workflow process of Conduit gives instant results*

Boris Continuum Complete

This plug-in set does much more than just keying and compositing in your favorite editing application. The Boris Continuum Complete (BCC) (www.borisfx.com) package includes nearly 200 filters for keying, compositing, image processing, distortion, lighting, temporal effects, and motion tracking.

Focusing on the keying aspect of BCC for After Effects, I was able to do a very quick key with the BCC Chroma Key tool and then apply a soft backlight effect around the edges of the subject with the BCC Light Wrap tool (see Figure 2.23). This technique lets you add an internal glow around your model and uses the data from the background image to match the colors, shape, and luminance for a believable composite.

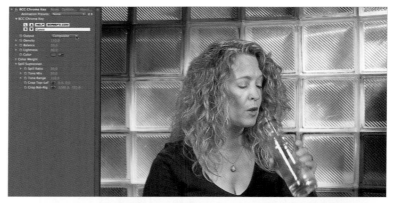

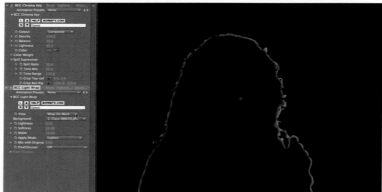

Figure 2.23 *BCC for After Effects has a great Light Wrap option that draws information from the background plate*

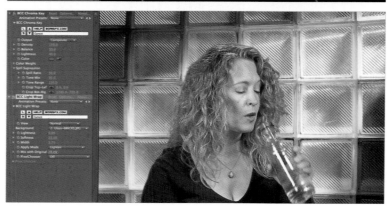

This is a very simple yet powerful toolset for compositing and maintaining a good balance of foreground and background plates.

Boris Continuum Complete 8 plug-ins work with the following applications:

- After Effects CC
- Final Cut Pro X
- Apple Motion
- Premiere Pro CC
- Avid Media Composer
- Sony Vegas Pro
- EDIUS
- Corel VideoStudio Pro

Primatte Chromakey (for Photoshop)

Primatte Chromakey by Digital Anarchy (www.digitalanarchy.com) is a highly effective keyer for both high-resolution stills and video in Adobe Photoshop CC (see Figure 2.24). Because video layers can be used in Photoshop (CS3 and newer), you can apply the Primatte Chromakey effect to a Smart Object and create a complete composition in Photoshop alone.

With spill suppression, color correction, edge detail refinement, and matte-correction tools, this is a serious keyer for both fine green or blue screen studio photography and those who need to composite a short video clip without going into an advanced video-editing program.

Primatte Chromakey works with the following application:

- Adobe Photoshop CC-CS3

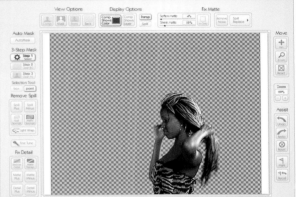

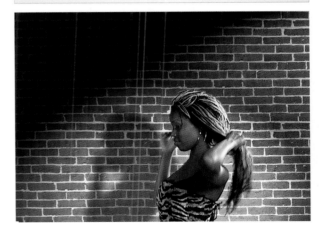

Figure 2.24 *Essential for Photoshop compositing, Digital Anarchy's Primatte Chromakey can be applied to both stills and videos*

Where to Learn More?

Products mentioned in this chapter:

- **Ultimatte:** www.ultimatte.com
- **Grass Valley:** www.grassvalley.com/products
- **NewTek TriCaster 8000:** www.newtek.com/products/tricaster-8000
- **ScopeBox:** www.scopebox.com
- **Apple FCP X:** www.apple.com
- **Avid Media Composer Adrenaline HD:** www.avid.com
- **DaVinci Resolve:** www.blackmagicdesign.com/products/davinciresolve
- **Sony Vegas Pro:** www.sonycreativesoftware.com/vegaspro
- **Red Giant Software, Primatte Keyer:**
 www.redgiantsoftware.com/products/all/primatte-keyer-pro/
- **Digital Anarchy, Primatte Chromakey (for Photoshop):**
 www.digitalanarchy.com/primatte/main.html
- **Boris FX, Boris Continuum Complete:** www.borisfx.com
- **Adobe Creative Cloud:** creative.adobe.com
- **Reflecmedia:** www.reflecmedia.com
- **Blackmagic Design UltraStudio 4K:** www.reflecmedia.com
- **VeeScope LIVE:** www.dvdxdv.com

References, resources, image, and footage credits:

- **Jonathan Erland, Composite Components:** www.digitalgreenscreen.com
- **The Academy of Motion Picture Arts and Sciences, Pickford Center:**
 www.oscars.org/academy/buildings/pickford.html
- **Pixel Corps:** www.pixelcorps.com
- **iStockphoto:** www.istockphoto.com
- **Barry Andersson:** www.barryandersson.com
- **VASST (Douglas Spotted Eagle's Sony Vegas Pro Training DVDs):**
 www.vasst.com/store/training-dvds.aspx

You can find a complete list of references and suggested continued reading/learning from this chapter in Appendix A.

Basic Shooting Setups

The foundational elements *for shooting all green screen setups are the materials used and the lighting of the background and the foreground subjects, including how these elements are positioned in relation to each other. Using the right combination of background materials, lighting, and positioning will save you hours of time during the keying or matte extraction process. The information in this book will guide you through these processes in various situations and production circumstances; but the basics, covered in this chapter, are always much the same.*

Basic Setups for Shooting Green Screen

You first need to understand the various setups required for the kind of keying you're going to do. For example, if you're doing a straight head shot or upper-torso shot of an actor that will get keyed out, then you don't need to worry about covering and lighting the floor in your green screen studio. If your actor will come in contact with the green background, then you need to approach the lighting entirely differently. This section will cover the basics; you can find more information about specific lighting techniques and setups in Chapter 9.

To grasp the basic concept of shooting green screen video, you must first understand how the camera sees the different elements in the shot. The green background must be evenly lit, or shadowed areas will be harder to key out. This is especially true for backgrounds behind fine hair or transparent items such as glass or liquids. The subject you're keying out needs to be far away from the green screen so you don't get spill from the reflective light off the screen onto your subject. In addition, the subject in the foreground must be lit separately so you have control over the exposure and direction of the light source(s) you require for your scene.

Figure 3.1 shows a starting setup for a project when you're trying to get a clean key with no shadows or interaction with the green screen. Of course, you need to add more lights if you can't get sufficient coverage on the screen or if you need to create a specific lighting of your subject to match the background onto which you're compositing.

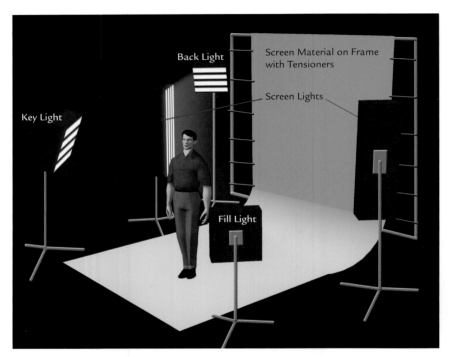

Figure 3.1 *A typical, basic green screen setup*

Notice that two lights are dedicated to lighting the green screen in this example setup. If you're using four-bank Kino Flo fluorescent lights (www.kinoflo.com), such as the Diva 400s (or equivalent), you should have enough coverage for a standard 10 x 10 background screen, provided you can move your subject a minimum of 8 feet away from the screen to avoid reflective spill off the brightly lit screen. Some setups even use green-colored bulbs to control the color temperature of the screen and reduce the amount of light needed to illuminate the backdrop, thus making it possible to get the subject even closer to the screen if there's no green light spill from the lights. I'll cover that in more detail in Chapter 9.

You use *model lights* to light your subject. These are the same as typical lighting used in still photography or video interviews. The three essential lights are the *key light*, the *fill light*, and the *back light*. If you're doing simple interviews or a talking-head shot in a studio, the layout of these three lights as shown in Figure 3.1 will probably be sufficient and pleasing to the viewer, because it's most flattering for your model or subject.

The *key light* is your main light. This is the predominant light source on your model and should be positioned to match the direction of the strongest light source in the background to which you're compositing. For instance, if your subject will be composited into an outdoor scene with strong sunlight, you need to match your key light to the direction the sun is shining in your background footage. Matching the color temperature and intensity is equally important. If you're compositing your subject onto a scene that's supposed to be under a streetlamp on a dark corner, then the same concepts apply, but the direction and intensity of the light source should be much different. For instance, the subject in Figure 3.2 appears to be underlit until you see the environment she is to be composited into. The key light source was positioned above and to the right to match the spot light at the bar.

The *fill light* is just as its name suggests: it fills in light throughout the scene. The position and intensity of this light (or several lights) give the illusion of creating available ambient light in a scene. To use the previous examples, a bright outdoor setting requires much more fill light than a dark scene under a streetlamp. Matching color temperature is equally important in the fill light and can be controlled with colored gels. You may opt for several fill lights, silks and or reflectors to achieve the proper lighting of your subject to match the final background plate you'll be compositing onto.

The *back light* is mostly used for studio settings; it creates a soft halo effect on the subject's hair. This gives a bit more definition from the background but isn't necessarily good for compositing into a background scene where you need to match lighting. In that case, you should have several fill lights to help provide even lighting.

Figure 3.2 A strong key light is positioned above the subject to best simulate the angle and intensity of the primary light source in the background footage she is composited into

In any case, be sure your subject is far enough from the green screen and the screen lights so that you have the most control over your foreground lighting and to avoid spill as much as possible. Figure 3.3 shows a couple different live green screen setups using both Kino Flo fluorescent lighting and Fiilex Spectral LED lights (www.fiilex.com).

Figure 3.3 *A live green screen shoot using the basic setup with Kino Flos and another using Fiilex Spectral LEDs*

Another popular, simple setup uses the model lights to light both the screen and the subject. The subject is close to the screen and the key light is predominantly strong, causing a shadow on the back wall. To compensate for the reflective spill, side spill-suppressor lights on either side of the subject warm up and wash out the spill, creating a clean key in the studio (see Figure 3.4). This setup is most popular for the purpose of interacting with the back wall surface, such as live TV weather forecasters who make contact with the screen and want to retain shadows on the wall (see Figure 3.5). Directors may use a blue screen in this case if they want subtle shadows and aren't worried about reflective spill. Note that your lighting may not be as even in this setup, because you use the available model lights to illuminate both the background and the foreground elements.

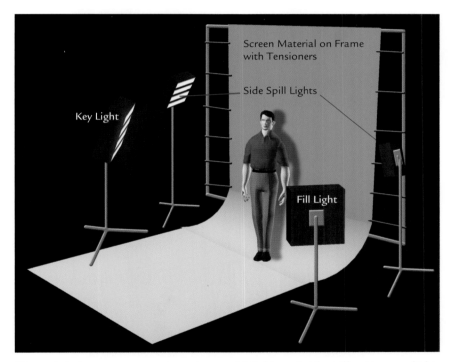

Figure 3.4 *A green screen setup using model lights and side spill-suppressor lights*

Yet another technique used in some larger green screen stages where the actors are on the green surface with a cyc wall, is to use what's referred to as a "China Ball" light that is a large diffused light source that doesn't cast heavy shadows. An example below in Figure 3.6 shows several China Ball lights on a set, along with some large silks that help illuminate a big area. There are several DIY China Ball light videos you can explore on YouTube.

Figure 3.5 *A live green screen shoot utilizing the side spill-suppressor lights*

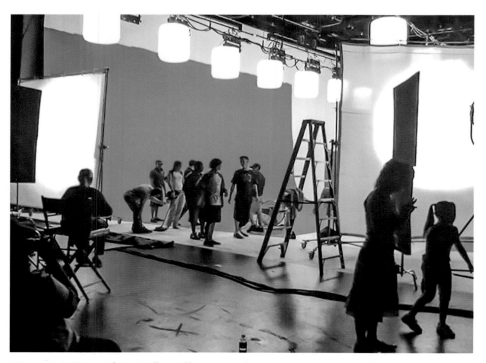

Figure 3.6 *Using China Balls to illuminate a large green screen sound stage*

Green Screen and Blue Screen Materials

You can use many materials for green screen and blue screen compositing, depending on your location, the scale of the project, the method of keying you'll use, and, of course, your budget. Large-scale projects such as motion-picture production use huge sets with seamless painted walls, cycs, and floors—not to mention a vast array of lights. On the opposite end of the spectrum, a low-budget independent video project or interview may use a pop-up green screen or even a piece of green material suspended from a rod or frame, with a couple of portable lights. In either case, knowing what you need to accomplish and doing some prior planning will help you get the most out of the materials you have at your disposal.

Painted Walls, Cycs, and Floors

In most cases, smaller studios have a flat wall that's painted evenly with green screen paint. A painted wall is easier to light evenly than a stretched or hanging fabric background, because it's flat, smooth, and has an even texture. The best paints to use are either Rosco's Chroma Key paints and DigiComp paints (www.rosco.com/us/index.cfm) or Composite Components' Digital Green, Digital Blue, or other colors (www.digitalgreenscreen.com), as shown in Figure 3.7. These paints are manufactured specifically for the correct color density and finish to give the proper amount of light reflectivity, saturation, and evenness on your painted surfaces. If you do some comparison shopping, you'll find that not just any green paint will work, and trying to get something mixed at your hardware store will probably give you more headaches than positive results. This isn't to say that you can't make it work. Many people have done low-budget shoots and had decent results from hardware store green and blue paint. If you're on a tight budget and that's all you can get your hands on, then using some green Kino Flo bulbs can help make up for it; but you'll probably spend much more time cleaning up poor-quality composite shots than if you use a paint made specifically for digital matte keying.

Note that painting your walls will require you to repaint periodically to cover up scuffs, smears, and handprints. Digital matte paint doesn't touch up well, and it's recommended that you repaint the entire surface as needed. With the

Composite Components Company

Digital Green®

Digital Blue™

Digital Video Blue™

Digital Red™

Post Office Box 421301, Los Angeles, CA 90042-1301 (323)25701163 Fax: (323) 257-0604

Figure 3.7 Composite Components Digital paints come in Digital Green, two kinds of Digital Blue, and Digital Red

premium digital matte paints costing upward of $60 per gallon, it's advisable that you try to keep your walls clean and free from contact as much as possible.

When you need a larger area, it's not always necessary to have a huge studio to achieve a near-infinite wall if you can build or install a cyc wall system. A *cyc* (short for *cyclorama*) is a seamless curved surface that joins the wall to the floor in a smooth transition. Infinity cycs are also curved to the adjoining right-angled wall, creating curved corners with an intricate three-directional corner joint. A few people have successfully built their own permanent cyc walls with building materials, plaster, and paint, which works if you're on a budget and are handy with construction. However, kit products offer flexibility, ease of installation, and, in some cases, portability. These systems include flooring as well as walls, so you can access 180° rotation in the horizontal and at least 90° in the vertical. This system allows the subjects to stand or walk virtually anywhere.

The most popular (albeit expensive) solution is the Pro Cyc System (www.procyc.com), shown in Figure 3.8. Pro Cyc sells manufactured fiberglass sections that you can mold into your permanent installation. It also sells portable infinity cyc kits that you put together on location: you can quickly patch the seams, paint, and be ready to go in hours instead of days. It even has a kit on wheels that you can assemble and roll around your studio as needed.

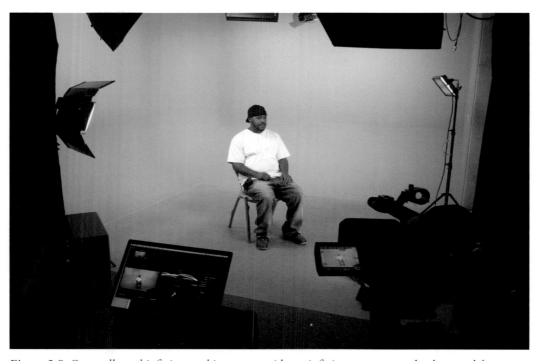

Figure 3.8 *Cyc walls and infinity cyc kits can provide an infinite green screen background for your studio when you're shooting your subject against the corner of the wall*

Digital Matte Keying Fabrics and Materials

Many manufacturers and suppliers have green screen and blue screen fabrics and materials available, but which ones should you use? Which products offer the best results, travel well with minimal wrinkling, hold up under heavy use, and are cost-effective? What fabric is best to use—nylon, Lycra, muslin, or foam? The answers to these questions vary about as much as the situations you may be shooting in. Small interview setups with studio lighting may require a more reflective surface than an outdoor staging. As you may imagine, few products can offer you everything you're looking for in all situations; but the following products are available for multiple uses.

Composite Components Fabrics

Composite Components Digital Green and Digital Blue backing fabric is a nylon-spandex material that stretches tight and smooth when hung in a frame correctly (see Figure 3.9). This material travels well with minimal wrinkling and optimum coverage. You can easily overlap pieces to cover large surfaces or to create a temporary and portable cyc setup. Composite Components also has leasing/rental programs for large setups.

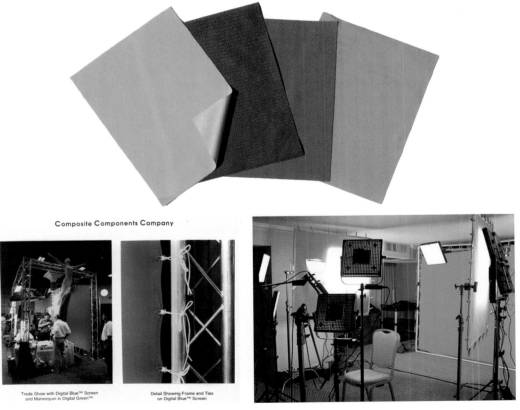

Composite Components Company

Trade Show with Digital Blue™ Screen and Mannequin in Digital Green™

Detail Showing Frame and Ties on Digital Blue™ Screen

Figure 3.9 You can achieve a variety of installations with Composite Components Digital Series fabric backgrounds

Composite Components also has a Digital Red material for use when you're shooting models, objects, and miniatures that have blue, green, or metallic surfaces. People don't usually key well against red because there is so much red in skin tones—which is why you rarely see a red screen on a normal production set.

Figure 3.10 Rosco offers a line of DigiComp colored paints, fabrics, tape, and cables

Rosco DigiComp Products

Rosco manufactures a line of compositing materials for both green screen and blue screen production (see Figure 3.10). In addition to the paints described earlier in this chapter, it has a DigiComp line of products that include a 100 percent cotton fabric with impregnated color dyes that can be spot-cleaned as necessary and still hold an accurate color density to match the DigiComp requirements. Fabrics come in 30′ and 60′ bolts and are 50in. wide.

In addition to the fabric, Rosco offers color-matched DigiComp gaffer tape as well as a line of DigiComp green and blue aircraft cable with PVC sleeves. This is highly useful for live TV studio production because it saves you time trying to hide cables or trying to fix the shot in postproduction.

Lastolite Chromakey Collapsible Blue and Green Screen

A few portable and collapsible keying backdrops are on the market, but the Bogen Lastolite Chromakey Collapsible is a higher-quality product than most (www.lastolite.com/5x6-collap-cromakey-blue-green-lllc5687). Lastolite, a manufacturer of photographic backgrounds and reflectors, offers a collapsible screen that's dual-sided for either green or blue chroma key (see Figure 3.11). This portable screen is great for interviews and outdoor shooting and is available in several popular sizes. I've had great keys both inside and out using this portable screen in much of my production for this book.

Generic Green Muslin

Green muslin is widely available through online wholesalers and marketers of video production gear and is often included with lighting kits for shooting green screen. However, this material is difficult to work with for many reasons.

First, it wrinkles *very* easily. In the test shot we did at my friend Colin Smith's home studio (Figure 3.12), we discovered that spending an hour steaming the green screen material only helped so much. Maybe if it was grommeted and mounted semipermanently to a frame it could be pulled tighter, but it was hard to work with in the field.

Second, the material absorbs light like a sponge. We had Kino Flo 400s with green tubes in them set to the highest setting, and we barely scoped near 60 percent green. If you want clean, professional results in your key, I highly recommend avoiding this material, regardless of how little it costs.

***Figure* 3.11** *Lastolite Chromakey Collapsible portable green and blue screens offer high-quality screen backdrops with the ultimate portability*

Figure 3.12 Green muslin is difficult to work with in the field

Reflective Media

The Reflecmedia Chromatte projection/reflection system (www.reflecmedia.com) uses a low-level but highly directional green or blue LED LiteRing. The LiteRing shines onto a background material made up of tiny glass beads, which reflect only the LED light back into the lens of the camera (see Figure 3.13). This arrangement provides a simple and clean key regardless of the surrounding lighting conditions and doesn't produce any color spill onto the subject you're shooting.

This footage can then be composited in real time with a low-end Ultimatte hardware solution such as the Ultimatte DV, or it can be recorded and composited like standard green screen or blue screen footage with a software keyer in postproduction. Your results are determined by the position of the subject against the backdrop and the intensity of the lighting you use with the ring lights. If you have too much intensity, you get a visual spill on the subject because of high-intensity light bouncing back into the lens—similar to shooting a figure against a very bright window or light source pointed directly at the camera.

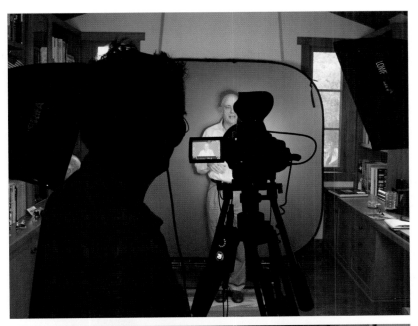

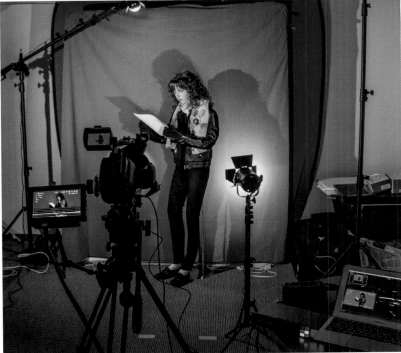

Figure 3.13 *Reflecmedia's LiteRing and Chromatte system work great for portable or studio setups*

See Chapter 9 for more about lighting in all situations. Details about properly lighting and using a scope, especially when using the Reflecmedia LiteRing system, will help you get the best results from any setup or materials you use.

Where to Learn More?

Products mentioned in this chapter:

- **Pro Cyc:** www.procyc.com
- **Kino Flo lighting:** www.kinoflo.com
- **Fiilex Spectral LED Lighting:** www.fiilex.com
- **Composite Components Digital Series products:** www.digitalgreenscreen.com
- **Rosco DigiComp products:** www.rosco.com/us/index.cfm
- **Lastolite Chromakey Collapsible blue and green screen background:** www.lastolite.com/5x6-collap-cromakey-blue-green-lllc5687
- **Reflecmedia Chromatte:** www.reflecmedia.com

You can find a complete list of references and suggested continued reading/learning from this chapter in Appendix A.

Basic Compositing Techniques

The world of compositing *has definitely changed over the past half century. From traveling matte film systems to modern-day green screen and roto masking done on a laptop, they all use similar concepts to produce the desired result: joining foreground elements onto the background plate. I'll cover many different techniques of shooting and postproduction compositing in subsequent chapters. This chapter will show you a few of the basic concepts in producing chroma keys, extracted matte composites and roto masks with common desktop software.*

Overview of Matting Compositing Techniques

The process of *chroma keying*, also called *color difference matting*, is a method of subject extraction done either with hardware, such as the Ultimatte system, or with a desktop software solution. The process involves first selecting a background color range in the spectrum (such as green from a green screen) from a foreground plate, then extracting the subject from this background color, and finally creating an alpha matte that allows only the subject image data to be visible. This process lets you composite the foreground plate and background plate together, creating the illusion that the two plates were created as one, through the lens of the camera (see Figure 4.1).

 If you're using a hardware compositor, such as the Ultimatte HD, then the compositing is done by combining the live foreground and the background plate and piping the composited imagery live to broadcast (such as a news or weather program) or to a storage device. This is how most live news programs, televised sporting events, and

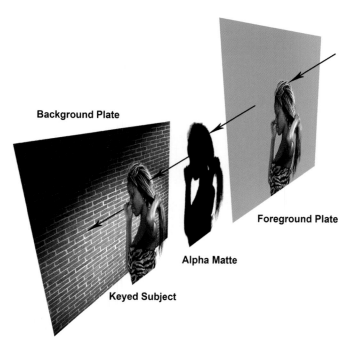

Figure 4.1 *The green screen compositing process extracts the subject from the green screen background*

virtual-set entertainment shows are produced today. In the motion-picture industry, many crews use the Ultimatte compositor as a preview to see whether the shot they're taking will work correctly in the final composite in postproduction software. They don't composite with the hardware at this stage, because doing so would limit their ability to separately control each plate—similar to flattening an image in Photoshop instead of saving the individual layers of a file.

Using a software-compositing workflow, you can process much more at the time of compositing, such as adding CGI effects, atmospheric conditions, lighting, animation, 3D characters and environments, and so on.

Software Chroma Keying, Matting and Compositing Process

No matter what software you normally use for video editing or production, chances are it has built-in chroma keying or matte extraction features that will let you do some basic compositing of your footage with a background. In most cases, your application will also have a third-party plug-in that will do a professional job of matting out the green screen from your source footage. Even problematic footage can be salvaged in most cases, but it may require a lot of effort to work around the poorly lit green screen. For more information about working with poor footage, refer to Chapter 16.

Basic Chroma Keying with Final Cut Pro (FCP X)

Honestly, I was a Final Cut Pro 7 user, but switched to the Adobe workflow since CS 6 and never got on board with FCP X, but I did want to represent it in this second edition of the book. I realize there will still be a lot of folks who may have just started out on FCP X or made the switch over and we need to address your needs as well. So I contacted my colleagues Mark Spencer and Steve Martin from Ripple Training and MacBreak Studio fame. They provided me with some screenshots from their video training on compositing with FCP X (bit.ly/Compositing-FCPX) so for further info on this process in FCP X, I urge you to check out their video training series.

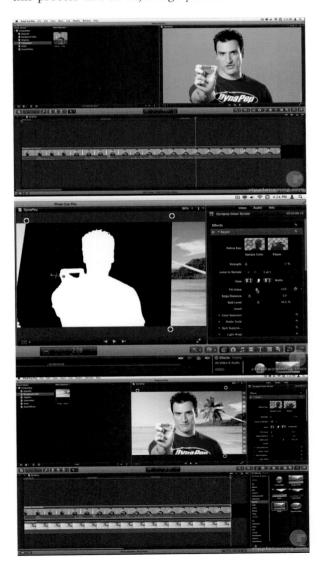

Figure 4.2 Simple green screen compositing in Final Cut Pro X

The process starts with a Compositing project that has the foreground (green screen footage) plate imported and selecting a Greenscreen Event for the footage and set the in and out points for the clip's length (see Figure 4.3).

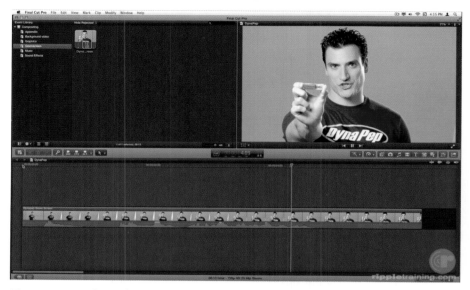

Figure 4.3 *Applying the Greenscreen Event to the foreground footage*

Then select a Background video from the Event Library to composite over, and add it to the edit clip on the Timeline. Be sure to move the added clip underneath the foreground clip (Figure 4.4).

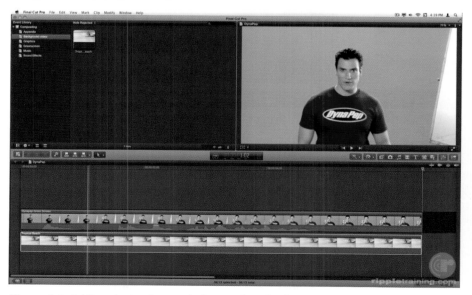

Figure 4.4 *Adding the background plate to the edit clip*

Next, open the Effects panel and select the Keying effect and drag onto the foreground clip. (Figure 4.5).

Figure 4.5 *Applying the Keyer effect to the foreground clip*

If your footage requires a mask to cut out unwanted items in your foreground plate like stands, screens, lights, edges of the green screen, etc. (otherwise known as a "garbage matte") then select the Mask effect and drag it over your foreground clip. Use the corner pins as shown in Figure 4.6 to position the mask edges to hide the unwanted elements, but take care to drag your playhead across the length of the clip to be sure you're not cutting off any part of your actor.

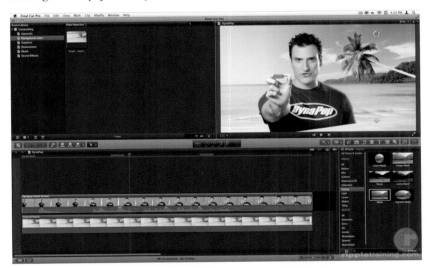

Figure 4.6 *Applying and adjusting the edges of the Mask effect to hide unwanted elements in the foreground plate*

To further adjust the keyed mask of the foreground plate, open the Inspector from the toolbar and select the Video pane to reveal the Keyer controls and select the white-on-black Matte View icon. This will show that you may have some spill on the skin or clothing. Adjust the Strength slider or Fill Holes slider to help eliminate some of these imperfections, as shown in Figure 4.7.

Figure 4.7 *Making adjustments to refine the Matte*

The final step is to make adjustments to the Spill Level slider and refine your color balance of the foreground plate to match the background plate (Figure 4.8).

Figure 4.8 *Adjusting the color Spill Level of the foreground plate*

Matting and Compositing Layers in After Effects

Adobe After Effects is the ultimate affordable desktop compositing tool. It gives you a lot of flexibility and control when you're working on several layers at a time. Adobe After Effects (CS3 or newer) includes a powerful matte extraction tool called Keylight. This plug-in handles motion blur and deals with spill suppression quite well, and with the inclusion of the new Key Cleaner tool in After Effects CC, you can get remarkable results.

The process is straightforward. Create a composition and import the foreground and background files, stacking the foreground layer on top of the background layer in the Timeline panel (see Figure 4.9).

Figure 4.9 Stacking the foreground and background layers in After Effects in preparation for compositing

Select the foreground green screen layer in the Timeline, and apply the Keylight plug-in (Effect ➢ Keying ➢ Keylight). Keylight's controls open in the Effects panel on the left. Use the eyedropper to select an average area of the green screen background around the subject. Change the View to Screen Matte so you can make adjustments with the Clip Black and Clip White sliders to create a clean alpha matte (see Figure 4.10).

Keylight includes a lot of controls you can adjust for the edges, foreground color correction, and more. It works well for a built-in matte extraction tool. However, it may have issues with reflectivity or color collisions that would be problematic for any chroma keyer or matte tool and that require hand-roto masking, as I'll discuss later in this chapter. Notice in Figure 4.12 the bad reflection on the briefcase, which causes it to be partially invisible for a few frames. I'll cover ways to avoid this during a shoot in Chapter 9.

Figure 4.10 *Applying Keylight to the green screen foreground and cleaning up the Screen Matte*

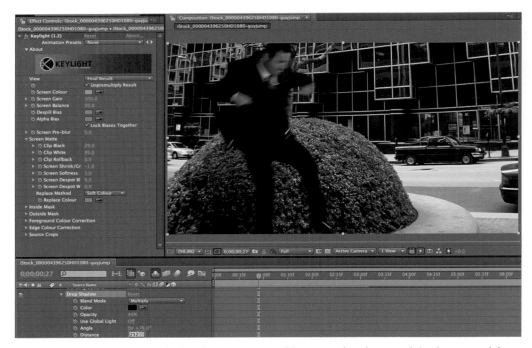

Figure 4.11 *Reflectivity on the briefcase creates problems in a few frames of the foreground footage*

To sell a composite, you need to create a sense of interaction with the foreground and background plates. This often requires shadows, reflections, light casting, and so on. One quick method is to add a drop shadow of your subject cast on the background.

In this case, I used a Drop Shadow Layer Style on the foreground plate (Layer ➤ Layer Styles ➤ Drop Shadow) and altered it to be faint and distant, giving it a subtle effect on the background plate (see Figure 4.12).

Figure 4.12 *A simple and subtle drop shadow helps to further combine the composite into a believable scene*

Overview of Layer Masks, Mattes and Roto-Masking Techniques

In addition to using a green screen foreground plate to create your composites, you can employ other effects and methods to create special effects, stylized video, or an enhancement to the compositing process. Using the green screen footage as a matte for other layers or video allows you to create interesting effects commonly used in commercials and music videos. In addition, using roto-spline masks lets you fix problematic green screen mattes or completely mask and isolate a moving subject in a piece of footage that wasn't shot against a green screen.

Creative Alpha Mattes

You've seen this type of effect used in opening titles for James Bond movies for decades, as well as music videos and even Apple iPod commercials. Using a green screen shot, the subject is extracted, and the alpha matte created by the green screen matte is used as a mask for other colored shapes, animation, or video to be revealed and composited together.

The example in Figure 4.13 has a green screen foreground plate that you can matte out with Keylight in After Effects, revealing just the black background behind the extracted subject.

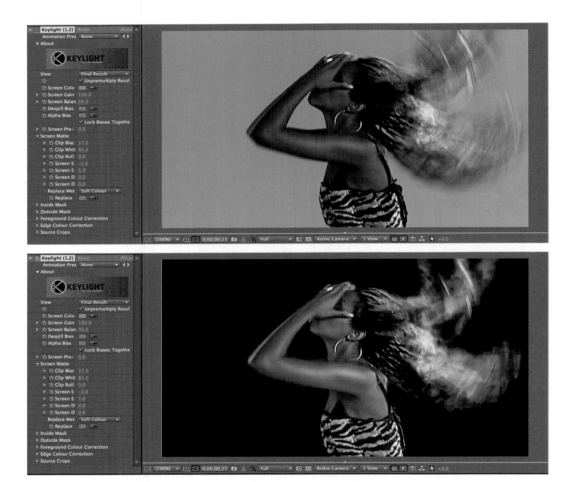

Figure 4.13 *A green screen subject is first extracted with Keylight in After Effects*

Then, import a background animation video on a layer beneath the foreground plate layer. Temporarily hide the foreground plate, and create a new solid white layer between the foreground and background layers (Layer ➢ New ➢ Solid). With the new white solid layer selected in the Timeline panel, apply an Alpha Track Matte (Layer ➢ Track Matte ➢ Alpha Matte), as in Figure 4.14.

This process creates a solid colored silhouette of the extracted foreground subject (see Figure 4.15). The effect can use several matted layers and elements to create an interesting effect with animated characters in a two-dimensional composite.

Another variation is to use the foreground subject layer as an alpha matte for the animation, revealed against a solid background or other video footage (see Figure 4.16). The process is the same: whatever layer you place beneath the matted subject layer can have an alpha matte applied to it.

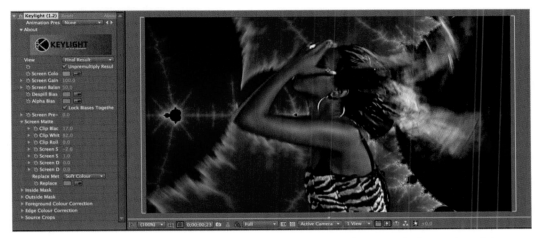

Figure 4.14 *Layering the background animation with the keyed foreground plate and applying an Alpha Track Matte to a new solid white layer*

Figure 4.15 *The matted character is silhouetted against the background animation*

Figure 4.16 *The matted subject layer provides the alpha matte for the animation layer against a plain black background*

Roto-Spline Masking

Roto-spline masking has many uses. For instance, you can use it to garbage-matte the green/blue screen, clean up holes in an extracted matte, or manually mask out a character or object in motion in a piece of footage that wasn't intentionally shot with extraction in mind. You can apply it to completely extract your subject or merely mask it from an applied effect to the rest of the image. You do this by creating a roto-bezier spline mask on a footage layer and tracking it over time.

In Figure 4.17, I wanted to extract the front fender and wheel from the car in the footage. The wheel turns and moves up and down as the car progresses down the road,

Figure 4.17 *Using the Pen tool in After Effects, the front fender and wheel of the car are masked out on the first frame*

and I had to track and adjust the roto-spline over time with keyframes in After Effects. I used the Pen tool to drag around the basic shape of the fender and edge of the tire, completing the mask loop by selecting the first point again at the end.

So that I could see the changes in the position of the tire/wheel more easily, I duplicated the original video footage layer, placed it underneath the masked footage layer, and reduced the opacity so I could see a difference between the foreground and background layers as I worked across time (see Figure 4.18).

Starting at Frame 0, I opened the Mask options on the Timeline in After Effects and selected the Stopwatch to set the first keyframe (see Figure 4.19). Doing so established

Figure 4.18 The original video layer is placed beneath the masked layer and adjusted so it's easier to see where the track points need to be moved over time

Figure 4.19 Clicking the stopwatch on the Mask properties in After Effects automatically generates keyframes to track the mask's point positions along the timeline

the base position of all the points on the mask and let me modify it over time to match the position of the tire/wheel in the video. Advancing down the timeline, I moved the Current Time Indicator to a position and started moving and adjusting the points on the mask edge to match the tire's edge. After Effects automatically tweened the positions of these points between keyframes.

In this example, I applied a zooming effect to the original video footage following the road as the car travels down the mountain. The masked layer is on top and remains sharp and in focus throughout the entire clip (see Figure 4.20). Note the various keyframes in the Timeline that were generated by tracking this process over the 10-second clip.

Figure 4.20 *An effect is applied to the bottom video footage layer, and the masked footage on top remains sharp and clear*

After Effects Roto Brush

One of the most useful compositing tools Adobe has added to After Effects in the past few years is the Roto Brush tool. This allows you to "paint" a selection of an object or character you want to mask out and it will attempt to look forward in the clip to see what pixel edges are moving based on the selection you make. Depending on the object or area you're trying to mask, the Roto Brush does a pretty amazing job that requires only little corrections over time— but it does indeed need these corrections as it's not entirely automated!

Starting with a layer that you want to mask out a character from your foreground plate, double-click it from the Timeline to open it in its own tabbed window and select the Roto Brush tool from the top menu bar. I like to reposition the Layer window so it's open beside my Comp window so I can see the immediate results of the roto process.

Then use the Roto Brush to paint a simple area inside the object you wish to mask with the green + brush as shown in Figure 4.21. You can adjust the brush size in the Brush palette on the side.

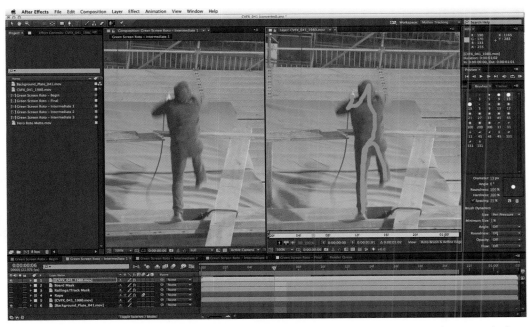

Figure 4.21 Using the Roto Brush to select an area you wish to mask out from your foreground plate

When the Roto Brush has made its first boundary selection, it will appear as a pink border so you can tell where the edges are. You can select more area with the green + brush as needed or use the Option/Alt key which will turn it to a red – brush and paint the area you wish to remove from the selection as shown in Figure 4.22.

Hit the Spacebar to let the playhead move forward to select a few frames, then go back and make more adjustments to the selection as needed, using the green + brush and the red – brush. It's important to note that the Roto Brush ONLY looks forward in the clip so if you go back to make changes, you will need to make sure that the edge data remains intact when you scrub forward again and it will have to re-render and re-calculate those frames (Figure 4.23).

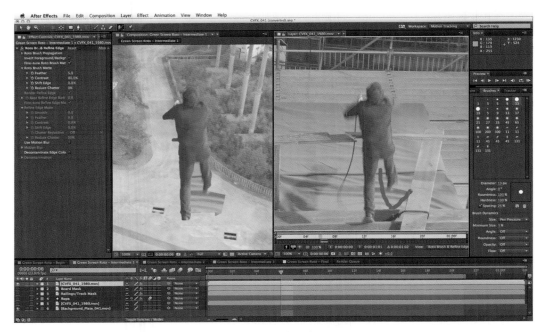

Figure 4.22 *Removing selected areas with the red – brush*

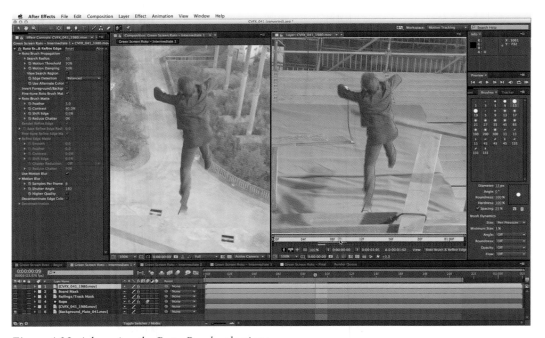

Figure 4.23 *Advancing the Roto Brush selections*

Once you have completed the entire clip and are satisfied with the Roto Brush selections, you can lock-in the selection data by clicking the Freeze button on the bottom-right of the Layer window (Figure 4.24). There are a lot more options and controls you can select to better refine your Roto Brush mask and other paint layer techniques for advanced compositing that you can learn about through some of my other training videos on my blog website (www.PixelPainter.com).

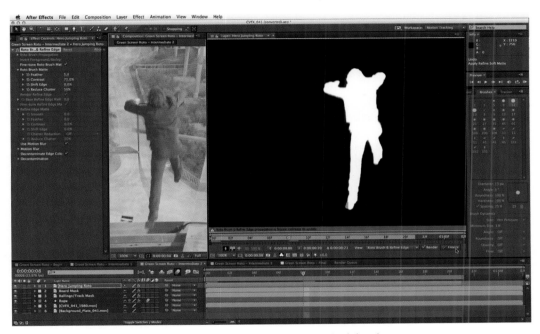

Figure 4.24 *Freezing the Roto Brush selection data at the end of the clip*

Where to Learn More?

Products mentioned in this chapter:

- **Apple Final Cut Pro X:** www.apple.com/final-cut-pro/
- **Adobe After Effects:** creative.adobe.com

Image and footage credits:

- **iStockphoto:** www.istockphoto.com
- **Ripple Training:** www.rippletraining.com
- **MacBreak Studio:** www.pixelcorps.tv/macbreak_studio
- **Jeff Foster's Blog:** www.PixelPainter.com

You can find a complete list of references and suggested continued reading/learning from this chapter in Appendix A.

Simple Setups on a Budget

Sure, you can get great *results when you have access to tens of thousands of dollars worth of gear, but what if you have limited gear and practically no budget? Can you get reasonable, usable results without expensive studio lighting, backdrops, or high-end video camcorders?*

Of course, it's always optimum to use the best setup you can get your hands on, but that's not always practical—and in some cases, not even necessary. If you're doing a quick green screen shot for a student project or a fun movie you're posting on YouTube, then you can get away with a lot, and nobody will be the wiser.

People have been coming up with creative solutions for working on tight budgets for years. Especially now, with digital photography and video cameras that allow you to adjust and set a custom white balance, you can use a less-expensive solution—shooting your scene outdoors, using hardware-store lighting, or even building your own portable lighting kit for less than $100.

In this chapter, I'll show you some techniques that follow the same principles you'd use in a professional studio environment but with low-cost (or free) lighting solutions.

Shooting Green Screen Outdoors to Save Money

The cheapest light source for any photo or video project is just outside your door. The sun offers many advantages for shooting but can also pose problems if you don't plan your shots right. Intensity and direction of the light source are seldom controllable, so you must position your setup accordingly. If you're working on a lengthy take, the angle of the sun (as well as the intensity and color values) may change within an hour or two. After several hours, you lose any chance for continuity between your first shots and your last.

The rules of proper shooting and lighting don't change just because you're limited to using sunlight. You must first determine what the final composited background scene will be and match the lighting of your subject. Even if you're in direct sunlight, you can control your lighting on the subject by allowing full sun to light the green screen and using reflectors and screens to shade and relight your subject to better match your scene. If you want your subject to remain in full sunlight, then you must plan the angle of the sun's direction in correlation to the scene you're compositing into. If it's 2 p.m. but your scene takes place at 10 a.m., then you need to position your subject to match the direction of the light source in your background footage.

For the scene in Figure 5.1, I positioned the portable Lastolite green screen at an angle to capture the full sunlight and used a piece of white foam core to act as a fill reflector to bounce sunlight onto the model's face and cut down on harsh shadows. I positioned the model at the angle I needed for my intended background footage and placed my video camcorder into position to match the correct angle and distance from the model.

The materials I used in this shot were the portable Lastolite green screen (you can get these online for $100 to $200, depending on the size), the light stands with some clamps I got at the hardware store, and the piece of white foam core. I matched the angle of the sun as closely as possible to the background footage and then added a lens blur to the background during compositing to create an illusion of a shorter depth of field. Total cost? A few hundred bucks. Beats the thousands I could have spent on a studio setup to get the same results. Also, for the price to rent the gear for this shoot for a weekend, I could have bought the setup I used here.

Normally, shooting on a cloudy day sounds like a great idea; but when you're using a green screen, it's much harder to get enough light on the screen to provide a decent key. This is one of the biggest issues that even seasoned motion-picture veterans encounter, and it ends up costing a lot more of their film budget to fix in postproduction. For this reason, many large outdoor productions are shot at night, when they can control the lighting to match whatever time of day or conditions they want to create.

If you want to simulate a cloudy day or diffused lighting on your model, but still want to use full sunlight to light your green screen and subject, you can still position the green screen in the sunlight while shading the model and using a bounce reflector as the main light source on the model's face. In Figure 5.2, I used the same setup as I did

for the full sunlight composition, but I used a reflector clamped to a stand as a shade from the direct sunlight. This not only created the shading I needed on my model but also provided a slight warm, ambient light back onto her face. The result was a much softer look.

Note that I only needed to shade the area of the model that was visible through the camcorder. I didn't need to shade her entirely or risk casting a shadow back onto my green screen, which had to remain brightly lit. Also, I was working by myself, so I had to use several light stands and clamps to do this shot. If you have a lot of hands around to help you hold reflectors or the background, you can also save money by not providing as many pieces of hardware (but you might consider springing for a pizza or two!).

Figure 5.1 *Positioning the green screen and model in the right direction in full sunlight*

Figure 5.2 *Using a reflector to shade the model and provide a soft reflective light source to light the shot—while maintaining full sunlight on the green screen*

Another reason to shoot outdoors is to create a realistic environment for either green or blue screen shots. This can be under the shade of a tree or around bushes or plants (see Figure 5.3). Be creative, and experiment with different locations that will allow you to put your subjects into scenes that would otherwise be difficult to replicate without spending a lot of time and money in the studio. You can read more about shooting blue screen outdoors in Chapter 9.

Figure 5.3 Placing the portable Lastolite blue screen under a tree with the subjects in shade to create a realistic effect

DIY Light Kits on the Cheap

I've seen dozens of strange lighting setups over the years, where people have had to cut corners and use what they had available (or what they could afford)—everything from clamp-on desk lamps to standing work lights and fluorescent light fixtures designed for a garage or workshop. Sure, you may be able to get away with some of these crude basics, especially with today's digital cameras and camcorders that let you set the white balance to adjust for off-color temperature lighting. But when it comes to shooting green screen, the fewer corners you cut, the better. That still doesn't mean that you have to buy or rent expensive lighting gear to get a good result.

I was inspired at a conference by colleague Victor Milt (www.victormilt.com), who showed how he makes homemade light kits from simple materials. He calls them the Milt NanoSoftLights (see Figure 5.4). He has included step-by-step instructions for building this light box in his video *Light It Right*, which is available from his website. You can easily build one of these soft-boxes for less than $100. The bulbs will cost you a bit more, depending on the quality you use, but this is by far the best alternative to professional studio lighting that I've seen to date. If you take your time and build it correctly, it will look as professional as well.

This professional-quality light can be made into your own configuration, size, and scale using simple tools. As you can see in Figure 5.4, the plug-in dimmer is an option I chose to control my lights, but it only works with the more expensive dimmable bulbs. You can't find these easily at the hardware store, so if you want optimum color temperatures that are closest to daylight (such as the 5100K dimmable bulbs I used here), you'll have to find a professional online lighting source. I got mine at www.buylighting.com and spent about $18 per bulb. At 75-watt light output per bulb, giving me a 450-watt output fixture, that's still a very reasonable price when you consider the alternative of having to buy expensive cool-lighting fixtures and tubes, or renting lights for a single day.

Figure 5.4 *DIY lights: the Milt NanoSoftLight with a plug-in dimmer and 5100K dimmable fluorescent bulbs*

Easily Folding a Portable Lastolite Green Screen

Most people have difficulty folding up a large Lastolite backdrop or large reflectors. If you don't do this properly, you can damage the screen. Or you may give up in frustration—I know I have!

I learned a really simple technique that's easy to remember and after some practice, you can master folding a large portable screen in no time. I call it the "Taco Fold". I've included a visual to show you the steps for taming this beast.

1 Pick up one corner of the Lastolite and lift it into the air. Use your foot to secure the opposite corner. (This may be difficult if you're too short to reach both corners—get some help if needed.)

2 Pull down on the top corner, and push the Lastolite to meet the opposing corner and then hold them together while lifting them both back up in the air – creating a large "Taco" shape.

3 With your left hand on the back rim, begin to twist and flex forward in a clockwise rotation and it will begin to collapse on itself. Don't fight it – just let it drop down. It creates two circular sections under your left hand and one extra circular section in your right hand.

4 Drop the section in your right hand on top of the other two collapsed sections, and even out the diameter of the sections as you pick up the Lastolite.

You can also use bulbs from the hardware store, but mind the color temperature of the bulb—most are very warm, because they try to simulate incandescent bulbs for use in the home. You can also unscrew a couple of bulbs to diminish the light output of your fixture as needed, if you choose not to use the more expensive dimmable bulbs.

Figure 5.5 *Using these simple materials, you can create a professional-looking, fully functional studio light kit that's portable and durable*

Any time you're working with electrical wiring and devices, it's important to take extra precautions for safety. Be sure your wiring is correct and all insulation is properly positioned, including tape joints, solder connections, and hot glue points. Also take care when handling light bulbs. It's a good idea to use gloves, not only to keep from burning your fingers but also to keep your bulbs clean and free from hand oils that may shorten the life of the bulbs. Even fluorescent bulbs that have been on for a period of time can be very hot to the touch.

I built one of these lights from Victor's instructions and added a few variations of my own as I went along. I used white duct tape on the inside surfaces to give the light a clean, professional look while maximizing the reflective white space. I also used more hot glue and Velcro than the original plan called for, because I wanted a sturdy and durable design (see Figure 5.6). I used more black duct tape over the heavily glued tabs shown here, to make the light look better and be more durable.

Figure 5.6 *Reinforced mounting and Velcro tabbed corners and flaps make this lightweight studio light more durable, for years of use*

You can also glue or Velcro a sheet of Mylar or frosted white film over the grid to get a softer, more even light. You could even drape a piece of white silk over the light box for a soft effect. The lights can be on for hours and still stay cool, which is a big advantage over the old-style hot lamps still used in many studios today.

The light can easily be collapsed for transport or storage. As shown in Figure 5.7, the screen comes out; then, you remove the bulbs and put them back in their original boxes for safekeeping. You remove the Velcro tabs, collapse the sides of the box, and fasten them together with Velcro tabs.

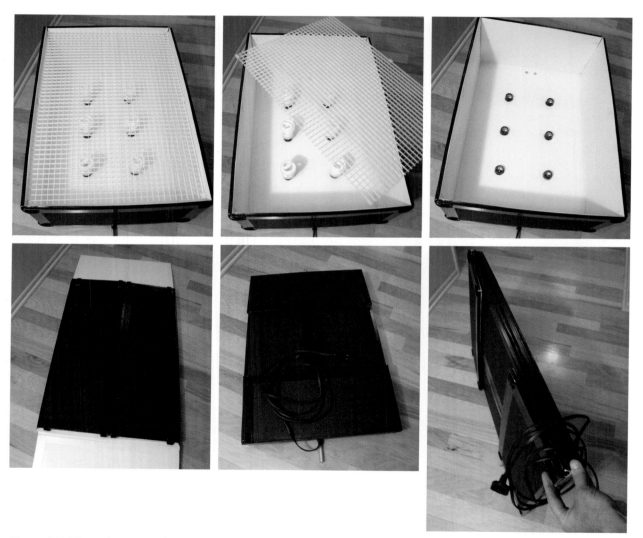

Figure 5.7 *The Milt NanoSoftLight design allows you to collapse the fixture for easy transport or storage*

I also used this simple concept to build some smaller, more compact fixtures for lighting my green screen backdrops. By using some simple components from the hardware store and some green fluorescent bulbs to enhance my green screen backdrop

(and use much less light to get the coverage I needed), I was able to put together light fixtures for less than $20 each. In Figure 5.8, you can see that I started with a couple of the green fluorescent bulbs screwed into a T and then attached to a socket plug. I put two of these into a power strip that I glued to the inside of the fixture. Because each of these bulbs draws only 24 watts (but has a 100-watt output), there is no danger of overloading the power strip: you're getting about 400 watts of light with less than a 100-watt draw. These lights burn cool for hours.

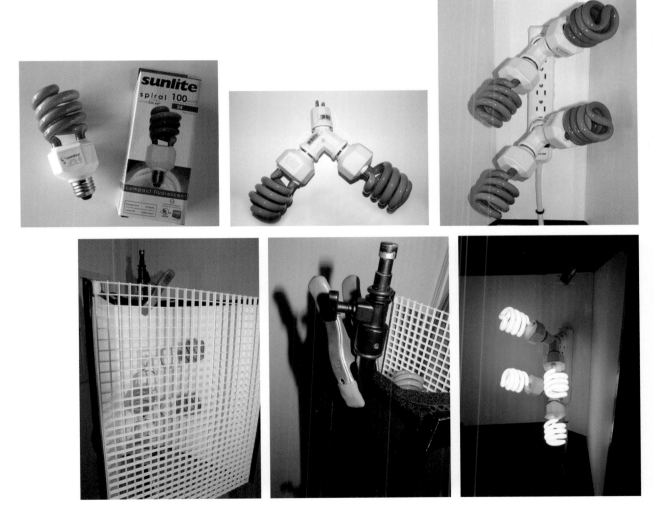

Figure 5.8 *This simple mini-fixture design is made up of simple components that you can pick up at the hardware store, along with a couple of foam-core flaps and a grid*

You can simply attach these mini-fixtures to any stand and move them around as needed (see Figure 5.9). You can also stack them vertically or attach them over each other on a stand to get a fuller light coverage.

Figure 5.9 *The mini-fixtures are small and light and can be clamped or stacked anywhere*

It's very important that you keep all the packaging materials for your bulbs to store them in after each use. These bulbs are expensive, and protecting them in storage and transportation ensures longer life for each bulb. You should also be sure to have a couple of spare bulbs on hand in case one gets damaged or stops working.

When you understand the concept of using fluorescent bulbs for quick and easy affordable lighting, you realize that you can put them up just about anywhere. You can use gaffer tape or duct tape to attach a power strip to a light stand, wall, or piece of furniture and pop in any number of bulbs to put light right where you need it (see Figure 5.10). These are great for filling soft spots on a wide screen; or, use a single bulb on a stand as a quick backlight to rim your subject's hair against a green screen.

Figure 5.10 *Tape a power strip to a stand to put a light anywhere you need it*

Shooting with Inexpensive Background Materials and the NanoSoftLights

People (including me) have used many materials over the years to save money—colored sheets, paper, plastic, and green paint from the hardware store. Yes, you can get by with these materials in a pinch, but your results will be far from perfect, and your shots will require a lot of postproduction work. In some areas, you can't scrimp and expect decent results.

For simplicity and portability, I've found the portable Lastolite green and blue screens the best for the money. They're durable and fairly accurate when lit properly. If I'm in a small confined space, I use green lighting to illuminate the background, because it requires less light output and produces less spill from the screen onto the subject I'm shooting.

In the example shown in Figure 5.11, I was shooting the model in my kitchen in an area approximately 10′ x 10′. This isn't much space to work in, but it's typical of what many people have available in their work environment or at home or school. I used the Lastolite green screen and two of my mini NanoLights to illuminate the background. Because I had low white ceilings, I had to block off some of the light spilling from the top of my fixtures with a couple pieces of cardboard (obviously a

design flaw on my part—something I need to fix for next time!). I also used a single bulb on a power strip attached to a stand for my back light, to rim the model's hair and give it a warm glow (the background footage also had a warm light). I lit the model with only the NanoSoftLight; a reflective card (a piece of white foam core clamped to a stand) bounced back the white light, filled the shadows in her face, and helped wash out any green spill.

Figure 5.11 *Using the NanoSoftLights with the Lastolite green screen background in a small space*

Another material I recommend for the budget conscious is a green screen paper background that you can get at your local photography supply store. This isn't just green paper on a roll, like that you might find at an art supply store; rather, it's a deep green impregnated paper that usually comes on a 9′ wide roll 12 yards long for about $60 (see Figure 5.12). You can hang the roll on a frame, roll it out to use it, and roll it back up when you're done; or you can cut off sections as you need them and tape them on any wall for an instant green screen.

Figure 5.12 *Green screen paper found at the photography supply store*

This paper works really well with the green NanoLights, and it doesn't create as much overspill as a more reflective screen material. Of course, optimally you want more distance between your subject and the green screen if at all possible; but when you're working in confined spaces, you need to minimize the spill as much as possible by manipulating the light sources and positioning (see Figure 5.13).

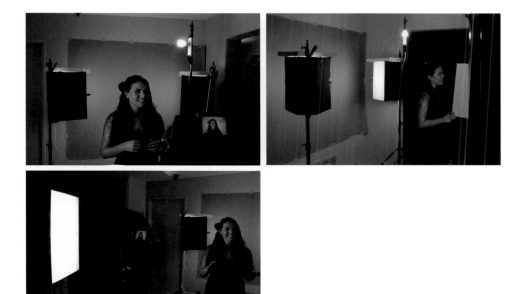

Figure 5.13 *Using the NanoLights with the green photo paper background in a small space*

The final result from the video footage captured on this shoot resulted in a decent composite in After Effects. I used Keylight to key out the green background (see Figure 5.14). Minimal color correction was needed on the foreground, because the Milt NanoSoftLight with the daylight bulbs did a great job of providing proper coverage.

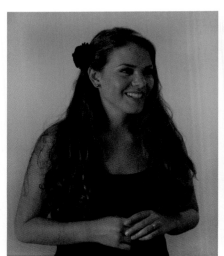 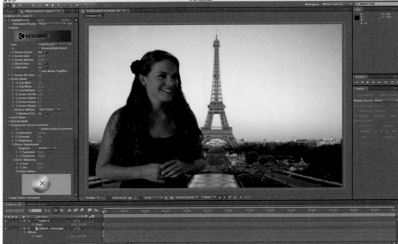

Figure 5.14 *Compositing the final shot in After Effects with Keylight*

Of course, you can't expect to get the exact same results with a setup like this and a mini-DV camcorder, but you'll get something that is acceptable. For more information about camera technology, see Chapter 11.

Where to Learn More

Products used or mentioned in this chapter:

- **Lastolite Portable Background:** www.lastolite.com/chromakey-backgrounds.php
- **BuyLighting.com:** www.buylighting.com
- **Adobe After Effects:** creative.adobe.com

Image and footage credits:

- **Stock Images, iStockphoto:** www.istockphoto.com
- **Victor Milt NanoSoftLight:** www.victormilt.com

You can find a complete list of references and suggested continued reading/learning from this chapter in Appendix A.

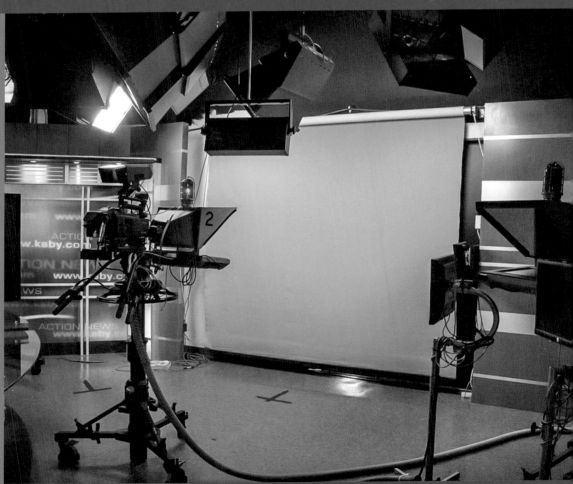

Green Screens in Live Broadcasts

We've all watched the TV *news and seen the large weather maps that the meteorologist stands in front of while delivering the evening's weather forecast. It's no mystery that they've been doing this in front of blue and green screens for decades. But you may still wonder, "How do they do that?" "What does the studio setup look like?", and "How does the hardware work?"*

I took a trip to a local TV station to find out how the process works—and has been working for more than 30 years. New technologies have surfaced in the past few years that allow even live broadcasts to utilize virtual studios that look real. That's what I share with you in this chapter.

Visiting a Typical Local TV Newsroom

I wanted to tour a typical local TV station to get a feel for how they use green screen for their on-air productions, and the management at KSBY Channel 6 in San Luis Obispo, California (www.ksby.com), stepped up to the plate (see Figure 6.1). This NBC affiliate for the central California coast isn't a fancy semiautomated HD station like you might see in a major metropolitan area but is more typical of the average station you'll find across the United States. That doesn't mean the studio doesn't remain competitive in their market with the existing hardware. They have managed to generate really good green screen with their setup for several years. I also chose this studio because of their use of the Ultimatte hardware system, and I wanted to see firsthand how well it worked.

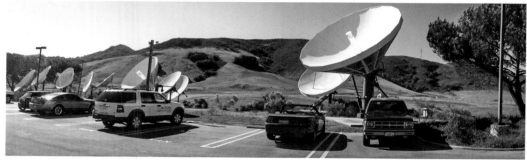

Figure 6.1 *My visit to the KSBY Channel 6 studios*

KSBY is perched on a hill with a fantastic array of satellite dishes lining the drive up to the studio building. I was greeted by chief engineer Bill Ingram, who showed me around the studio and shared with me how it all works. The newsroom studio is quite compact and very functional. All of the lighting and set structures are built in, so it's just a matter of turning on the lights and positioning the cameras at the appropriate talent. It

was great to see how efficient this team was as I observed them prepping for the evening's broadcast, with bumpers and teasers.

The Studio's Green Screen

Because the green screen at KSBY isn't required for all their broadcasts, it's rolled up above another section of the set (to protect it and keep it clean) and lowered as needed for the main evening weather broadcast. The material is a heavy canvas that has been painted with Roscoe Digital Green and rolled onto an automated roller that raises and lowers it. Even though it has a few wrinkles and imperfections from use, the Ultimatte system will still key out the background. The studio has built-in lighting in the ceiling that's permanently positioned and balanced for the broadcast. The cameras are rolled around into position for the shot (see Figure 6.2).

Figure 6.2 *The green screen in the newsroom studio is rolled down as needed*

The meteorologist stands in front of the green screen while watching monitors on both sides of the screen as well as a teleprompter that turns into another monitor; this shows the composite of both the meteorologist and the weather map and graphics in the background (see Figure 6.3). The meteorologist can use a remote to change the screen behind them to reflect a map, the five-day forecast, or whatever imagery they want to present during their segment.

Because the Ultimatte hardware is so sophisticated, the talent can be physically close to the green screen and cast a shadow. The spill will be suppressed while the shadow is retained in the final composite.

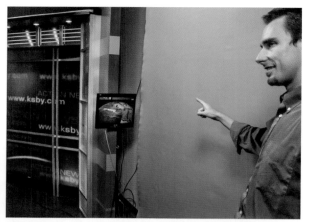

Figure 6.3 *The meteorologist stands in front of the green screen at close range*

The Ultimatte Hardware in Action

In a television studio where most of the hardware is installed and set in a fixed location, it's not necessary to have all your equipment in its own case or cabinet. Most of the hardware is installed in large racks in the equipment room and control rooms, where it can be cooled efficiently and not disturbed or accidentally bumped or unplugged. The controls are set and monitored; but because the lighting and conditions in the studio don't change, the controls don't need to be readjusted frequently.

At KSBY, the Ultimatte hardware compositor is merely a motherboard card slipped into one of the racks shown in Figure 6.4. After the adjustments on the Ultimatte are fine-tuned, it's set and locked in the cabinet in the rack so it can't be altered inadvertently.

Figure 6.4 *The Ultimatte hardware compositor is one of many items installed permanently in the studio's racks*

The signal from the camera positioned on the green screen is controlled by the switcher in the control room and runs through the Ultimatte hardware, which makes the live composite. The switcher controls the live camera feeds, on-air graphics like over-the-shoulder insets and lower thirds, motion graphics, and cuts to recorded video clips (see Figure 6.5).

Figure 6.5 *The Ultimatte is controlled by the switcher in the control room*

The end result coming from the Ultimatte hardware is a clean composite that retains shadows and eliminates color spill and screen background imperfections, as shown in Figure 6.6.

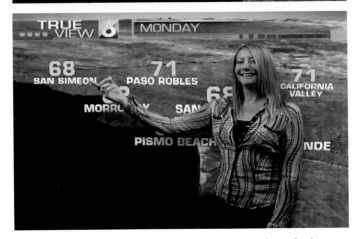

Figure 6.6 *Using the Ultimatte on the live broadcast feed to create a clean composite*

Many switchers used in live broadcasting will communicate with the Ultimatte or similar products, such as a complete switcher/keyer system from Grass Valley (www.grassvalley.com/products_broadcast/).

Live Broadcast with Virtual Sets

With new technology surfacing every day, this field will grow by leaps and bounds in the next few years. Currently, live virtual sets are somewhat easily detectable, but their quality and realism is increasing. Widely used in sports shows and entertainment news, the virtual set is becoming a cost-savings issue for studios and networks as well as providing a "wow" factor visually.

One such product that is nothing short of amazing is the TriCaster 8000 (www.newtek.com/products/tricaster-8000.html) This hardware and software combination makes it possible to take live green screen footage from a couple of camera angles and create multiple cameras that can be switched in a virtual set environment, complete with enhanced shadows, reflections, refraction, and transparency.

The TriCaster provides an interface to your equipment and cameras and is the powerhouse behind the system. The software-switcher interface controls the hardware's functions. The interface is quite intuitive to use and the results are remarkable (see Figure 6.7).

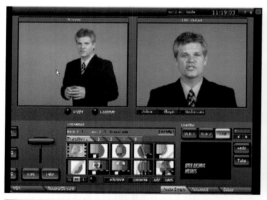
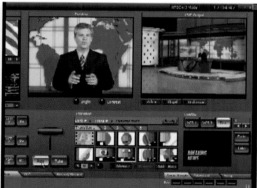
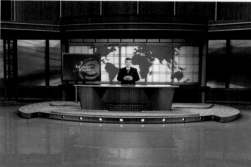

Figure 6.7 *The TriCaster 8000 with a virtual set*

For more information about the TriCaster 8000 and its capabilities, see Chapter 17.

Where to Learn More?

Products used or mentioned in this chapter:

- **VirtualSetWorks.com:** www.virtualsetworks.com
- **Ultimatte Corp.:** www.ultimatte.com
- **Grass Valley:** www.grassvalley.com/products_broadcast/
- **NewTek TriCaster 8000:** www.newtek.com/products/tricaster-8000.html

Image and footage credits:

- **KSBY TV:** www.ksby.com

You can find a complete list of references and suggested continued reading/learning from this chapter in Appendix A.

How the Pros Do It

How do the big visual effects (VFX)

studios manage huge productions? What is it like to work at a professional VFX studio? What if you want to produce an independent film that rivals a big studio production?

You may not be able to compete with the big studios when it comes to resources and capabilities, but maybe you can strive to create your own indie film or go to work for one of the VFX studios some day. The thrill of working on a major motion picture or commercial production can be a fulfilling and rewarding experience—and it may get you more work on other projects. Many big studios are always looking for talented artists, animators, and compositors—while a growing number of smaller studios and Indie filmmakers are looking for talent to work on productions remotely out of their home studios.

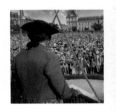

In this chapter, I'll give you an in-depth look at some award-winning indie filmmakers who currently have exciting new projects in production, so you can see if this is an avenue you want to explore.

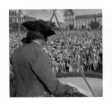

Traveling Back in Time with HBO's *John Adams*

In early 2010, I went to an effects production house in Santa Maria, CA called CafeFX to interview some of the people who worked in the film industry and talk about some of their productions. Unfortunately, the company closed its doors later that year due to the ever-changing economic climate in the film and television industries. This is after 17 years in business and working on many major award-winning motion pictures over the years. I'm truly grateful for the opportunity to meet with them and get to know some of the people who worked their magic on screens big and small.

HBO looked to CafeFX to provide much of the extensive VFX required for the seven-part miniseries *John Adams* (www.imdb.com/title/tt0472027/), including set extensions, matte paintings, 3D modeling, and set construction. With the bulk of the filming done with green screen elements on location, the CafeFX team was able to work their magic to bring this epic story to life under the direction of studio visual effects supervisor Erik Henry and visual effects designer Robert Stromberg who have collaborated with CafeFX on a number of projects.

When I sat down to interview CafeFX's visual effects supervisor, Jeff Goldman, he shared a bit about the process of shooting and creating the effects for this project (see Figure 7.1). As far as postproduction work, he said that *John Adams* went fairly smoothly. He pointed out that although quite a bit of footage was shot before CafeFX was brought on board to do the VFX, CafeFX did have an opportunity to get involved with the shooting later, which made some of the more difficult virtual production a lot easier.

Figure 7.1 *Visual effects supervisor Jeff Goldman talks about working on HBO's* John Adams

The bulk of the film series was shot in Richmond, Virginia, and Colonial Williamsburg for the United States scenes; for the European scenes, they went to Budapest, Hungary. Working from old maps and paintings for reference, and doing some extensive research, CafeFX created what Boston and the harbor may have looked like in 1776. Re-creating historic buildings, ships, and objects, the company created many set extensions and matte painting composites to replicate backdrops for the early American and European landscapes.

Many of the eighteenth-century building facades were constructed only to the top of the second story for shooting the live footage. Then, they were tracked and matchmoved to digitally produce the remainder of the buildings and surrounding sets, as shown in the canal scene in Figure 7.2. More than 300 effects shots were produced, with astounding attention to detail.

Figure 7.2 *Set extensions like this scene were typical of more than 300 VFX shots created by CafeFX*

Figure 7.2 (continued)

As epic as this production was, it went without big sweeping crane moves and locked-off shots and brought the first-person experience to the viewer through the use of handheld cameras. This would have posed a problem without the tracking and matchmoving technology available today.

A scene on board a ship at sea (see Figure 7.3) was set up in a field on a hill and shot against green screen panels around the front edges. The ship on set was dressed to simulate a cold winter, with ice on the deck. The crew had only one day to shoot everything needed for this scene, so proper setup with tracking markers wasn't possible.

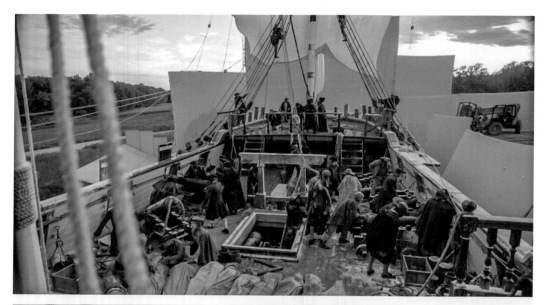

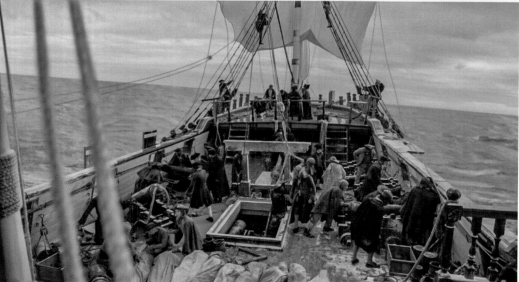

Figure 7.3 *The storm at sea sequence grew to be an epic scene completed with extensive postproduction work*

The ship wasn't even put on a gimbal, so all of its motion had to be completed in post. The ocean waves were originally used in another movie that CafeFX had worked on (*Master and Commander*), but they weren't the right scale; CafeFX used DigitalFusion to stitch together footage and create a wider background to pan across when simulating the motion of the ship and matching the camera's movements.

As described by compositor Michael Bozulich, many of the green screen shots supplied to CafeFX needed a lot of roto work (see Figure 7.4). Many of the scenes were too big to fully cover with green screen material, and with the lighting of the outdoor scenes there wasn't enough information available from the green screen they had in some shots to manage a clean matte extraction. For example, shots with ropes and netting against the background required roto work of each individual strand in many cases. This is a painstaking process that requires a lot of time and patience.

Figure 7.4 *Compositor Michael Bozulich talks about compositing techniques used on HBO's* John Adams

This was the case in the harbor scene shown in Figure 7.5: the foreground characters were shot against green screen, and an entire background matte painting was created from a composite of actual footage elements and CG water and ship models. The ropes and mesh in the foreground plate presented issues for compositing, and much of it needed to be rotoscoped (or roto-matted) to create matte outlines for the foreground plates.

Because the CafeFX team was involved in the green screen shooting in Hungary, proper previsualization was possible. They also had more control over the light on the green screen stages as opposed to using random panels for many of the previous exterior shots provided to them for compositing. With the shots in mind before heading to Hungary to re-create most of the European settings, the team generated prints of the

Figure 7.5 *Many detailed foreground plates required hand roto work for intricate details that didn't key out with the green screen alone*

proposed set backgrounds to give the set-design crew an accurate guideline for how to construct the green screen stages—and the DP a guide for how to shoot them. The finished product was amazingly realistic, as you can see in the shot of the king's throne in Figure 7.6.

Figure 7.6 *Having tight previsualization planning to build a set and shoot it provided CafeFX with great source footage from which to composite*

Many of the scenes were shot with an extremely wide-angle lens (14.5mm) and handheld cameras, which can be a real problem when you're trying to do 3D tracking and match the distortions in compositing. CafeFX used boujou (`www.2d3.com`) to extract the 3D tracking and matchmoving, which allowed the most flexibility in compositing. Although the example in Figure 7.7 shows the extremity of the distortion around the outer edges, careful planning with the green screen and tracking points helped make the composite a bit easier.

Figure 7.7 *Many of the scenes were shot with a wide-angle lens, which made compositing difficult*

An example of an extremely complex shot is the hot-air balloon in France (see Figure 7.8). In the film, you'd swear they employed thousands of extras and had an elaborate set—or even shot it at an historic location. But in reality, the scene was shot on a field with about 100 actors in costume. VFX Supervisor Jeff Goldman said they tried to replicate the same people in different positions and composite them all back in, but because it took time to re-costume and reposition them, the lighting changed dramatically. They tried to use some of the crowd that was shot on the one side, but that also didn't work well because of the wide lens distortions and the camera angles. CafeFX opted to utilize CG characters to fill in the bulk of the crowd and place real actors in the foreground positions. Many other matte painting elements were employed to create the entire scene.

Figure 7.8 *Several matte painting and compositing techniques were used to create this pivotal scene*

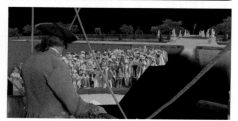

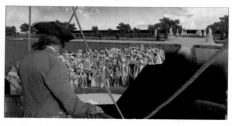

Figure 7.9 The sequence of how this balloon launch scene was matted and re-created by the compositor

Breakdown of a Composite

A shot like the hot-air balloon launch required more than a simple background replacement. In this case, the background was the real focal point, and the details had to be right—from the landmark buildings to the crowds of people to the smoke in the foreground. All of this had to be done with precision—while being tracked and matchmoved to the handheld camera.

First, the green screen matte was extracted and the rest of the foreground was roto matted to clear the way for background elements. Paying attention to detail that might not even end up in the shot, the team generated the midground elements, including a running fountain up the middle.

Next, they inserted the sky, and then the main buildings in the background. The CG crowds in motion were inserted from background to foreground in layers, matching the depth, scale, and perspective of the proposed grounds. This stage also included the shadow layers of the inserted character groups.

The remaining CG characters and the live action subjects were positioned with the smoke from the balloon, and an overall color correction was applied to the scene, as shown in the sequence in Figure 7.9.

Proof that compositing is more than merely stacking a few layers of elements in a scene and keying out the green, a studio production like the work CafeFX did with *John Adams* shows that quality movie magic is a very involved and painstaking process.

To see some of the before and after shots in this series, check out the video clips in the Chapter 7 folder from the media download website. Unfortunately, CafeFX no longer maintains their website archives or examples of their work.

Normally, big motion-picture productions utilize several VFX studios to do all the effects shots that today's highly visual films demand. Projects can be divided between VFX studios and can have several VFX supervisors managing the workflow. Rarely will you find that a single VFX studio has done all the effects work for a major motion picture. Even big studios like ILM and DreamWorks may farm out FX shots, models, or scenes to several other VFX studios. Just watch the end credits of a blockbuster movie and see all the studios listed for a single project. Many smaller boutique VFX studios produce shots, animations, and composition work uncredited (referred to as ghosting); the work is farmed out to keep the production on schedule. This isn't atypical for how the Hollywood VFX industry works.

Indie Filmmakers Tackle Big Effects

I've talked with several independent filmmakers during the course of researching materials for this book, and most have come to a simple conclusion: what separates the big VFX houses and the small independents is time and money. What may take a big VFX house a few months to create will take a small Indie artist years to complete. Often, a large VFX house has the latest software (including custom asset management and render farm coding), dozens of employees, and hundreds of computers rendering and working around the clock. This costs them big money from big studio production budgets. On the other hand, many indie filmmakers work with a handful of artists, a half-dozen computers, and off-the-shelf desktop software. They rely on ingenuity and craftsmanship to get their work done, and they aren't in a rush to complete it for a blockbuster release. Many take several years to complete their vision and rely on family and friends to pitch in at times. More often than not, you can sense a true love of the craft from a quality film short.

Hydralab's Marvel in Miniature: *Machine*

When I approached Hydralab's founder Sunit Parekh-Gaihede about his work-in-progress short film titled Machine, I wasn't sure what the project was about exactly—or how it was being done. There were a few pictures on the website (blog.machinefilm.com) and a slight back story, but it wasn't until I had a lengthy phone interview with Sunit from Denmark that I fully grasped the project and how they are producing it.

The project is being done by Sunit and his team of modelers and artists at the university where he works, and he gives a lot of credit to the model makers for their incredible attention to detail. They have built incredible miniature sets and are shooting them with a DSLR frame by frame on a motion-control track they've built using Lego components and some hardware (see Figure 7.10). This gives the depth of field they're looking for in the background plate. Then, the CG characters are created and animated in Maya and composited on the stop-motion background sequences, with computer-created pan and tilt simulation to give a handheld camera feel to the film.

Figure 7.10 DSLR camera mounted on a motion-control track to shoot the miniature sets for background footage

Figure 7.10 *(continued)*

The detail in the miniature sets is breathtakingly realistic—right down to the marks on the glass jars in the kitchen and the leaves on the streets. These sets would make great museum pieces after the filming is done. All the city streets have been created in 1:24 scale, and the interior rooms are 1:12 scale (see Figure 7.11). Many of the scenic props were made by hand; but with the help of a 3D imaging printer company, Moddler (www.moddler.com/), the team was able to take 3D computer models and create exact scale replicas of streetlights, benches, waste cans, hydrants, and more.

Figure 7.11 *Detailed 1:24 and 1:12 scale sets of exterior and interior shots*

Figure 7.11 (continued)

Figure 7.11 *(continued)*

The sets are shot against blue screen so a replacement sky or other exterior elements can be positioned in compositing (see Figure 7.12). Lighting effects, camera depth of field, and environment effects are added in post to increase the believability of the miniature sets.

Figure 7.12 *The sets are shot against blue screen for compositing in post*

Figure 7.12 *(continued)*

The film is still in ongoing-production but a lot of sneaks, tests and animations are viewable on the site (Figure 7.13). You can follow the progress of the production and the technology behind it by going to the team's blog: `blog.machinefilm.com`.

Figure 7.13 *A composited scene in* Machine *showing the miniature set with the 3D CG character*

Pendragon Pictures 1800s Version of H. G. Wells' *The War of the Worlds*

Just months prior to Steve Spielberg's epic summer blockbuster hitting the theaters in 2005, Timothy Hines released his version of H. G. Wells' *The War of the Worlds* on DVD. After originally pitching to a large studio and finding himself politically roadblocked, Hines started production on his version of the film as an indie project in 2000. He abandoned his original direction—a modern-day rendition of the story set in Seattle, Washington—after the attacks in New York on September 11, 2001. He then turned to the original Wells novel and decided to make it a period piece as Wells had written it in the late 1800s.

Controversy over the release erupted after Spielberg's announcement of his intended epic feature with Tom Cruise. The result was a lot of criticism for Hines—including negative reviews regarding the low-budget quality of the visual effects. Mindful that he had done this on a shoestring budget and skeleton crew, Hines focused more attention on the authenticity of the storytelling than on how much money could be spent on VFX.

Although the production was fast-paced and under-funded, Hines was determined to get out a production that told the story visually that H. G. Wells told in words. He kept

the dialogue and tone of the production in the period in which it was written. His VFX consisted of a lot of green screen elements that were composited on desktop computers with off-the-shelf software, some 3D modeling and animation, as well as a few miniature set pieces, props, and mechanical figures (see Figure 7.14).

Figure 7.14 *Live green screen actors, mechanized creatures, and 3D aliens made up the bulk of the VFX on a budget*

Figure 7.14 *(continued)*

The film was never a major theatrical release, and there are some obvious low-budget effects moments, but the overall impression is overwhelmingly about the story and how it was presented in its original time period. How very unique to imagine aliens and robots from another planet in a time before motion pictures were a reality! Hines has sold over a million copies of the DVD worldwide and distributed it to several countries.

Given the limited amount of time, money, and resources that Hines and company had available to produce such an undertaking, I applaud him for not letting that stop him from producing the film of his childhood dreams. In Figure 7.15, are a few composites from the finished film.

Figure 7.15 Some of the green screen shots and final composites from the film production

Figure 7.15 *(continued)*

Figure 7.15 *(continued)*

By the time Hines' version of *The War of the Worlds* hit the market, he was well underway on his new feature film called *Chrome*, which was proposed to be released in 2010, yet never completed to date. You can learn more about their various film productions on the Pendragon Pictures home page at `www.pendragonpictures.com`.

Note that since this release, Hines and Company has re-scripted, cut and edited in some updated scenes, enhanced effects and built the story around a "recovered interview film" from the early 60s of the last known survivor from the incident—a clever update I'd say.

Kanen Flowers/That Studio—*Hero Punk*

Kanen Flowers is the founder of *Scruffy.TV* and the host of *That Post Show* (the most popular postproduction podcast on iTunes). He has a history of web and Hollywood successes, including the original *That Media Show* (now *The Scruffy Show*) which helped launch Glee star Darren Criss and then starred Morgan Cullen and Austin Scott.

Still currently in production at time of this printing, *Hero Punk* (`www.heropunk.com`) is a 100% green screened live-action adventure against a complex 3D world in a dark-comic styling.

"We created *Hero Punk* because we believe there are not enough dark, hard science fiction films in the world." says Flowers. "We also wanted to do something with Superheroes in the future. *Hero Punk* is a dystopian, hard sci-fi superhero film that—we believe—the studios would never make. *Hero Punk* takes place in a dystopian, cyberpunk future. It is a combination of a style called "Steam Punk"—along with a present which has nano-bots, bio-enhancements and gene therapy." (Figure 7.16)

When finished, *Hero Punk* will be made available online for a small fee (around $10) and will also be distributed on Netflix, iTunes and/or Amazon as a full-length feature, available for rent and purchase though various retail and online media sources. You can see the production efforts and trailers at their website (`www.heropunk.com`).

Figure 7.16 *Some of the green screen shots and test composites from the film in production*

Figure 7.16 *(continued)*

Films In Motion Theatrical Release - *The Courier*

This "B-level" feature hit the box office briefly in 2012 then went promptly to video and Netflix. The director of *The Courier* (www.imdb.com/name/nm0001709) was relatively unknown (Hany Abu-Assad) and was fairly low-budget, save for the cast which includes Jeffrey Dean Morgan, Til Schweiger and Mickey Rourke.

I'm only mentioning this movie because I worked on it for Louisiana-based production company Films In Motion for 3 solid months compositing over 80 shots—all in one heroic action hostage scene, which I cover in more detail at the end of Chapter 19. At least my role as a compositor was a fun, challenging and rewarding one! Check out some of the before and after shots I had to composite, which was actually very little green screen and mostly roto and other tricks (Figure 7.17).

Figure 7.17 Some of the green screen shots and test composites from the film in production

Figure 7.17 (continued)

Figure 7.17 (continued)

I managed to acomplish this all with a 4K workflow using a DPX image sequence to ingest the raw foreground/background plates into Adobe After Effects, complete all the compositing and then render out composited DPX image sequence to upload to the Films In Motion server. The entire project was done remotely and my only connection with them was through emails and on the phone.

Where to Learn More?

Products and services mentioned in this chapter:

- **2d3 for boujou:** www.2d3.com
- **Moddler:** www.moddler.com

Image and footage credits:

- **CafeFX:** www.cafefx.com
- **HBO Films - John Adams:** www.imdb.com/title/tt0472027/
- **Hydralab's Machine:** blog.machinefilm.com
- **Pendragon Pictures for The War of the Worlds:** www.pendragonpictures.com
- **Hero Punk—That Studio:** www.heropunk.com
- **The Courier:** www.imdb.com/name/nm0001709
- **Jeff Foster's Blog:** www.pixelpainter.com
- **Kanen Flowers/That Studio:** www.thatstudio.com/team
- **Films In Motion:** www.filmsinmotion.com

You can find a complete list of references and suggested continued reading/learning from this chapter in Appendix A.

PART II

Setting the Scene

Welcome to the fun part—this is where it gets exciting! You now have choices to make regarding your production, and these chapters will help you decide how to approach the project with the proper tools and planning. What kind of screen will you use? How will you light it? What kind of background materials will you use? How will you convey your ideas to your talent? How will you be sure the shots you create will work with the backgrounds you're compositing into? So many questions still need to be addressed, and only proper planning and direction will ensure the results you're expecting.

Choosing the Right Matting Process for Your Project

I've developed this entire part *of the book (Chapters 8–13) to both integrate the information that directly relates to your specific project needs and help prepare you for shooting and compositing your shots. I highly advise you to read all the chapters in this part before settling on a workflow. You may be surprised that the best workflow for your project may not be the exact process you initially planned to implement.*

Using the key principles in these chapters to plan the set, lighting, cameras, compositing workflow, screen type, and screen color may save you thousands of dollars in both production and postproduction. Conversely, poor planning before production starts may result in a failed project, with improper footage capture, bad camera angles or lighting, or the wrong workflow if your project is live instead of recorded. You must consider all of these elements from the start, and this part of the book will help you do that.

Should I Choose Hardware or Software Matting/Compositing?

The first part of planning is choosing whether to use hardware or software matting/compositing. In most cases, the average compositor records green screen with an HD video camera and then composites the footage with a background plate that's a still

image, a graphic, a CG virtual set, or animation of video footage, in a software compositor such as Adobe After Effects CC or with plug-ins for Premiere ProCC, Final Cut Pro, Avid Media Composer, and others. This includes most everything from school projects with consumer-grade cameras to Indie films shot with DSLRs to high-end digital workflows used by the major motion picture studios.

First Things First: Planning Your Project

Nothing is as important to your compositing project as the initial planning. Everything needs to be considered from the very beginning. For example, will this be a live composite, such as a TV broadcast; a webcast; or a composite recorded direct to digital video? Do you need a soundstage, or are you doing talking-head shots for a commercial or corporate video? Are you shooting outdoors or on location? Do you need a live previsualization setup for your green screen shoot? All of these factors determine the path to the correct matting process for your project and the budget you require.

As the saying goes, you don't need a sledgehammer to kill a fly—and the same is true for the production of your shoot. If a portable pop-up screen will suffice for a talking-head shot, then you don't necessarily need to rent an entire green screen stage for the day. You may even consider a portable Reflecmedia system if a simple matted shot is all that is required and you don't need to pack a lot of lights. However, if you're shooting a commercial production with a model and flowing hair at 60fps, then you need to make sure all the conditions are perfect—and that may require a professionally set up studio.

This chapter is about understanding the tools and processes before you plan your budget. Knowing how you'll achieve the results the project calls for will dictate the path you take and what the workflow will entail.

Refer to Chapters 8–14 before committing yourself to any one workflow process.

If you're considering a live composited project, then you'll achieve the best results using a hardware compositor such as an Ultimatte system (www.ultimatte.com). Although you may be able to use software solutions for live preview compositing to test for alignment and lighting angles, exposures, and so on, a high-quality hardware compositor like the Ultimatte is the best solution for live compositing. For low-budget solutions, you may want to consider VeeScope LIVE or a Newtek Tricaster, as mentioned in Chapter 2. Grass Valley (www.grassvalley.com) makes another popular hardware compositor used by TV stations for news and weather; but the company licenses the technology from Ultimatte, so I focus primarily on Ultimatte hardware in this book.

On larger green screen sets, the director of photography (DP) may choose to use a hardware compositor to line up the background plate with the camera angles and lighting on set. This enables the DP to make adjustments on the spot instead of relying entirely on postproduction. The footage is captured with the green or blue screen data intact on the foreground plate, so the software compositors can work with garbage matting and

rotoscoping to aid in the masking and compositing of the foreground and background elements.

As shown in Figure 8.1, the Ultimatte hardware compositor makes an incredible matte. In this example, a live video feed of the blue screen stage is matched with the camera moves in a pre-rendered virtual set designed for a trade show booth at the NAB Show.

Figure 8.1 Ultimatte system used on a live staged set at the NAB Show in Las Vegas

You can see how it helps a director line up a shot during the shoot if you have the background footage to composite over ahead of time. Hardware compositors allow you to work in real time and align all the elements directly on-screen. This gives you greater flexibility in creating green screen set pieces such as chairs, tables, counters, walls, and so on that will match the correct height and scale of the set to which you're compositing.

Several virtual set manufacturers have products on the market today, such as ready-made sets from VirtualSet.com (www.virtualsetworks.com) and Full Mental Jacket (www.fullmentaljacket.com); see Figure 8.2. You can even have one built to your specifications by a 3D artist. More advanced virtual sets, such as the Vizrt Viz Virtual Studio (www.vizrt.com/products/viz_virtual_studio/), have camera and crane moves already animated in so you can set your motion-control camera rig to match their specifications or use an interactive system that works remotely with your camera control system. See Chapter 18 for more information about these techniques.

Figure 8.2 *Most virtual sets come as templates with layers and alpha channels that you can build around your live actors*

The Ultimatte systems are widely used on TV sets for sports and weather anchors, who often work in front of a large-scale map or graphic wall. For more information about working with Ultimatte and the various methods in which it's implemented, see Chapters 6, 17, and 18.

Software compositing includes any workflow that imports green screen or blue screen footage for compositing on the computer. With many plug-ins available for consumer products—from Windows MovieMaker and iMovie all the way up to higher-end professional applications like Adobe After Effects CC, Premiere Pro CC, Final Cut Pro X, and Avid Media Composer—the desktop computer user can find solutions to get great compositing results.

Many of the top postproduction studios, such as Digital Domain, ILM, and Weta Digital use proprietary software that's custom designed for their workflow (see Figure 8.3). Working at these studios, you must start from the ground up to learn their ever-evolving software systems.

Your project planning must begin by deciding on your intended end result. This will determine the next steps in your project workflow planning.

Figure 8.3 *Example of a professional studio's composited shot on a blue screen stage with a motion-control camera and model*

What Kind of Shots Do I Need?

The next part of planning your project is to determine the kinds of shots you need to capture for the composites. Do you need several different kinds of shots, or are they primarily one position or closed environment? Are you doing simple head interviews or head shots? Will you need to be in a studio, or are you shooting remotely on location?

A combination of types of required shots may be suitable for a portable system of lights, cloth background, and the like. This will help keep your production costs down as well.

You must consider many other things when you choose the matting process. In addition to the storyboard that will be created from the script or basic production layout for your shoot, you have to consider different aspects of the production, including cameras and camera rigging (tripods, dollies, cranes, cabling, media, and so on), lighting, and support hardware (stands, sandbags, cabling, power sources, scrims, silks, gels, reflectors, and so on). You must also plan for the props you'll use on set and which ones need to be colored to matte out later. If you're using virtual sets, and you have control over the angles and lighting of the CG modeling, then you'll have much more flexibility when the green screen shots are completed to make any last-minute changes or alterations. If you're using a premade virtual set or prerecorded video footage as your background, then you must take great care to align the camera angle of the foreground green screen to what you're compositing it onto.

Depending on your project, you may need to consider only a couple of these factors. A simple interview or straight-on talking-head shot may take only one camera and a couple of lights with your choice of backdrop material or green screen system. But more complex productions require more cameras and various camera angles, scene repositioning, and multiple setups to accommodate the direction from the storyboard. This is why proper planning, storyboarding, and previsualization is so important *before* you begin shooting.

I'll break down the various types of shots you may require for your project and cover the possibilities of workflows and materials for each shot. Chances are, one system will work for all your needs unless you're on a big-budget movie project that requires several large-scale scenarios.

Single Interviews and Talking-Head Shots

For the basic interview or talking-head shot, you can consider a few options. The Reflecmedia LED LiteRing system is portable and relatively inexpensive compared to using multiple lights to light a portable green screen (see Figure 8.4). The downside may be dealing with reflectivity on the subject (glasses, jewelry, and so on). Also, the LEDs are too bright to have the subject look directly into the lens for extended periods of time, and this system doesn't work well with a teleprompter.

An alternative is to use portable lights from Kino Flo with a portable green screen backdrop. This requires more room to accommodate the extra lights and further subject distance from the backdrop, but it may produce a higher quality result. The image of Colin Smith in Figure 8.5 (PhotoshopCAFE) was shot against a muslin backdrop with Kino Flo green tubes in a pair of Diva 400s to saturate the background. He was about 12 feet in front of the screen to avoid green spill from the intense lights.

Figure 8.4 *Composited head shot from Reflecmedia system*

Figure 8.5 *Composited image from a portable backdrop shot with Kino Flo lighting*

You can also do these kinds of shots in a smaller traditional green screen studio that may have fixed lights built in. These studios are usually available to rent for a nominal fee, and if your project is short term, this may be the way to go. Although most professional photo and video stores are quickly disappearing these days, you find ones that have a rental department that carries most of the items discussed here and charges daily rates. More available today, are the various online retailers and video production gear rental companies such as (www.borrowlenses.com) and (www.lensprotogo.com) you can get really good professional cameras, lenses, lighting gear and grip at reasonable rates. Plus it's easier getting your production costs worked into the budget by checking these rental houses ahead of time so you'll know what it's going to take to get the shots done.

Action and Full-Body Motion

These shots can vary from a casual walk-on from the side of a virtual set to a live-action fight scene for a movie. The green or blue screen must be large enough to incorporate walls and floors, because your subject is walking and you're capturing their feet. You must also deal with the lighting for the scene to work correctly. Reflecmedia has a system that includes a large backdrop cloth and reflective floor materials, but you have to use a slightly elevated camera angle to get the floor to reflect back into the lens correctly (see Figure 8.6). This workflow lends itself nicely to the Ultimatte hardware system for live broadcast as well.

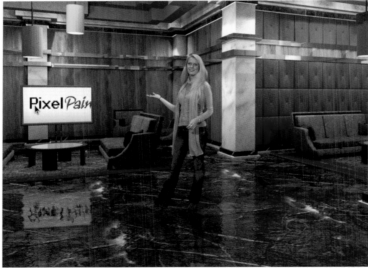

Figure 8.6 Composite shot from Reflecmedia full-scene reflective materials

You can also use green screen cloth to accomplish background-to-floor coverage, but often it's difficult to light correctly and to avoid wrinkles in the fabric. Wrinkle-resistant materials are available, such as foam-backed cloth and a special Lycra material available through Composite Components Company (www.digitalgreenscreen.com). Other materials may cause reflectivity issues or be challenging due to shadows deep in the wrinkles. You need to use a good frame system to hold the material taut on all edges and secure the floor material with gaffer tape (which is also available in green and foam-backed). The example in Figure 8.7 is a temporary installation on the testing sound stage at Panavision.

Figure 8.7 *Composite Components Digital Green fabric installed at Panavision*

For this type of shot, the preferred setting is a permanent green screen studio with built-in cyc walls and painted surfaces, including the floors. Such a studio generally has a fixed lighting setup as well. This is a costly and time-consuming venture to attempt to build yourself, so it's highly advisable that you rent a studio for this type of work (see Figure 8.8).

Figure 8.8 *Shot from a green screen studio set with the final composite*

Creative Shots and Lighting for Effect

Not all green screen shots require evenly lit talent with perfect conditions and a nice rim light. If you're shooting for a specific effect, such as light coming in through a window or a night scene, then you must light your subjects accordingly, keeping your green background plate evenly lit and consistently bright. Figure 8.9 shows several before and after shots from the web series *Dead End City* (http://youtu.be/O-yduSHg-ME). Creator/Director Jeff

Figure 8.9 *Before and after green screen and composited shots from the web series* Dead End City

Varga said that he wanted a comic book-style film noire look to his series. He creates all of his sets in DAZ Studio and composites everything in Adobe After Effects. You can learn more about his entire previsualization, production, and postproduction process and techniques in Chapter 12.

Where to Learn More?

Products mentioned in this chapter:

- **DAZ 3D Studio:** www.daz3d.com
- **Vizrt Viz Virtual Studio:** www.vizrt.com/products/viz_virtual_studio/
- **Ultimatte Corporation:** www.ultimatte.com
- **Grass Valley:** www.grassvalley.com
- **Composite Components Company:** www.digitalgreenscreen.com
- **Panavision:** www.panavision.com/
- **VirtualSetWorks.com:** www.virtualsetworks.com
- **Full Mental Jacket:** www.fullmentaljacket.com
- **BorrowLenses.com:** www.borrowlenses.com
- **LensProToGo:** www.lensprotogo.com

Image and footage credits:

- **Jeff Varga, Dead End City (Pilot):** http://youtu.be/O-yduSHg-ME
- **MRMC, Mark Roberts Motion Control:** www.mrmoco.com/
- **Colin Smith, PhotoshopCAFE:** www.photoshopcafe.com

You can find a complete list of references and suggested continued reading/learning from this chapter in Appendix A.

Proper Lighting Techniques

The *most* important aspect of shooting *any type of green or blue screen project is the appropriate lighting. If the subject isn't lit correctly or the green screen is too dark, too bright, or uneven, chances are you'll have problems pulling a good matte. As in the other chapters in this part of this book, this chapter focuses on specific situations to show proper lighting techniques for both the background screen and the foreground subject. If you take away only one major thing from this book, it should really be THIS chapter!*

In Chapter 8, I discussed the fact that you have to do a great deal of planning before shooting. Knowing what kind of matting you'll need to do determines how you should set up and light the shot. This chapter will show you several methods for proper lighting in various conditions—provided you've done your homework in determining how you need your subject to look in the final composite.

Lighting the Screen and Foreground Subjects

There are as many creative ways to light a green/blue screen background as there are camera angles and scenarios. But you must follow a few basic rules for favorable results, no matter how big or small your project is. You can also use several types of lighting systems, in different combinations, as well as shoot against a screen backdrop outdoors.

I'll cover some of the basics in this chapter, but you should also refer to the other chapters in this part of the book to get the specific details for your desired effect.

First Things First: Planning Your Project

Because I'll be covering various types of lighting situations in this chapter, it's important to understand what your options are before you head to the studio and set up the lights. Ask yourself what scenes will require what kind of lighting and atmosphere. Are you merely shooting an interview/talking head? How big is the required stage area for your scene? Will you be lighting the floor as well as the background? Will it be daytime or night? Will the scene be indoors or outdoors? Will your character be interacting with other characters or props/objects that aren't on the green screen stage?

Nothing wastes more time than shooting a great scene with the wrong lighting for the intended composition. Take the time to really study your storyboards and make sure your direction for postproduction compositing is as detailed as your on-set direction. You can eat up a lot of your postproduction budget trying to fix bad lighting on a scene. It's imperative that the production and postproduction directors and supervisors are in constant communication throughout a project to be sure they all have a clear vision of what the final scene should look like.

As I'll cover in Chapter 12 and several other chapters in this book, the importance of planning and "pre-viz" (or previsualization) in the form of storyboards, animatics, virtual set prints, and guides, will help you eliminate costly and time-consuming mistakes on the set.

Be sure to refer to Chapter 8 and Chapters 10–13 before committing yourself to any one particular type of lighting. And if you're on a tight budget, don't miss how to make your own fluorescent studio lights for under $100 in Chapter 5, "Simple Setups on a Budget."

Green Screen on the Go

Several different portable pop-up fabric green screens are available on the Internet and in photo/video stores, so you may decide to use portable lights and key out people in interviews or corporate-still headshots. I've used these portable green screens before and tried to shoot with available light but failed miserably. However, if I'm shooting stills with a flash (and a diffuser such as the Gary Fong Lightsphere), then portable green screens work quite well without shadows or hotspots. Note that if you'll be shooting video on location and plan to drag all the gear with you to light both the screen and the subject, you may need a small group of roadies and a truck to haul it all with you.

Instead, you can use several portable options to set up your green screen on the go. I'll cover the Reflecmedia LED front-projection green screen system, Kino Flos, and Litepanels in the following sections.

Reflecmedia LED System

One alternative to carrying around extra lights is the Reflecmedia LED front-projection green screen system. It uses a green LED LiteRing that mounts around the camera lens and projects a direct green light onto a reflective backdrop covered in millions of tiny glass beads; these beads reflect the light directionally back into the camera. The light isn't very visible unless you're directly behind the camera. Further, unless you're in a very

low-light environment, the LEDs aren't bright enough to cause much green light spill onto the subject you're shooting.

Figure 9.1 shows a Reflecmedia LED front-projection green screen system in action with a Panasonic AG-HPX300 camcorder.

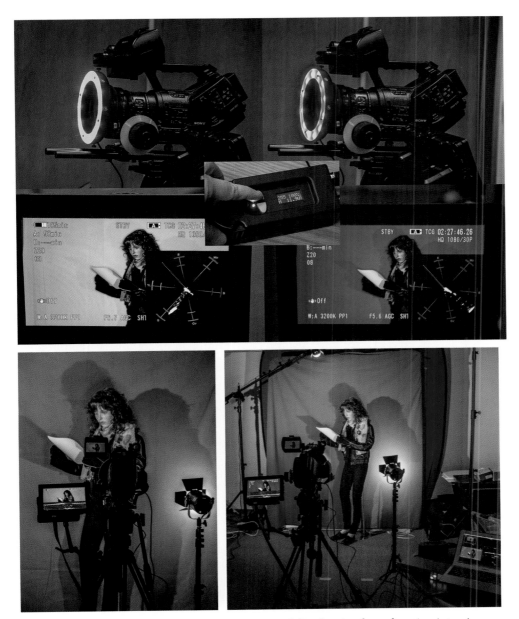

Figure 9.1 *The Reflecmedia system gives you portability for simple on-location interviews or close proximity shots*

The examples in Figure 9.1 show a slight shadow on the side of the subject being shot in the image; viewing the scene directly from the lens of the video camera, you can see in the LCD monitor inserts that a perfect green or blue background is achieved. A digital control is part of the system to allow you to dial in the appropriate amount of green or blue light for your shot. I discovered that it's imperative that you have not only a separate video monitor for your green screen shots but also a live scope, such as the built-in scopes on the smallHD DP7-PRO OLED field monitor (smallhd.com/products/dp7-pro/) I've been using, or at least using a software scope on a laptop that can measure the intensity of the green light. In this setting, which was in a controlled studio, I actually needed more light control than is typical in a casual interview session, so it was important to measure and control just the right amount of light.

I maintained the basic setup in this shot as outlined in Chapter 3, with a key light, a fill light, and a soft back light set high above the subject (see Figure 9.2). Using Fiilex Specular LED lights (www.fiilex.com) to light my subject, I was able to use only two P360s and one P180 to light my subject. The Reflecmedia system was scoped on the laptop using the ScopeBox software (which I'll cover in more detail later in this chapter). The live feedback of the scope makes setting up your shots a cinch with this lighting system. It's actually easier to match the Reflecmedia lighting to your desired model lighting.

In another on-location situation, such as in Figure 9.3, adding a couple of diffused Lowell lights was sufficient to even out the subject, along with the available ambient light from windows, skylights, and the like. This subject was talking directly into the camera, simulating being on a big stage talking to his audience, so the lighting needed to simulate that environment as well. The camera was zoomed in to crop only his upper torso, providing a "talking head" shot.

One of the issues I discovered with the LED LiteRing is that anything that is reflective—eyeglasses, jewelry, clothing, or objects that are held or stationary—can bounce back the green light into the camera. Therefore, you'll have "holes" in whatever you're shooting come compositing time. Obviously, you need to eliminate anything that can cause problems if you can and, as suggested by the engineers at Reflecmedia, have the subject look off-camera during interviews so glasses won't reflect the green LEDs.

Another issue is that when a subject looks directly into the camera for an extended period, the LEDs are so bright that they can cause temporary blindness. Although this only causes discomfort for a short time, most subjects would probably prefer not to be subjected to it for long. The same goes for using a teleprompter: the LEDs render the reflective glass useless, and they also reflect back into the camera lens off the teleprompter's glass. The only solutions I've seen are to mount a small prompter screen off to the side or directly above the lens or to use cue cards, but these options hardly replace a real, reflective over-the-lens teleprompter.

Overall, our testing showed that in many light-controlled settings, this system works well; but primarily you need good, even lighting to counteract the effects of the green LEDs. And although the system is adequate for quick interviews and low-budget productions, the very nature of front-projection reflective media green screen can't give you the same results as a well-lit green screen production studio, because there's no way to perfectly align the nodal point of the camera's lens with the light source.

Note that Reflecmedia now combined the green and blue LEDs into one LiteRing module for immediate switching between green/blue screen production, as seen in a full-length example shot in Chapter 8, "Choosing the Right Matting Process for Your Project." For more information, visit the website at `www.reflecmedia.com`

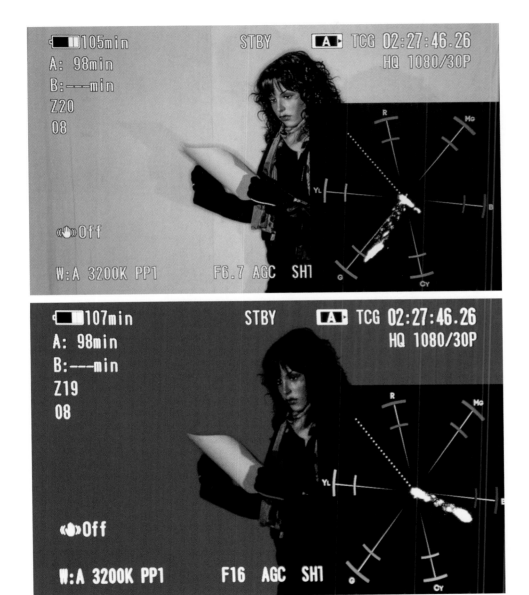

Figure 9.2 *Using the Reflecmedia system with portable LED lights in a small studio setting*

Figure 9.3 *The Reflecmedia system used on location for a talking head interview in a client's office*

Kino Flos

You can use many types of lights to illuminate your green screen and subjects, so this section covers only one particular type of lighting. I chose to use Kino Flos in these examples not only due to their popularity in the professional film industry but also because of their reliability and variety of options, which make them a truly flexible lighting option for any scale project.

On a small-scale project, such as a talking head or an interview, you can set up a couple of Diva 400s with standard 32K tubes at maximum power to illuminate the green or blue screen, or you can use colored True Match tubes from Kino Flo and reduce the amount of light needed to illuminate the backdrop.

I first learned about this method from Alex Lindsay of dvGarage and Pixel Corps fame, in an article he wrote for the ProVideo Coalition online (`www.provideocoalition.com`). I wondered why you would need green light on a green background. Then I saw his test shots, and they were nothing short of amazing. I asked him about the spill from the green lights, and he said it was even less than the higher intensity from brighter lights bouncing off the green wall. All of my tests produced the same results (see Figure 9.4).

Figure 9.4 *Alex Lindsay shares how he uses green True Color tubes from Kino Flo in his portable setups (shown here combined with Litepanels LED panel lights)*

I tested both the green and blue bulbs from Kino Flo and got excellent results. However, the blue bulbs put off a lot less light, and I had to use all four tubes at maximum power in each Diva 400 fixture on the blue fabric pop-up screen; but it was evenly lit with no hot spots or shadows. I chose to use blue in Figure 9.5 because I wanted to see what kind of separation I would get with green foliage in the foreground. Note how close the subject and plant were to the Diva 400 fixtures, and yet I got virtually no light spill on them.

Figure 9.5 *Using Kino Flo True Match blue tubes in Diva 400 fixtures to illuminate a blue pop-up screen with minimal spill and low-lighting conditions*

The beauty of using this system is that you can bring down the intensity of the lighting on set and have more control over how you want the subject to be shot. I kept the lighting in this test fairly bright because I wanted the green in the foliage to show up. I used Kino Flo BarFlys to light the subject and the tree in the foreground. You will

notice in Figure 9.6 that the test model's hair is pretty dark against the deep blue background, but it still mattes out well.

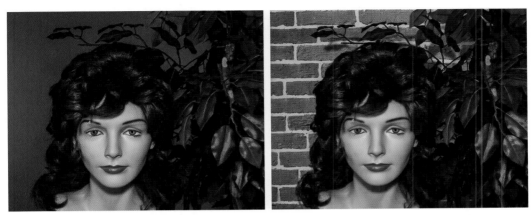

Figure 9.6 *The blue screen background is easily extracted in this scene, using only the Kino Flo blue tube with the smaller compact BarFlys*

Kino Flo makes many different models of lighting fixtures, from large-scale studio units to smaller portable lights such as the kits I worked with in these examples (see Figure 9.7). I must say that the BarFlys are heavier duty than the Diva 400s. The BarFlys have all-metal construction and easy-to-assemble fixtures, mounts, and cabling to the controllers. The Diva 400s are made to be very light for their size. Although the corrugated plastic construction may be a bit off-putting at first, that feeling goes away after you wrangle one of these by yourself onto a light stand at shoulder height. You can also switch the Diva 400s from four to two tubes, and they have an output controller/dimmer on the ballast base.

When illuminating the painted green screen wall behind my subject, the green tubes were so intense that the scope from the camera live feed was going off the chart. I had to turn off two bulbs on each fixture and decrease the intensity on the Diva 400 ballasts to approximately 80 percent so the green level read correctly in the scope.

A Closer Look at the Kino Flo Lights

What exactly are Kino Flo lights, and what makes them so special? It's in the ballasts. The electronics that control the lights have a high-quality design that can operate at full power without failure, and which delivers even, consistent lighting. These lights are designed to work flicker-free with any shutter speed. Be sure to check out their website listed at the end of the chapter to learn more about Kino Flo professional lighting products.

Figure 9.7 *Portable Kino Flo setup with green True Match tubes in the Diva 400 fixtures and BarFly 200s at 50 percent*

When I switched to 32K (standard) tubes to illuminate the painted green screen wall, in the same fixture location, I had to increase the controls to 100 percent and activate all four tubes in each fixture (see Figure 9.8). The scope readings were adequate but the intensity of the green was far less than that from the green tubes. The wall almost appears washed out.

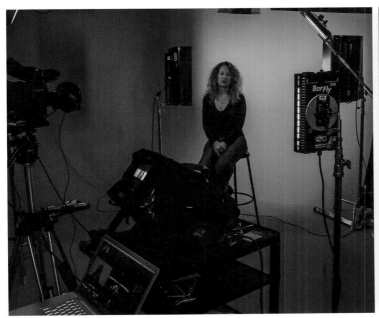

Figure 9.8 *Portable Kino Flo setup with 32K tubes in the Diva 400 fixtures and BarFly 200s at 50 percent*

Although this is still the traditional method of lighting a green or blue screen background, I've found that using the True Match colored tubes from Kino Flo have considerably changed the game for portable lighting situations. I've talked with a few larger green screen studios that want to try them on a larger-scale installation. Of course, they won't work in all situations, such as full-coverage floor-to-wall cycs where the subjects have to come in contact with the surface, because the green light would spill onto the actors. For more information about Kino Flo lighting, visit the website at www.kinoflo.com.

Sure, many other options are available on the market, including direct competitors to Kino Flo, but without the controllability or consistent output that Kino Flos deliver. Many permanent studios have hot lights installed that have an amazing output to cover larger areas—such as HMIs, 12K Par Cans, high-wattage tungsten, and halogen-based lighting systems, which are required on a huge location shoots—but when it comes to portability and close proximity, you'll want to use only cool lights such as fluorescents and LED panels.

LED Litepanels: Multi-LED Panels

Litepanels are another popular option for portable lighting. These compact LED lights not only are cool enough to place in very close proximity to your subject but also can run on battery power and are fully dimmable from 0 to 100 with minimal color shift. The company has models that allow you to change the color temperature on the fly to match the setting you're shooting for. You can see Litepanels in use in Alex Lindsay's

portable setup in Figure 9.4 earlier in this chapter. You can learn more about these lights at `www.litepanels.com`

Fiilex Specular LED Lighting: A New Concept in Portable Lighting

LED technology is advancing rapidly. While panel LED lighting has been the first approach in delivering variable temp/intensity cool portable lighting, they are often still bulky and have limited light shaping capabilities. This is where new emerging technology of Fiilex Specular LED Lights (`www.fiilex.com`) comes in. Their parent company, Di-Con has been producing fiber optics communication and lighting for decades and they develop all their own LED technology—not just shove off the shelf LEDs into a box and label it with their brand.

I've had the opportunity to work with these lights now for a few months now and have written a couple articles and reviews on them for the ProVideo Coalition (`providecoalition.com/jfoster/story/fiilex-p-series-led-lights`) and have since worked with them on portable green screen setups for this book, as well as live workshops. I find their flexibility and natural lighting feel a refreshing departure from both fluorescent and panel lighting—with the ability to quickly snap on diffusers or Fresnel lenses to give more control of the light shape and texture. They also have a broad range of measurable color temperature and intensity in a very portable light.

As shown in the examples in Figure 9.9, I've used a combination of these lights to light both the green screen backgrounds and the foreground subjects. Also featured here is the Q500 light which has a large diameter Fresnel and hue adjustments to refine skin color on your subjects.

Figure 9.9 *Fiilex Specular LED Lighting on portable green screen setups*

Studio Lighting

Most studios that have a permanent green screen with a cyc wall built in have fixed lighting for the walls. These are usually color-safe fluorescent tubes such as Kino Flos or

another product running 32K lights along the top of the cyc wall and shining down toward the floor.

Thanks to the Ventura Technology Development Center (VTDC) in California, I was able to use their green screen studio and shoot my lighting tests. The studio has a permanent cyc wall installation with a traditional flat studio lighting setup, shown in Figure 9.10. The cyc wall is illuminated by three 4-foot banks of four-tube fluorescents, with two diffused key/fill hot lights mounted to the ceiling and one backlight that's gelled with an amber gel. The cyc wall lights are adequate, although after seeing my green Kino Flos, Terry Wieser, who runs the department at VTDC, said he's going to be making some changes in his lighting. Specifically, the backlight isn't entirely necessary unless you want a golden rim light on your subjects. Originally, it was intended to help reduce the green spill from the back wall onto the subject, but with today's smarter compositing and keying software, spill suppression is virtually eliminated instantly. In this configuration, the key and fill lights were full and flattened out the subject.

In a larger studio environment, you may find only the lights for the green screen walls permanently installed; the remainder of the lights are positioned remotely to accommodate a variety of scenes on the sound stage.

Figure 9.10 *VTDC's small permanent green screen studio with fixed lighting attached to the ceiling*

For the web movie series *Dead End City* pilot (`http://youtu.be/O-yduSHg-ME`), producer/director Jeff Varga shoots full green screen shots at a large Burbank studio. The entire series is in full green screen; Jeff composites into virtual worlds with Adobe After Effects. The series is highly stylized and has the look of film noire meets Marvel Comics.

The studio is typical of most large production facilities and resembles a warehouse or airplane hangar more than what you may picture when you think of a high-tech studio. In this studio, the green cyc wall is made of hanging and stretched fabric, although the lighting is attached on the ceiling. As you can see in Figure 9.11, a lot of Kino Flos are used in this production.

The lighting for each scene is adjusted for the environment it will later be composited into. This is where portable lighting is important: you need to place it exactly where it's needed on the subject in each shot. The compositing afterward shows how the subjects are lit for the scenes they're in (see Figure 9.12).

For more information about matching the lighting and settings for the subjects to the environment they will be composited into, see Chapter 10.

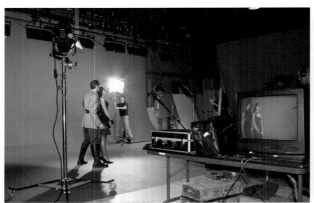

Figure 9.11 *Larger studios have fixed green screen and background lights, but the lights for each scene are portable*

Figure 9.12 *The lighting on the subjects in each scene is determined by the environment they will be composited into*

The Importance of Using a Scope

The most important aspect of shooting green screen is the proper luminance level of the green background. Having a bright, evenly lit chroma background will save you hours of frustration (and money) in postproduction. Alex Lindsay is quoted as stating, "With green screen, 80 percent of your post budget is lost on the set!" He's right. I've had to work on projects for days trying to revive poorly shot green screen footage, whereas I could have been doing more with the compositing, VFX, or animation instead. Several projects have had shots removed because the incorrectly shot footage was unusable. Many times, you'll have to hand-roto each frame to extrapolate the image data you're trying to matte.

Another thing I have learned from Alex is the importance of using a software scope to measure the green screen's luminance level (see Figure 9.13). To do this, you must have your camera tethered to your laptop or a nearby desktop computer and view the live feed through a hardware scope or field monitor/cameras with a built in vector scope and waveform.

You can also use the scope in dvGarage's Conduit, but another stand-alone application called ScopeBox (www.scopebox.com) works amazing well. I believe this software is a must for properly illuminating the Reflecmedia background, because trusting your visual acuity on the LCD screen or studio monitor isn't enough to capture the data correctly—or Blackmagic Design's UltraScope Software (www.blackmagicdesign.com) for use with their BMD Cinema Cameras.

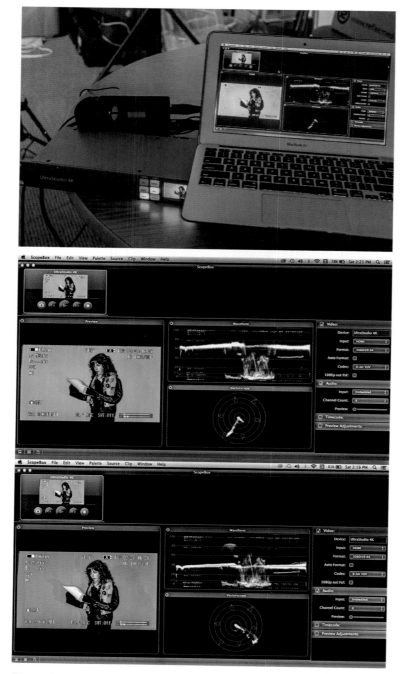

Figure 9.13 *Using ScopeBox on set to measure the amount of front-projection LED light to apply*

Figure 9.14 *Blackmagic Design's UltraScope connected to a BMD Cinema Cam*

ScopeBox is more than just a chroma/luminance meter. You can use it to capture live video feed from your camera source to a QuickTime or DV stream, among other features. You can overlay both chroma and luma zebras to help you identify hot spots. It also provides a software Focus Assist, which is a feature built in on the Panasonic camcorders, in addition to audio VU meters.

ScopeBox has several scope tools to give you just the information you need to measure your lighting data, including a Waveform monitor, Vectorscope, and RGB Parade. Using these tools in conjunction with each other, you can fine-tune your set with confidence that the images you capture will be correct. Note in Figure 9.13 that the LEDs are down in the first frame, maxed out in the second frame, and then normalized in the third frame with the green vector data peaked at just under 60 percent.

Looking at the Vectorscope, you want to see the green spike come as close as possible to the little box marked G and not go beyond it. On this scope, it's near the 80 percent point. However, looking at the waveform monitor, it's peaking at around 55 percent. The RGB Parade gives you the 0–255 RGB equivalent for each color. You want the peak line of the green to be around 200.

Even with fixed lighting in a permanent green screen studio, it's important to measure the output with a scope to be sure your levels are correct on both the foreground and background. You can't always trust your monitor and especially not the on-camera LCD viewfinder. In Figure 9.15, the first shot was taken before adjusting the lights and the iris on the camera to produce the best possible combination to light the scene.

Figure 9.15 Before and after shots in the same studio, utilizing the data through the scope to make appropriate adjustments to lights and camera

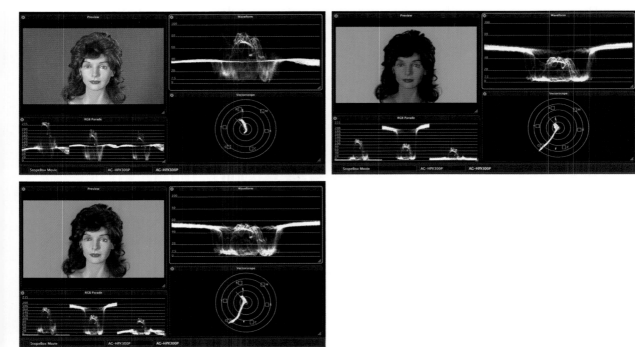

Figure 9.16 Using ScopeBox to provide the Vector scope data, the Waveform monitor and RGB Parade, with the Reflecmedia system turned down and up at normal

Note that regarding software scopes, there are limitations to what you can hope to achieve if you're shooting 2K HD professionally. Sure, a software scope can get you close in most cases, but nothing replaces a good hardware scope or at least a monitor with a built-in scope. The software scopes may give you a decent reading, but the bottleneck in the design is the I/O—the signal coming from the camera and into the computer (usually FireWire or USB). That signal may cause compression and communication issues that may affect the readable data.

For more information about using hardware scopes and working with cameras, see Chapter 11, "Digital Cameras and Camcorders."

Using Portable Devices to Measure Your Screens

With the advent of portable devices like the iPad and the iPhone, developers have been busy making useful tools to help you get a fantastic green screen lit, even before you set up your camera!

One of my favorites is the Green Screener App from Hollywood Camera Work (`www.hollywoodcamerawork.us/gs_index.html`) which uses your iPad's camera to show you a live preview metering of the evenness of your green screen lighting. It will automatically adjust exposure from your lighting and give you a good idea of how even the lighting is and show you hot spots/shadows. This doesn't replace a scope, however, but is a great tool I use in conjunction with a scope to dial in my shot.

Another great tool which is useful for precise measurements on your iPhone is the CineMeter App by Adam Wilt (`www.adamwilt.com/cinemeter/`). I love this app because I *always* have it with me! It will allow you to select your camera's ISO, Shutter Speed and Aperture to get the most accurate reading and will display both the preview and the Waveform in real time. This works even when your talent is in the shot as well.

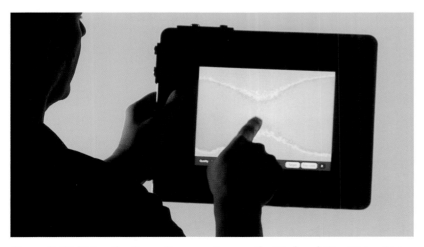

Figure 9.17 Using the Green Screener App on the iPad and CineMeter App on the iPhone to get instant metering of the green screen lighting

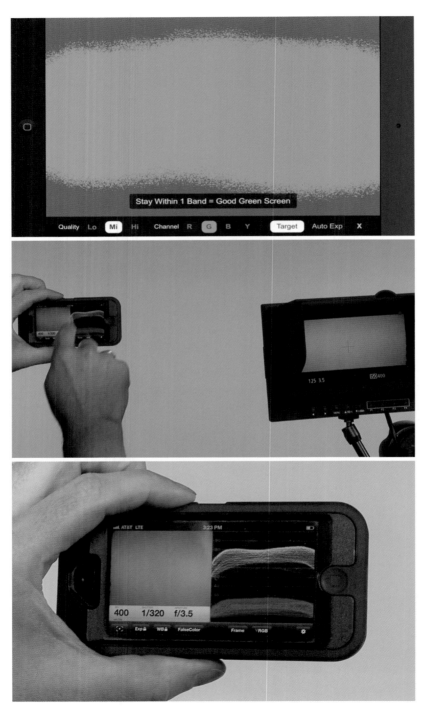

Figure 9.17 (continued)

Shooting Green and Blue Screen Outdoors

When you're using the sun to light your scene, you have a lot of factors to consider. What are you trying to match? Time of day? Light position? Shadows? Surrounding foliage?

Sometimes, chroma backgrounds are used outside to allow easier replacement of entire towns or sets behind a foreground scene, and the angle of the sun isn't as critical because the screens are so huge and far in the background. This is evident in many major movie productions, such as the *Terminator*, *Titanic*, and, most recently, HBO's *John Adams*.

Other times, a blue screen may be desirable if foliage is present in the foreground or the subjects are close enough to cast a shadow onto the screen and you want to retain those shadows in close proximity. The reflective blue spill light is complementary to the outdoor lighting and thus more acceptable in the composite.

For example, the model shown in Figure 9.18 could have been shot with a single bright light source in the studio for this scene. However, I knew the background was going to be outdoors, and it took only a few minutes to align the portable screen and position the subject in the direction of the sun, close enough to cast a shadow in the right place. It was a 10-minute production and served its purpose well.

Figure 9.18 *A quick setup with a portable screen outside positioned the subject for this composition*

In the example shown in Figure 9.19, the subjects are close to the screen in filtered sunlight under a tree. The shadows of both the subjects and the tree above them are cast onto the screen background. The shadows were retained from the keying software, and the composite was completed with a natural look that would have been much more difficult to reproduce in the studio or add back in post.

With myriad possibilities, you can have a lot of fun with both video and still photography using a simple portable screen, some reflectors, and the sun as your light source. Refer to Chapter 5 for more information on simple, cost-effective setups for shooting outdoors.

Figure 9.19 *Shooting this scene outdoors allowed the natural shadows and filtered sunlight through the tree branches to be retained for compositing in the final image*

Where to Learn More?

Products mentioned in this chapter:

- **Reflecmedia:** www.reflecmedia.com
- **Kino Flo:** www.kinoflo.com
- **Fiilex LED Lights:** www.fiilex.com
- **ScopeBox:** www.scopebox.com
- **Green Screener App:** www.hollywoodcamerawork.us/gs_index.html
- **CineMeter App:** www.adamwilt.com/cinemeter/
- **Litepanels:** www.litepanels.com
- **Conduit—dvGarage:** www.dvgarage.com

Image and footage credits:

- **Jeff Varga, Dead End City (Pilot):** http://youtu.be/O-yduSHg-ME
- **Alex Lindsay, ProVideo Coalition:** www.provideocoalition.com
- **Ventura Technology Development Center (VTDC):** www.tdctraining.com

You can find a complete list of references and suggested continued reading/learning from this chapter in Appendix A.

Nature's Spirits
Imagery of Natural and Supernatural Beauty

Matching Your Subjects to the Background

Are you planning your *green screen shoot* *with an intended background in mind? Do you have a virtual set that you must try to match your subjects to, or are you going to create your background to match the shots you get? Do you have green screen footage that was handed to you by a colleague or client, for which you must create a matching background? All of these are possible scenarios during almost every project.*

Both still photographers and videographers have dealt with each situation at one time or another and must know how to approach the project from every angle. This is about more than just compositing— it's about working with what you've got and still creating a great composite.

In this chapter, I'll show you some of the basic elements to look out for, including matching lighting angles, compositing tips, and motion tracking.

First Things First: Planning Your Project

Most of the time, you should have a clear vision of what kind of background your green screen subjects will be composited against. Sometimes it's as simple as stating that you want your actor on the beach or holding up a pair of sunglasses against a sunset. That can work well for still photography because you don't have to worry about motion in the background or camera movement, and usually you're not concerned with camera angles as much as you are with lighting. But when you're considering a video green screen production, you must take everything into consideration, including the lighting, positioning of the camera to the subject, location of set props and how they align with the intended background or virtual set, and motion tracking to match both the foreground and background plates.

In addition, you may not have a storyboard to work from—only green screen footage that you must composite onto "something." In this chapter, I'll show you some tips for making it work and pulling off a believable shot. Using Adobe After Effects, you can either motion-track your green screen foreground plate and match your background to the camera motion, or vice versa. Some filtering effects can add extra believability to the composite.

Refer to the rest of the chapters in this part (Chapters 9 and 11–14) for more information on integrating your talent with the background environment.

Creating Simple Composites

A simple composite uses flat studio lighting. You'll composite onto a background that doesn't require you to adjust scale, angles, or lighting or do any other further finessing to get a good result. This is primarily done in still photography when you have a "floating" product shot of some kind.

For example, the green screen image in Figure 10.1 could be used for an optical supply company or dispensary. Usually, a few art director's notes accompany such a project, and you have to key out the background, adjust for the spill, and make other corrections manually in Photoshop.

The image was first keyed in Photoshop using Digital Anarchy's Primatte keyer. Then, I removed the spill by painting the flesh color back over the green cast areas, taking care to mask the areas of the hand where it touches the glasses. It also helps to lock the transparency of a layer so the color you paint back in doesn't bleed outside the edges you just matted out.

I then chose the background image and applied a matched deep blue to the eyeglass frames with a paintbrush in Color mode. As you can see, in this kind of composite, you can use almost anything in the background, because it doesn't have to give scale, angle, or lighting cues to the foreground image to look believable.

Lighting and Camera Angles

Most basic green screen shots require a straight-on shot of your subject posed in whatever direction they need to face in order to interact with the intended scene. Your camera is directly opposite the green screen, and the subject is sandwiched somewhere in between. But having the right angle to the subject and correctly cropping the subject in frame are what will sell the final composition. If you have a detailed storyboard and your background clips or images or virtual set is already designed and available, then it's much easier to line up your green screen shot and position the camera and subjects in the correct location (see Figure 10.2).

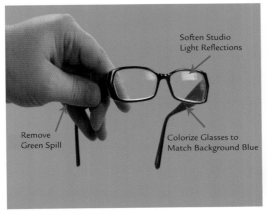

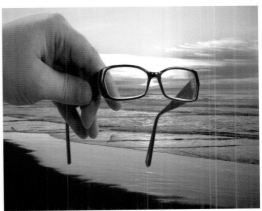

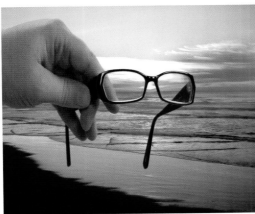

Figure 10.1 These images are typical examples of simple compositing with a green screen image

In this case, the background footage was shot on a location with the camera locked-off on a tripod. I simulated the low, soft lighting of the lounge in the green screen shot so the two videos would match correctly. Because this subject didn't need to interact with the bar surface—she was seated in front of it—a simple, straight-on angle was needed, although I had to lower the camera to match the height of the original shot.

It can be very helpful if you take some measurements while shooting both the location and the green screen shots, and note them for your shooting log. This way, regardless of whether you shoot the green screen footage or the background plate first, you can match the camera height, distance, and any other attributes of the shoot, including the aperture settings and focal length of your lens. This takes careful planning and shouldn't be overlooked if possible. I've worked on projects without this information and have had to guess by eyeballing my best shot, but taking the time to use a tape measure or even a piece of string and a protractor helps immensely.

You can learn more about setting up proper lighting and working with cameras and lenses in Chapters 9 and 11.

Figure 10.2 *The height and angle of the camera as well as the lighting of both the background location and the green screen shots were intended to match*

Integrating Props with Sets

Many times, the actor needs to come in contact with a piece of furniture on the set or knock on a door in a virtual world. You can either place the actual props and surfaces in the green screen set or create a colored surface the actor can interact with, which you'll either key or roto out in post.

Having an actual prop or surface on the set means less chance of ending up with a floating subject, or the actor missing the mark when they have to interact with an object's surface. The disadvantages are that they often absorb so much of the green from the green screen surface that you have to spend a great deal of time trying to get a good key or rotoscoping the colors and textures back in during postproduction.

For example, the shot shown in Figure 10.3 from *Dead End City* incorporates a door—an actress is standing in front of it and then knocks on it. Another actress opens the door, and we look "in." Notice in the figure that the door is open and both actors are standing there, but a C-stand is on the left side. This helped to hold the door in position when it was closed, and it's easily garbage-matted out in the final shot; we still see the door as it was.

Figure 10.3 The door is used in the green screen shot, so the end composite is much more believable

The next scene required a bit more effort to get the foreground and background to work together. The green screen footage was recorded before the background plate, so the cameraman had to do his best to line up the shot from a still image of the green screen actress's position. This included the angle of the afternoon sun, which needed to match the actress's lighting. The angle was a bit off, and the blue screen box the actress was leaning on didn't quite lend itself as a believable hard table surface.

You'll see in Figure 10.4 that the process included first masking and lining up the green screen plate with the background plate in position, scaling, and rotating, using After Effects. I applied Keylight to remove the green screen and then applied it a second time to remove the blue screen box the actress was leaning on. Finally, some filter effects that added a subtle lens blur and color correction completed the composite.

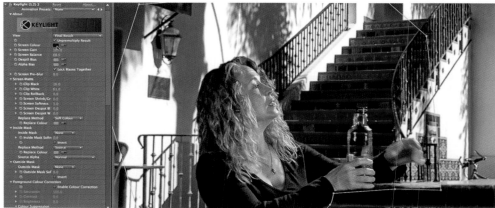

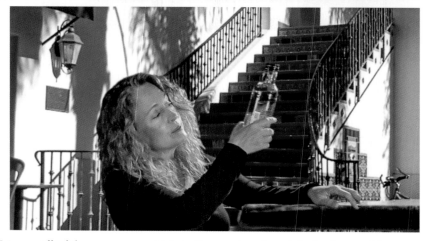

Figure 10.4 Using a still of the green screen plate to line up shooting of the background footage

This is why it's usually best to get your backgrounds first, line up the green screen characters, and do a quick overlay or test composite on site to ensure that the lighting and camera angles are correct. If I have green screen shots completed first and have to shoot my backgrounds later, I always print out several shots of the subject in action so I can align the proper angles visually. Of course, it's always best practice to shoot your backgrounds first and take good notes/measurements of the camera's position, lens focal length, exposures, and so on. But realistically, this isn't always feasible.

Another example I shot in front of a live audience during a workshop I conducted at NAB (National Association of Broadcasters) in Las Vegas to demonstrate various lighting techniques. In this case, I asked my assistant Ludita Varo-Curescu to pretend she was driving a car at night. Other than not having a prop steering wheel for her, we managed to pull off the lighting for the effect quite nicely!

Tracking and Matchmoving Green Screen Shots

If you're working with handheld, craned, dollied, pan, zoom, or tilt in any of your shots, then you need to track your footage to match the foreground and background plates. With some planning ahead of time, you can usually do this in the studio, where you can place markers on your green screen in order to track it in postproduction, or by using a software tracker to follow an object or point of interest in the footage.

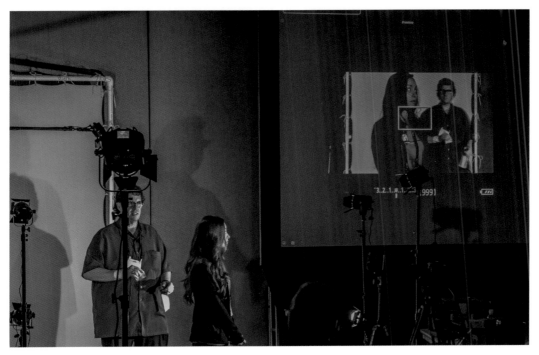

Figure 10.5 *Shooting a live green screen workshop at NAB in Las Vegas*

Figure 10.5 (continued)

Although trackers usually work pretty accurately, sometimes you have to manually fake it by nudging, rotating, scaling, and distorting a green screen plate or background to make it match. You can see an example in Chapter 19, where I had to match a camera dolly move. This is a time-consuming and painstaking process that can really test your patience.

The sequence of shots in Figure 10.6 was taken in a green screen studio by Per Holmes from www.hollywoodcamerawork.us These shots have a strange pattern on the

walls that makes it easier to track and place the actress into the composited scene. Per has determined that when moving the camera around and changing the angles, sometimes a typical grid marker distorts too much and becomes unrecognizable to the software trackers.

This technique requires a great deal of work in a 3D environment such as Maya or 3ds Max to create a matching virtual set. Per has a training DVD set that covers in-depth techniques for motion tracking and working with virtual 3D elements in Maya. You can download this footage clip and many others for free from his site at `www.hollywoodcamerawork.us/greenscreenplates.html`

Figure 10.6 This sequence has a camera dolly and zoom while shooting the actress walking and sitting on a prop

Tracking Handheld Background Footage

The project shown in Figure 10.7 started with the green screen shot. Next the background plate was captured, and then a third element was added to the scene. The subject was shot with the Reflecmedia LED LiteRing system, a low, directional light from a single light source, and little ambient lighting on her face. I then captured some cheesy handheld video with a small camcorder and created the scenario for her to be pointing and looking at the sky. As luck would have it, I also happened to get a shot of a C130 cargo airlifter zooming over the mountains with my still camera, and the lighting and angles were all right, so I had a little fun.

Using After Effects, I created a composition with the handheld background footage and brought in the green screen footage as a layer above it. I applied Keylight to extract the foreground plate and then motion-tracked the highlight on the taillight of the truck to match the two plates together. This requires some adjustments and tweaking to the motion track because the motion blur from the moving camera affected the size and shape of the highlights on the lens of the taillight.

I then created a subcomp from the still image of the aircraft. I used Keylight to knock out the sky, isolated the props on their own layer, applied a motion blur of about 10 pixels, and rotated the angle to simulate spinning props (see Figure 10.8). I brought it into the main composition as a subcomp, and animated it by hand to give it a natural handheld match-move as the camera panned up to the sky.

Figure 10.7 *The green screen footage is keyed out, and a motion track is created from a point on the background plate*

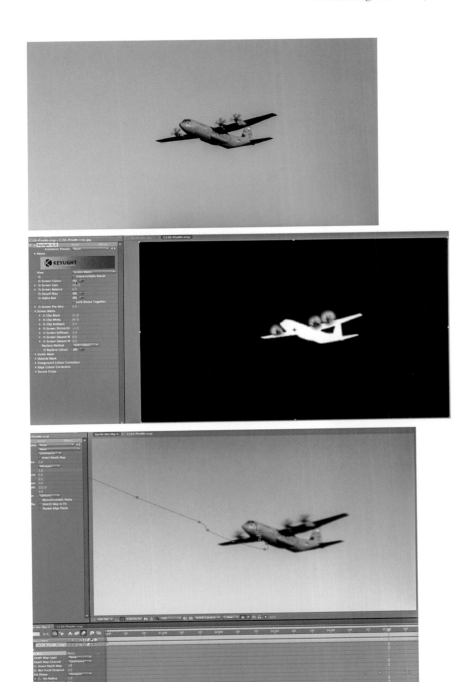

Figure 10.8 *A subcomp is created by extracting the plane from the sky and simulating rotating props; it's then brought back into the main comp to be animated into the background footage*

I also created a little simulated camera zoom and autofocus blurring for the plane, to create a more realistic effect. The sequence in Figure 10.9 shows the transition that starts to the right of the truck, pans around to view the subject pointing to the sky, and then finally moves up to the sky and zooms/focuses on the plane. It's very short and lasts only a few seconds, but the effect works pretty well.

You can view this project and the final rendered movie in the Chapter 10 folder in the media downloads.

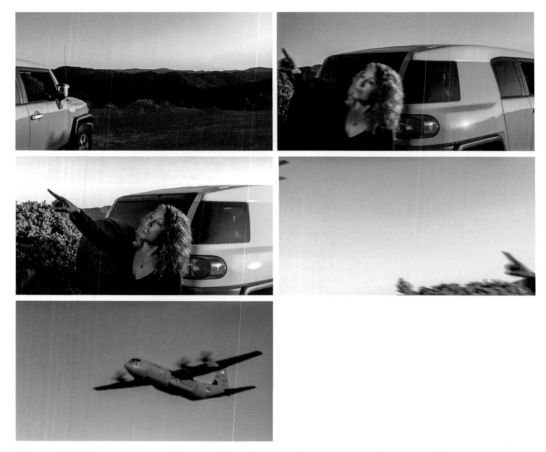

Figure 10.9 The green screen footage is keyed out, and a motion track is created from a point on the background plate

Tracking the Green Screen Insert

Sometimes you'll have a situation where the green screen isn't the main subject, but rather the foreground framing around the subject. Whether it's a picture that needs to be inserted into a frame on the wall as a camera goes by or a scene in which the windows

are green screened so you have to put a new external environment behind them, if the camera is moving, you need to be sure the background plate moves with it.

This first example uses a green canvas into which I inserted a painting. The camera was hand held and moved away from the woman blotting the surface of the painting. The trick was to track the corners of the painting but not her arm. This footage was provided by Per Holmes; he placed some blue tape squares around the upper portion of the canvas prior to shooting so there would be good detailed tracking points to use. As shown in Figure 10.10, the tracking was done with Mocha for After Effects, a planar tracker that ships with the After Effects CS4 Production Premium suite. A tracking spline was set up around all the blue markers, and the corner pin surface was set to that.

Figure 10.10 *Using Mocha for After Effects to track the motion of the green canvas in the video*

I then exported the tracking and corner pin data to the clipboard and pasted them onto the image layer in After Effects that served as the inserted painting. Doing this applies position and corner pin information to the layer but doesn't affect the anchor point; if you need to adjust the image layer's position to better match the positioning on the video layer, you can move the anchor point position until it matches. You can see in Figure 10.11 that the painting layer is still on top of the original video layer at this point.

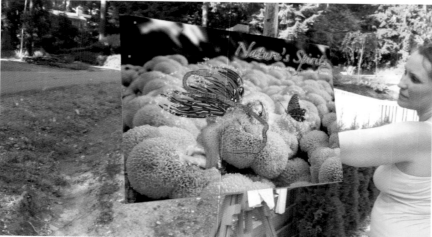

Figure 10.11 *Applying the motion-tracking corner pin and position data to the still image painting layer in After Effects*

You can take a couple of approaches to this kind of shot. One is straightforward but requires a bit of mask manipulation over time to clear an area around the woman's arm and the cloth, followed by keying out the green screen around that region only. This is much more time-consuming but yields a better effect. However, if the canvas was a reflective surface and you wanted to retain those reflections and light, you would need to key that particular area.

The other method is to try to apply two keys to the video layer and let the painting layer show through. This is what I did in Figure 10.12 as an example. I first applied Keylight to the green surface, but I had to force the key through the entire length of the clips because the bright white from the building in the background caused a glare on the surface that washed it out and created a green glow. I then applied a second Keylight to the blue squares on the canvas to eliminate them and allow the painting to show through. The problem with this clip is that it contains so much natural green foliage throughout the scene; the blue in the woman's shirt also gets washed out after keying.

To do a quick fix on this, I duplicated the original footage layer and placed it directly beneath the one to which I applied Keylight (see Figure 10.13). With no filtering applied to this second, lower copy, I selected Layer ➤ Track Matte ➤ Alpha Matte. It revealed the full-color version of the video while retaining the punched-out hole on the canvas where the inserted painting shows through.

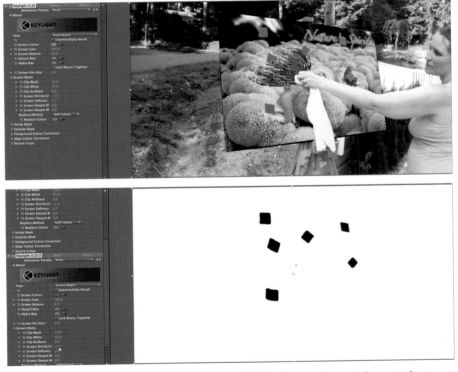

Figure 10.12 *Keylight is applied to the original video footage layer to key out the green canvas and blue marks*

Figure 10.12 (continued)

Figure 10.13 *Using an Alpha track matte on the original video footage layer to retain its full vibrant color, and keeping the keyed regions intact*

Figure 10.14 *The choice of backgrounds can greatly alter the intended mood of the scene*

Using Multiple Backgrounds to Alter the Mood of a Scene

In the project shown in Figure 10.14, I tried two different approaches to creating an exterior background for a scene that had green screen paper applied to the outside windows. The camera dollies in on the window and focuses on the candelabra next to the tree. To create a contrasting ambiance, I selected a cooler-colored winter city and added a layer of heavy snow particles between the two plates. The color palette of the entire scene contrasted greatly with the warm and homey atmosphere of the second approach; in that case, the background was closer to the window, and I had to make several adjustments over time to compensate.

You can learn more about how I created this project in Chapter 19.

Where to Learn More?

Products used or mentioned in this chapter:

- **Adobe After Effects CC and Photoshop CC:** creative.adobe.com
- **Primatte for Photoshop:** www.digitalanarchy.com
- **Visual Effects for Directors:** www.hollywoodcamerawork.us

Image and footage credits:

- **Clips from Dead End City (Pilot):** http://youtu.be/O-yduSHg-ME
- **Free Green Screen Plates from Hollywood Camera Work:** www.hollywoodcamerawork.us/greenscreenplates.html
- **Still images from iStockphoto.com:** www.istockphoto.com

You can find a complete list of references and suggested continued reading/learning from this chapter in Appendix A.

Digital Cameras
and Camcorders

No matter how well you've *set up your green screen studio with the proper background materials and lighting, if you shoot with inferior gear, then it's all for naught. For truly clean green or blue screen footage, you need a minimum of a low-end pro high-definition (HD) camera to avoid edge artifacts and interlacing issues commonly found in standard definition (SD) and consumer HD cameras. This is not to say that it can't be done on older or cheaper camera gear, but you're going to make the compositing in post much more difficult.*

In addition to selecting the camera, you must take care in choosing the right lens—or at least the best "sweet spot" in a built-in zoom on your camcorder. If you use too wide of an angle and get distortion around the edges in either your foreground green screen footage or your background footage, it will be much more difficult to precisely match up the final composite. Don't buy into the myth that you can shoot sloppy footage and "fix it in post!" As the old saying goes, "garbage in, garbage out"; and if you don't have everything figured out before you shoot, you won't be able to make miracles happen in post.

In this chapter, I'll cover some of the basics of how digital cameras and camcorders work and what to watch out for when you're selecting a camera to use for your green screen work.

First Things First: Planning Your Project

You can often get away with using a lower-resolution camera or even a cheaper HD camcorder when filming live shots and background footage if you're working on a small, low-budget video. But beware of attempting to shoot your green screen footage with a low-quality DV cam, because the results may be totally unusable. Learning the principles of videography—the cameras, lenses, lighting, formats, aspect ratios, frame rates, and compression codecs—will help you make better decisions when you plan the different shoots in your project.

Your best bet is to start with a low-end pro HD camera that has a good lens and good electronics. Using a consumer camera or camcorder that claims to be HD may not give you the results you're hoping for. Most small handheld camcorders won't produce a good green screen shot.

Take the time to properly scope your green screen shots, to ensure that you have the best lighting and camera settings; and log and track this information for later incorporation into your background footage, whether you're shooting it afterward or adjusting it in post. These steps will garner the best results most consistently and help you develop good production habits. At minimum, whether you're shooting background footage or green screen shots, you need to keep track of the camera's settings, lens focal length, tripod height, angles, and subject/object distances. It's also helpful to note the recording frame rate and lighting positions when recording your data. Your best tools may be a notebook, pencil, tape measure, and protractor. It doesn't hurt to take some still camera shots of your entire setup for reference, either.

Digital Camcorder Basics

Understanding the difference between types of cameras will help you make the right decision about which to use for what kind of shooting situation. The marketing hype of camera manufacturers doesn't make the job easy, so do some research before spending your hard-earned money. This goes for renting gear for a production, as well. The more informed you are, and the more familiar you are with different camcorders, the easier it will be to know what type of gear you need for various situations. This knowledge comes from researching the cameras you're interested in using on the Web, reading reviews, and asking other working pros.

With today's demand for HD media delivery in broadcast, recorded media, and online, the use of SD and DV has diminished drastically in favor of HD. This means there is a flood of used cameras on the market, so you may be tempted to buy what was considered state-of-the-art gear a few years ago only to find that is now mostly obsolete. Don't do it if you're considering any kind of quality production. As far as the issues with 2K vs. 4K and beyond, technology is ever-evolving at the time of this edition and 4K workflows are just starting to emerge in the mainstream, but only at the high-end. We also currently have cameras like the RED line that are capable of 5K and 6K resolution. But at the heart of it all, resolution is just a number; how the sensors are created and the information is divided into photosites is what we'll be focusing on in this chapter.

Familiarizing yourself with the various video formats is the best start to understanding what you need for your production. A wealth of information about emerging technologies

and reviews of current camera models is available all over the Internet. One source for this information is the Pro Video Coalition (www.provideocoalition.com).

Interlaced vs. Progressive Scan Formats

Interlaced scan video was developed for cathode-ray tube (CRT) television displays and is made up of 576 horizontal scan lines across the screen. The interlacing divides these into even/odd lines and refreshes them alternately at a rate of 30 frames per second (fps). This introduces potential flicker and "jaggies" when you view single frames that appear between the scan frames, but when the images are refreshed rapidly in motion, as on television, such imperfections aren't readily visible. Interlaced scanning has been a standard for broadcast television and video tape (VHS/BETA) for decades.

The two global industry standards are NTSC and PAL:

NTSC is based on a 525-line, 60-field/30fps at 60Hz system for transmission and display of video images. This is an interlaced system in which each frame is scanned in two fields of 262 lines, which is then combined to display a frame of video with 525 scan lines. NTSC is the official analog video standard in the United States, Canada, Mexico, some parts of Central and South America, Japan, Taiwan, and Korea.

PAL is the dominant format in the world for analog television broadcasting and video display and is based on a 625-line, 50-field/25fps, 50Hz system. The signal is interlaced, like NTSC, into two fields, composed of 312 lines each. PAL has a better overall picture than NTSC because of the greater number of scan lines. Also, because color was part of the standard from the beginning, color consistency between stations and TVs is much better. In addition, PAL's frame rate (25fps) is closer to that of film (24fps). Countries on the PAL system include the United Kingdom, Germany, Spain, Portugal, Italy, China, India, most of Africa, and the Middle East.

Note that before the advent of 24p cameras, many indie filmmakers used PAL cameras and created film prints from the video. Because the frame rates are so close, this worked well in avoiding reverse 3:2 pull-down issues inherent in going with NTSC video out to film.

Today's technology has surpassed that of the CRT, and the demands for clearer pictures to LCD, TFT, and plasma monitors has promoted an alternative method of getting images to the screen, known as *progressive scanning*. With the progressive scan, each row of pixels is scanned onto the screen in sequential order, from top to bottom. This is done at 60fps, which provides a smoother, more detailed image and allows higher-resolution display of image details, text, and graphics without the flicker often associated with interlaced scan. Although cameras vary, some videographers shoot at 24p, which yields 48 progressive scans per second.

The chart shown here presents the industry standards for both progressive scan and interlaced. Notice the huge leap between standard NTSC (SD) and even broadcast HDV—although both are still interlaced. These would be projection TVs and scan-converted flat panels—some of which can run 720p as well.

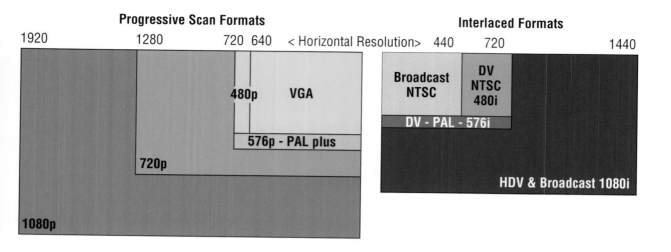

To illustrate both ends of the spectrum, Figure 11.1 compares an NTSC DV image (the top image) to the same detail of an HD 1080p image (the bottom image). Notice the size difference between the two, which drastically reduces details in the edges in addition to the interlacing issues you'll surely encounter. You can imagine how this might affect the edges of a green screen shot from which you're trying to extract a mask.

As a real-world comparison of these two extremes, I used a Sony PD170 Mini-DV camcorder, which was an acceptable industry standard for DV only a few short years ago, and a newer Panasonic HPX300 HD camcorder. I set up in a fixed-light green screen studio with even screen lighting and a mannequin as a model. The pair of images in Figure 11.2 show the green screen shot and extracted matte from the footage shot from the PD170 Mini-DV camcorder at NTSC resolution.

I shot the same setup with the Panasonic HPX300 HD camcorder at 1080p (Figure 11.3). Of course, this isn't intended to be a side-by-side comparison of which is the better camcorder, because that would be like comparing apples to oranges, but this figure shows the extremes of the media formats in general. You can see the details of the hair retained in the matte extraction from the 1080p image.

Even lower-resolution HD cameras that are progressive-scan will give you a better image from which to extract a matte than most interlaced camcorders, including a professional Beta SP. That only goes for the image quality. You must consider two other very important aspects, as well: the sensor/electronics and the lens.

Image Sensors and Sampling Ratios

Nothing is more misunderstood and wrongly referenced in camcorder and digital single-lens reflex (DSLR) marketing than the image sensor's capabilities. The image sensor or charged coupling device (CCD) is the part of the camera or camcorder that receives the image data from the lens. The CCD is a grid of light-sensitive cells called *photosites*, representing pixels, that collect values for RGB (or YUV). The size and pattern of the cells on the surface of the sensor determine the true resolution of the camera. Figure 11.4 shows a typical CCD of a DSLR.

Figure 11.1 *A detailed comparison of an NTSC (top) image and an HD 1080p (bottom) image*

Figure 11.2 *Green screen footage shot with a Sony PD170 Mini-DV camcorder at NTSC, with the extracted matte*

Figure 11.3 Green screen footage shot with a Panasonic HPX300 HD camcorder at 1080p, with the extracted matte

Figure 11.4 A typical CCD image sensor from a DSLR

The digital video signal (also referred to as YUV) has basically three components: the luminance or green channel (Y), the color value of the luminance deducted from the color red (R-Y), and the color value of the luminance deducted from the color blue (B-Y). When digitized, these three parameters of the component video signal are assigned a numeric value. The grouping and interpolation order of these values from the sensor determine the resolution and color density of the camera's output. I'll explain more in the following section.

The Truth about HD, 2K, and 4K

Several camcorders on the market claim to be HD, 2K, or even 4K, when they may not really be what they claim. Sure, they may create an image/footage file that appears to be HD, but when you investigate the actual camera specifications, you may learn that the final footage has been interpolated from the CCD or complementary metal-oxide semiconductor (CMOS) sensor through the camera and then out to the image file.

First, let's look at HD. Just because a camcorder claims to be HD doesn't mean you're going to get true HD saturated data in your footage files. It starts with a one-third-size sensor, which means the surface area of the sensor is small—based on one third the size of the imaging area on a standard 35mm film camera. The progressive scans of this sensor are interpolated to produce the correct number of pixels, but the data in those pixels is primarily from the luminance, or green channel. This gives the grayscale part of the image a lot of clarity and sharpness, but the color saturation from the red and blue channels suffers greatly. The interpolation compensates by averaging the data and creates a simulated HD image that looks pretty good with live footage but wreaks havoc on a green screen shot.

This interpolated HD sampling scan rate is commonly referred to as 4:1:1. This means there are four luminance or green pixels to every one each of red and blue pixels, which hold the color information for a shot. This chart shows an illustration of how this looks on a small section of a sensor's grid surface, and just how much of the grid is assigned to the luminance pixels.

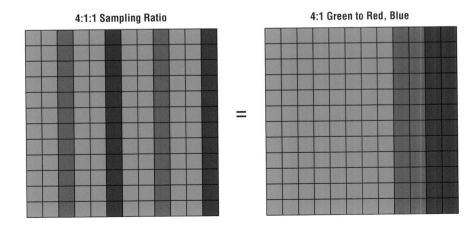

This is typical of most HD camcorders that are considered prosumer or consumer-based handheld camcorders bearing the HD moniker. Beware the temptation of buying an HD camera based on price, marketing, and megapixel rating. You may have a 10MP camera or DSLR that also shoots video, or a name-brand handheld HD camcorder, but make sure it is not a 4:1:1 camera if you intend to produce high-quality green screen footage! Yes, you can get by with it if you're only working on a small student film or a YouTube commercial production; but for a true HD green screen production, you need a 4:2:2 camera.

What is 4:2:2? What's 4:4:4? What's the difference between 2K and 4K? Keep reading.

An Interview with Panavision's John Galt about 2K vs. 4K

I've learned a lot during the process of researching this book and interviewing some of the industry's top technology experts. Such an expert is John Galt, Panavision's senior vice president of advanced digital imaging (www.panavision.com), who led the team to develop the Genesis camera and who is responsible for the F900 Star Wars camera. John has been an industry technology leader for decades and has written several scientific white papers and given talks on the subject of digital camera technology. One such paper that he presented in 2004 was "How Many Pixels in Lawrence of Arabia?" which is available to view online (www.jts2004.org/english/proceedings/Galt.html).

When I interviewed John, he explained some simple principles that greatly affect how you approach shooting high-resolution footage and why people are confused about today's 4K-camera technology (Figure 11.5).

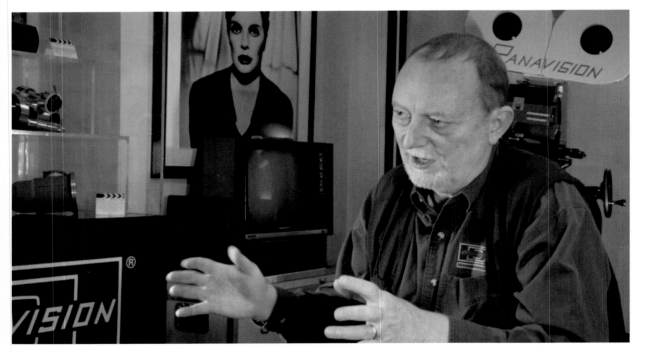

Figure 11.5 *Interviewing with John Galt at Panavision*

John pointed out that originally, the terms *2K* and *4K* referred to the output of a film scanner. Each frame of 35mm film scanned gave you 4,000 red pixels, 4,000 green pixels, and 4,000 blue pixels—in other words, 4K all around. The high-end HD cameras (true 4K) have the same relationship on a full-frame sensor, providing 4,096 photo sites (pixels) in an imaging area of 35mm film. This means you have 4,096 red, 4,096 green, and 4,096 blue photo sites captured, which is commonly referred to as 4:4:4. The chart shown here illustrates a small section of a 4K sensor's photosite grid. Notice the equal number of pixels for red, green, and blue.

4:4:4 Sampling Ratio Equal Values R, G, B

Of course, to get this kind of imaging quality, you're going to spend a lot of money. Currently, a high-end camera from Panavision is something you can rent for a high-end, big budget production. Panasonic makes a fantastic 4:4:4 VariCam P2 camcorder, the AJ-HPX3700, which has a street price of around $60,000. However, the drawbacks are that it's still only a two-thirds frame sensor and is limited to speeds up to 30fps. Cameras like this usually rent for more than $1,000 per day if you're with a qualified production company.

The rest of the HD market consists of 4:2:2 professional camcorders and DSLRs. Prices range from about $3,500 up to $50,000, and most of that goes for the electronics and the lenses provided with the camera. Such cameras are primarily based on CMOS sensor technology with interpolation but still provide beautiful results.

Early in the digital imaging developmental years, a Kodak engineer, Dr. Bryce Bayer, developed a sampling pattern that utilized twice as many green photo sites as red and blue, coupled with a low-pass filter to remove moiré patterns that might occur. This made it possible to produce an acceptable quality image in a sensor that could be mass-produced. Over the years, as sensors have become larger in size and higher resolution, this formula still maintains the bulk of the lower-end professional imaging market. The 4:2:2 sampling ratio is referred to as the *Bayer Pattern sensor*. The chart shown here presents how Bayer Pattern photo sites are aligned on the surface of the sensor.

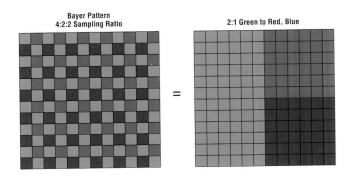

Bayer Pattern
4:2:2 Sampling Ratio 2:1 Green to Red, Blue

John continued with the math: "If the aspect ratio of a full 35mm film frame is 4 x 3 and you have 4,096 photo sites across the width and 3,000 along the height, then you have basically 4K by 3K. That's 12 million of each of the green, red, and blue photo sites, or 36 million photo sites. That equates to what you'd get with a 4K film scan—a 36 megapixel scan."

As confirmed by film technology pioneer and Scientific & Technology Oscar recipient Jonathan Erland from the Academy of Motion Pictures Arts and Sciences (www.oscars.org), not all 4K cameras on the market are truly 4K. Take the RED ONE (www.red.com/) for example—it's an amazing and highly flexible and customizable camera, but it lacks the truth behind its 4K capabilities. As John Galt states, "4K doesn't mean that just because you have 4,096 green photo sites and 2,048 red and blue that get interpolated through software, it's a true 4K camera! You can't take an 8.3 million photosite sensor and create 36 million pixels out of that without interpolation and claim to have a 4K camera." Making such claims is often referred to as *marketing pixels*. Mr. Erland points out that RED isn't the only company that does this, of course. Most digital camera manufacturers fudge the numbers with a similar technique and rely heavily on pushing the megapixels.

The footage from a 4:2:2 camera is beautiful, and the flexibility of today's pro camcorders is amazing. Speeds up to 60fps are standard in many models, such as the Panasonic AG-HPX170 that I used for many of the projects I shot for this book. Also the Sony EX3 and Canon EOS 60D were used for some of the more recent projects which performed remarkably well for low-mid range filmmaking.

For a comparison on two different cameras, I went to my friend and colleague Paul Kalbach's studio, Artichoke Productions (www.artichokeproductions.com) to shoot with my portable setup and my Sony EX3 alongside his RED EPIC. While his test mannequin may have seen a lot more miles and mishaps than mine has, it was still an interesting test to see what kind of green screen footage the RED EPIC provided.

I wasn't surprised at the quality of the footage the RED EPIC produced, of course, but for most of my productions that are 1080p or 2K, the Blackmagic Design Pocket Cinema Camera or the Pocket Cinema Camera would suffice quite nicely. For that matter, most of the Sony EX3 footage I've shot in the past couple of years was fine for 1080p and surprisingly, with enough light, the 60D doesn't do too bad either.

It all depends on the level of production you're working on. For most readers of this book, any camcorder or DSLR that can produce true 1080p HD (1920 x 1080 pixels) will be more than sufficient. The more information you can get in, the more you have to work with when you have to extract a matte from green or blue screen footage.

The Lens

Chances are, if you're thinking of getting a decent 1080p professional camcorder, it will come with a reasonable built-in lens or have the ability to use interchangeable lenses. Many of the low-end professional series camcorders have a built-in zoom lens that produces a fairly sharp image across the zoom range. This is fine for most live shooting work, but when you pan your camera or someone walks in from the side of a locked-off camera, you may notice some distortion and lens aberrations. This is caused by a

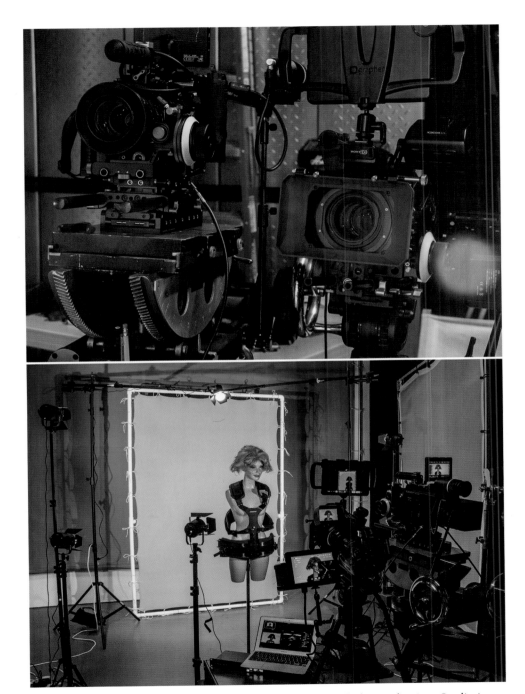

Figure 11.6 *RED EPIC and Sony EX3 comparisons at Artichoke Productions Studio in Emeryville, CA*

Figure 11.7 *A comparison of different composites using (first to last) Canon EOS 60D, Blackmagic Design Pocket Cinema Camera, Blackmagic Design Cinema Camera, Sony EX3 and RED EPIC*

Figure 11.7 *(continued)*

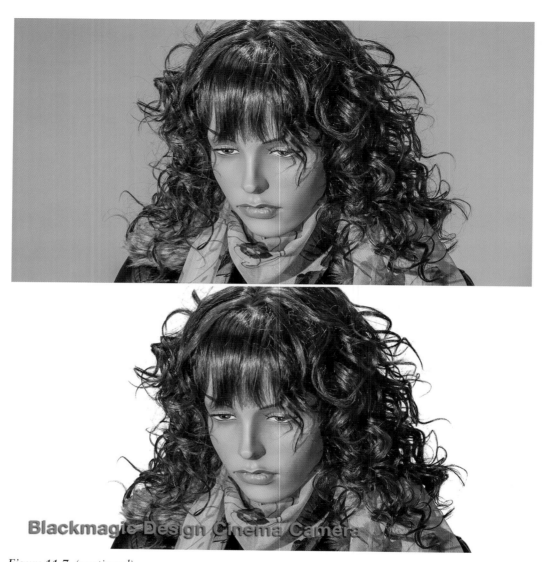

Figure 11.7 *(continued)*

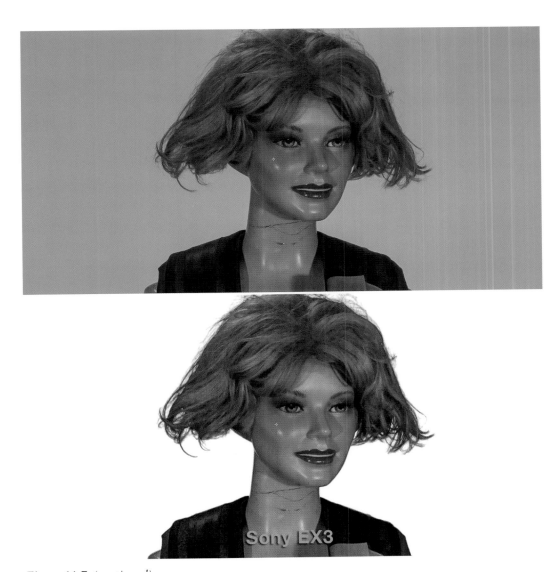

Figure 11.7 *(continued)*

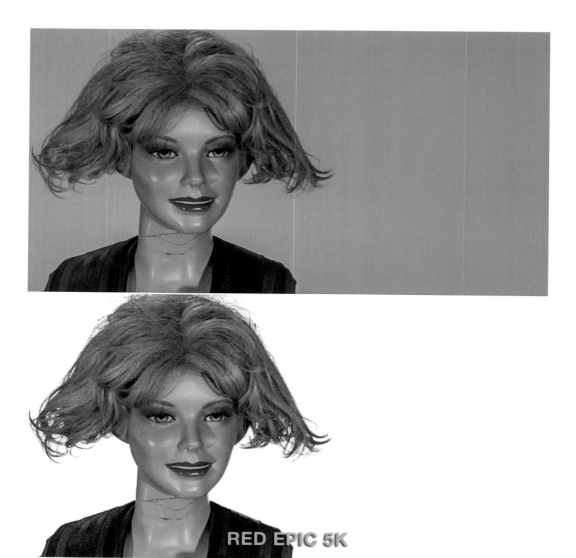

Figure 11.7 *(continued)*

compromise in the manufacture of the zoom lens to accommodate a large range of focal integrity in the main two-thirds of the center of the lens.

Most DPs working on big-budget productions that use high-end professional cameras choose to use a *prime lens*. This is a fixed focal–length lens that usually accommodates more light in through the aperture, giving more control over the depth of field (DOF) and low-light conditions. There is also much less chance of the barrel distortions that zoom lenses can produce.

However, even with built-in zoom lenses, the focal range may have a sweet spot that tends to crop out the majority of the barrel distortion around the edges. As you get accustomed to your camera, you'll discover what focal length works best for you.

You can test this by mounting your camera on a tripod and aiming it at some buildings or other vertical surfaces in sequence. Zoom out all the way to get the widest focal length your lens will provide. Then, pan the camera back and forth and observe the distortions on the vertical surfaces, such as door, windows, and edges of the buildings. Zoom in small increments, and observe the actual focal lengths. Take notes of where along the zoom path this distortion is least prevalent. This is where you'll want to shoot the bulk of your background footage as well as the green screen footage if you have subjects or objects coming in from the sides or extending out of the edges of the frame. The edges of the image tend to bow in slightly where the blue building on the right comes into frame.

Of course, either having an adapter on a camcorder that accepts interchangeable lenses or various DSLR lens mounts, will give you a lot more options. Also, shooting with a DSLR may allow you to use prime lenses which will give you optimal results and exceptional DOF, but might not be best for shooting against a green screen unless there's very little movement by your subject.

Correcting Barrel Distortion in After Effects

Sometimes you can't avoid distortion in your shots; or perhaps you've been given footage with distortion around the outer edges, and you're faced with compositing a scene with it. Fortunately, a correction-effect filter that comes with Adobe After Effects can help reduce the distortion in a natural way.

I imported a video into After Effects and created a new composition from the footage. I first turned on the rulers and drew a single guide to give me a visual sense of how much distortion was in my footage on the right side of the frame.

I then selected the Optical Correction effect (Effect ➤ Distort ➤ Optical Correction). Enabling the Reverse Lens Distortion option to create a concave warping of the image around the edges, I slowly increased the amount of the Field Of View (FOV) setting (see Figure 11.8). If the distortion doesn't appear to be centered where you need it to be affected the most, you can reposition the View Center by clicking the target icon and moving it on the screen until you see that the most correction is applied where you need it in the frame.

This effect works well on green screen footage too, if your subjects tend to distort when walking toward the camera and off to the side, or if you have a set extension or props/objects on the green screen stage that extend off the sides and the distortion doesn't match your background plate.

If you don't have After Effects to make these corrections, your NLE software editor may provide other corrective options, such as Keystone or Pinning corrections. You may also be able to apply a slight bulge distortion effect in the opposite direction of the lens distortion introduced by your camera. If you have an overlay grid or guides that you can use for alignment, it can be a helpful aid in correcting the distortions with whatever effect you apply.

Figure 11.8 *Barrel distortion in the built-in zoom lens can create problems on the edges of the frame. Adjusting the Field Of View with Reverse Lens Distortion selected corrects the distortion of the frame*

Scoping Your Camera

I've mentioned in other chapters in this book that using a scope on your camera to set up the lighting of your green screen scenes is the single most important step to a successful shot. This applies to shooting backgrounds and live action shots as well. Changes in location and lighting conditions affect not only the white balance in your scene but all aspects of your camera's profile.

I've shared in Chapter 9 how to use the iPad and iPhone Apps and the software scope called ScopeBox (www.scopebox.com) to set the lighting correctly for your scene. But how do you set up your camera on location to obtain consistent color, exposure, and white balance?

Professionals use a hardware scope or waveform monitor both in the studio and on location to ensure this level of consistency. Several manufacturers have hardware scopes on the market for studio installation and portable devices. Figure 11.9 shows waveform monitors from Leader and Tektronix.

Figure 11.9 *Hardware scopes and waveform monitors help to set up your camera in the studio and on location*

Another important tool for obtaining the best color balance as well as setting up the back focus is a professional ChromaDuMonde chart (www.dsclabs.com/chromadumonde.htm). Such a precision screen-printed chart on a metal surface costs several hundred dollars, but there's no substitute for a quality tool like this. The example shown Figure 11.10 was screen-captured from the signal running through a Tektronix waveform monitor as shot through a Sony EX3.

Figure 11.10 *Using a ChromaDuMonde chart to set up your camera will ensure the best results from each shoot*

You'll use several modes on a scope to determine the proper setup of the camera and the lighting of your set. Using the Sony EX3 and monitoring color bars from the camera, you can see how well the color balance from the signal gives sharp, direct readings across the ranges in each of the different modes. In Figure 11.11, you can see the balance from top to bottom as viewed in Vector, RGB Parade, and Component modes. Note that in addition to checking the RGB values and white balance on your camera, you can use the waveform monitor to provide the knee (or clipping) adjustment as well. Most modern cameras have a zebra setting that shows diagonal dotted lines in motion on the hot spots visible in your viewfinder.

In the industry, Sony camcorders are known to fall a bit short in the green to cyan space in their electronics, which makes them less desirable for professional green screen capturing. Using the EX3 to shoot on the balanced ChromaDuMonde chart, you can see that the Vector scope reveals this shift in the green and cyan ranges (see Figure 11.12).

Figure 11.11 *Three different scope monitoring modes: Vector, RGB Parade, and Component*

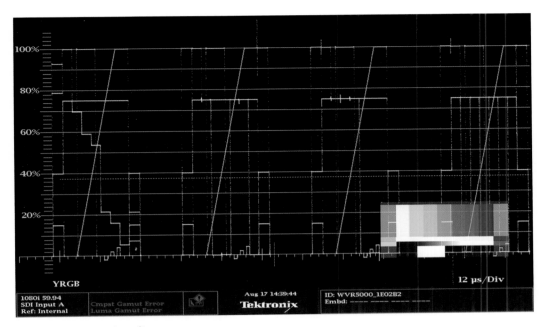

Figure 11.11 (continued)

Figure 11.12 Shooting the ChromaDuMonde chart with the Sony EX3 as seen through the Vector scope

There are some high-quality field monitors that provide a good reference as well as built-in scopes, such as the SmallHD DP7-PRO OLED Field Monitor (www.smallhd.com/products/dp7-pro/dp7-pro-oled.html). You can switch between Vectorscope for getting the green dialed-in, the Waveform to set your levels correctly and RGB Parade to check the balance.

Figure 11.13 *Using the built-in scopes on the SmallHD DP7-PRO OLED Field Monitor*

Another workflow I've recently been using is to connect my cameras to the Blackmagic Design UltraStudio 4K (www.blackmagicdesign.com) which then splits the signal to HDMI for my reference monitor and Thunderbolt to my MacBook Air or MacBook Pro (Figure 11.14). Then depending on which camera I'm shooting with, I can use either ScopeBox or the Blackmagic UltraScope software.

Figure 11.13 (continued)

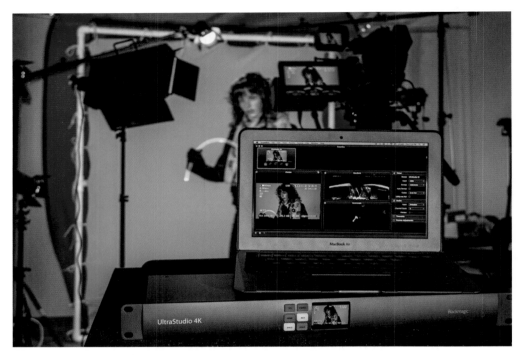

Figure 11.3 *(continued)*

Figure 11.14 *Using the Blackmagic Design UltraStudio 4K to feed the camera's signal to reference monitor and a Thunderbolt-enabled MacBook Air running ScopeBox or Blackmagic UltraScope software*

Where to Learn More?

Products used or mentioned in this chapter:

- **RED EPIC Camera:** www.red.com
- **Panasonic Pro Camcorders:** www.panasonic.com/business/provideo/
- **Panavision:** www.panavision.com
- **ScopeBox software:** www.scopebox.com
- **Leader Waveform Monitors:** www.leaderusa.com
- **Tektronix Waveform Monitors:** www.tek.com/waveform-monitor
- **Sony EX3:** pro.sony.com/bbsc/ssr/product-PMWEX3/
- **Canon EOS 60D:**
 www.usa.canon.com/cusa/consumer/products/cameras/slr_cameras/eos_60d
- **SmallHD DP7-PRO OLED Display:**
 www.smallhd.com/products/dp7-pro/dp7-pro-oled.html
- **ChromaDuMonde Chart:** www.dsclabs.com/chromadumonde.htm

Image and footage credits:

- **iStockphoto:** www.istockphoto.com
- **John Galt, White Paper:** www.jts2004.org/english/proceedings/Galt.html
- **Jonathan Erland, Composite Components Company:** www.digitalgreenscreen.com
- **Paul Kalbach, Artichoke Productions:** www.artichokeproductions.com

You can find a complete list of references and suggested continued reading/learning from this chapter in Appendix A.

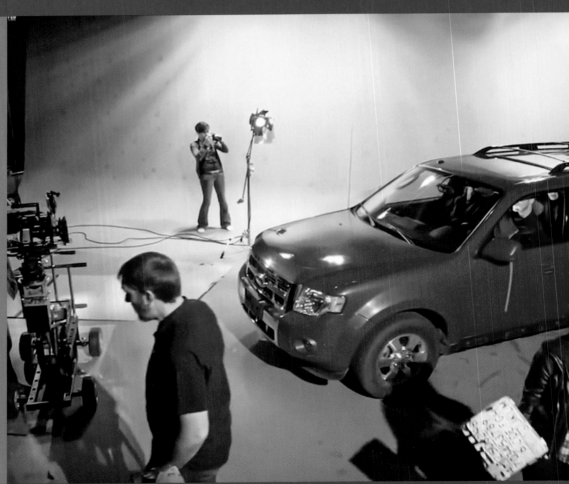

Storyboarding and Directing Your Talent

Before you take the ideas *in your head and just start shooting footage, it's very important that you first create a storyboard of your project. This will be a visual guide—a map of sorts—that will allow you to communicate those ideas to the rest of your crew. It will also help keep you on course so you don't stray too much from your original plan, which can end up wasting a lot of time and money. The better you can communicate these ideas to your talent and crew, the more successful your project will be, both in front of the green screen and in the postproduction process.*

In this chapter, you'll learn how real-world productions storyboard their projects, and you'll find out how you can work with your postproduction team on the set. Finally, I'll cover how to use your storyboard to your benefit to direct your actors.

The Importance of Previsualization and Storyboarding

To plan the shots you need, whether your project is a live-action shoot with some occasional green screen shots or a full-blown green screen production with a virtual set, you need at least a few previsualization scenes to better get a feel for what you're going to produce. This may require some test shots to see whether a particular effect will work. Or if you're using

outdoor lighting for a partial scene, you need to visualize the location and time of day that will be best to shoot in. This is also when location scouting takes place, especially if you have to do any matte painting or rotoscope work for a background or environment.

First Things First: Planning Your Project

This chapter is all about previsualizing your project. The more that you can help your crew and your talent to visualize what you're hoping to get from them, the better your results will be. The lighting and camera angles all rely on this information—as does the planning for your crew and your budget. If you know how many angles you want for each shot, then you can determine how many cameras you need, how much green screen background, how many lights, and so on. These are just the basics, of course; as you dig down, you'll see how one little change can have a domino effect throughout your production.

In addition to storyboarding your shots, you need to communicate what you're hoping to get from your talent. You're the director, and you have to paint a picture of where they will be in their virtual world and communicate this effectively. This is where it helps to have not only clear storyboards and direction, but also good actors. If you're a film student and are trying to do a budget production, then go to the theater department and get your talent. It's imperative that the talent knows how to pantomime accurately and "believe" they're in an environment that doesn't exist until you composite them.

Having a good storyboard (preferably with overlay images) will help you line up your camera angles and get the correct lighting quickly without having to reshoot later. The quicker you can get through the shooting, the fresher your talent will be, and the happier your crew will be!

Refer to Chapters 10, 11, and 13 for more information about integrating your talent with the background environment.

If you're creating a virtual world, then it's best to render some test shots of your different scenes in 3D. Use the same creative camera angles that you want in your final production. This helps everyone on the project understand how they will re-create your world by doing their parts—whether it's acting, shooting, lighting, or postproduction compositing. That includes *you* if you're doing a one-person project on a low budget!

But you don't have to be a 3D wizard to create a viable storyboard. Even some good sketches or renderings on a sketchpad will suffice if you can give a good visual representation of each shot. Many short films and commercial projects have been successfully planned on a notebook sketchpad!

Some productions, such as *Sin City*, were developed from comic book-style renderings, because the final effect in the movie was to emulate a comic book come to life. More complicated and realistic virtual worlds created in films such as *Sky Captain and the World of Tomorrow* required more 3D renderings for previsualization. But movies like these require much more postproduction work than typical visual effects shots that are edited in with live-action footage. They also require much tighter planning and storyboarding to get the ideas across.

If you're heading into a project, capturing green screen footage, and planning to figure out later where to put the figures, then you're working against yourself. It's much harder to match a background to your green screen figure in scale, angle, perspective,

lighting, focal length, and so on, than the other way around. Sure, you can take canned green screen footage and make something that will work, especially if it's a virtual background in 3D or some 2D layers in After Effects, but if you're planning a full project, then you need some serious planning—and a storyboard.

Haven: A Case-Study Production

Animator, VFX pro, and filmmaker James Parris is producing a new feature film, and he shared some of the effects shots with me for use in this book. The film is titled *Haven*, and without giving away the good stuff from his movie, he shared his Animatics for a sequence in one of the scenes. *Animatics* is a series of sketches put into a near-real-time pacing with voice-over narration and music for effect. This is often presented to potential investors or team members on a project to give them a feeling for the dialogue and the sense of pace and emotion in a scene.

In the pairs of images in Figure 12.1, I've matched some of the Animatics frames with frames from the actual production footage for comparison. This was taken from a postproduction reel, so there are labels where James has given the VFX artists and compositors instructions in the different shots. You'll see other example images and clips from this production in other chapters throughout the book.

Figure 12.1 These paired images represent the Animatics frames and the corresponding clips from the live action footage

Figure 12.1 *(continued)*

Hero Punk: A Case-Study Production

Kanen Flowers is the creator, producer and director of this futuristic sci-fi film that incorporates green screen production with motion tracking and an entirely virtual world, as introduced in Chapter 7. According to his interview video on the Hero Punk website (www.heropunk.com), the script required a few re-writes before he was totally satisfied with the story and then he stepped up the pre-production process with some magnificent storyboard work that could be a comic book unto itself (Figure 12.2). The way the production is coming together with a massive global team of production and postproduction editors, compositors and virtual world creators is quite an undertaking.

Figure 12.2 *Kanen Flowers discusses the process of writing, production and postproduction on Hero Punk*

Figure 12.2 (continued)

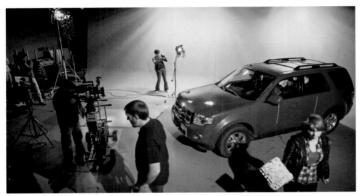

Figure 12.2 *(continued)*

Taking a few frames from the storyboards and matching them up with a preliminary composite of the scenes shot from them (Figure 12.3), you can quickly understand the importance of tight storyboards to the director when you have a very limited time to shoot.

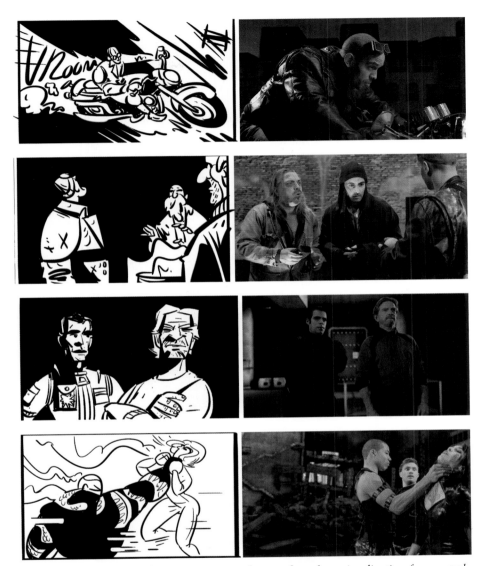

Figure 12.3 These paired images represent the storyboard previsualization frames and the corresponding clips from the final composited movie

Dead End City: A Case-Study Production

Inspired by Frank Miller's *Sin City*, creator Jeff Varga wanted to bring a video series to the Web. *Dead End City, the Pilot Episodes* (www.vimeo.com/11910694) is described as "Guns, smoking-hot babes, and the walking dead. What more could you ask for?" His series features actor Gary Graham (*Alien Nation* and *Star Trek: Enterprise*) as his lead

character in this over-the-top, film noir-style shoot-'em-up, filmed entirely on green screen and composited into a virtual world.

Because the pilot episodes were primarily produced in-house to attract investors and sponsors, Varga used DAZ Studio to create his CG virtual environments. The added benefit of doing this was the ability to preplan his shots precisely as he was going to composite them. Using stand-in figures in the DAZ application (mostly scantily clad, because it saves rendering time), he was able to do both previsualization and storyboarding simultaneously. Instead of using sketch drawings of the sequences, as is most commonly done, Varga built the virtual sets he would later render in his final composite scenes; he then added stand-in figures, which let him previsualize how the final scene might look with the composited actors. The sequence of image pairs in Figure 12.4 shows the comparison of storyboard frames with the final composited clips from the movie.

Note how the basic details of the environment elements are similar but not fully rendered in the storyboard images. While the creator was developing his storyboards, he was also developing his virtual set. This process ensured the correct camera angles on the green screen stage and made it easy for him to create the final background scenes by rendering out his models (without the 3D characters) in a higher-resolution render before compositing.

Figure 12.4 *These paired images represent the storyboard previsualization frames and the corresponding clips from the final composited movie*

Figure 12.4 (continued)

"Pre-Post": Working as a Team with Postproduction on the Set

You can save a lot of time and frustration on a project (not to mention a large chunk of your budget) by involving all of your team members from the planning stages to the green screen shoot and through to postproduction. Communication about all the aspects of a project is key for success (Figure 12.5). Big-budget major motion-picture productions spend a lot of money making sure that every aspect of a production is communicated upstream and down, which is why they need their big budgets. Look at the end credits of an effects-laden movie, and you'll see what I mean. In addition to compositors, animators, and editors, you see several layers of management—producers, directors, and coordinators. They make sure the machine is well oiled and the project runs smoothly. Every stage of the project is communicated from the first planning and storyboarding discussions through to the end credit roll.

For smaller, low-budget projects, you may have only a couple of people working on all aspects of production. That's even more reason to stay in constant communication and solicit feedback from each team member along the way.

For instance, if you're shooting green screen action on a small sound stage, be sure the director or technician who is building the virtual set or providing the VFX and compositing is present so they can work with the camera crew and live-action director to eliminate potential problems that may occur later down the line. Such feedback is critical on the set—it goes beyond what the storyboard or comps tell the live-action director.

In other chapters, I've shared horror stories of production nightmares where editors and compositors were handed horrendous green screen footage and expected to "make it work." Such situations aren't limited to independent films and low-budget commercial projects—I've often heard stories of big-budget film directors deciding on the set that it's

easier to "fix it in post" than it is to take 20 minutes to move a couple of lights around while the cast and crew wait. In one instance, a director was told that a craft services truck was partially in the shot and that the crew would have the driver move, which would take maybe two minutes. But the arrogant director decided to leave the truck in— because it could be roto'd out in post.

Figure 12.5 *Maintaining constant communication and collaboration between postproduction and shooting on the set will produce better results and a smoother production*

Several of the professionals I've interviewed have shared the same concerns about the assumptions directors have about postproduction compositing and the way directors misuse the process. They all refer to how the classic filmmaker Alfred Hitchcock approached movie making. He had a complete vision of the way each scene was to look through the lens, and he was decisive about how each prop, light, and character in each scene should be positioned. He wouldn't roll film until all the conditions were perfect. Most of his movies were shot with one take in each scene and very little B-roll.

Often, directors head into a blue or green screen shoot with only a vague idea of how the composite will look in the end; they're counting on the expertise of the postproduction facility to figure it out and make it work. As Jonathan Erland from the Academy of Motion Pictures Arts and Sciences stated, "Deferral for decision making in directing a film using blue screen is sloppy filmmaking!" He continued, "Unless the entire set has been designed before you shoot the foreground element, you could end up with a very awkward composite . . . with unjustified shadows and light sources." Of course, with today's impressive software technology, just about anything can be re-created on the

computer, including changing the light cast on a person or faking a drop shadow. But doing so is often avoidable and unnecessarily costly in both time and money.

That's Why They Call It "Acting"

As I mentioned earlier in the chapter, it's imperative that your talent be, well, talented. Many times, I've seen subjects who were comfortable on-camera in a normal situation or reading a teleprompter fall apart when directed to pretend to be somewhere or do something. This is why I recommend using theatrical people whenever possible, because they can immerse themselves not only into their character but also in their imaginary environment. Sure, you can use props and furniture as much as possible to help create space, boundaries, and interaction with other objects, but if the actors aren't believable, then your audience won't be convinced.

Here are a few comments about shooting the green screen process from the creator and lead actors from *Dead End City*. These are excerpted from the *Behind the Scenes* Green Screen video on Vimeo.

Gary Graham (Figure 12.6) states the following:

> My character moves across the stage and doesn't bump into the furniture. This is the most exciting thing that I can manage on this, because the furniture is imaginary. In fact, everything except the actual actor is imaginary!

Figure 12.6 Actor Gary Graham discusses the process of working in an imaginary world

He continues:

> There are so many things to think about and consider . . . just blocking-wise, getting your lines, remembering the relationships, just for your own character. Then you have to create the room in your mind, and the director starts painting it for you, and you have to remember all that . . . because if you don't, you're walking through walls and putting your hands through tables.

Creator/director Jeff Varga (Figure 12.7) instructs the actors that "You can't be behind this invisible line right here . . . otherwise we'd need another green screen." Varga goes

on to discuss the process: "Writing for the green screen pretty much allows you [sic] . . . the sky's the limit. We want to go to Paris, at night time—well, that would cost us millions of dollars to go do that. We just sit down in post and create the environments."

Figure 12.7 Creator/Director Jeff Varga explains why he chooses to shoot all green screen and use virtual sets

Actor Matthew Nicolau (Figure 12.8) states, "If you aren't really diligent, you quit believing the circumstances which [sic] . . . then your character doesn't live. That's the most difficult part, to constantly be believing where you're at."

Actor Tennessee Webb (Figure 12.9) describes the art of pantomime to stay in character:

It's like you're going into your home, and you're going to fix dinner. So you go to the cabinet, and you take out a pot. And then put whatever you're going to do into that pot, bring it to a boil . . . make sure it's right, ready . . . put it on a plate . . . do a taste test, and enjoy your dinner. But there's nothing there. You've had to pantomime that whole thing! That's working in front of a green screen.

Figure 12.8 Actor Matthew Nicolau describes the importance of staying in character and believing you're in this place

Figure 12.9 Actor Tennessee Webb talks about the process of the art of pantomime when working in front of a green screen

It's imperative that you choose the right actors or subjects for your green screen production. In addition, *you* must communicate with them both visually with a storyboard as well as verbally, to help paint a mental picture of who they are, where they are, and what they're supposed to be doing.

Where to Learn More?

Products mentioned in this chapter:

- **DAZ 3D Studio:** www.daz3d.com

Image and footage credits:

- **James Parris: Paper Tiger Films for Haven:** www.papertigerfilms.com
- **Kanen Flowers:** www.heropunk.com
- **Jeff Varga: Dead End City:** www.vimeo.com/11910694
- **Jonathan Erland: Composite Components Company and A.M.P.A.S.:** www.digitalgreenscreen.com and www.oscars.org

You can find a complete list of references and suggested continued reading/learning from this chapter in Appendix A.

Interacting with the Background and Objects

When you're planning your *green screen shots, you may not always want just a floating subject, a simple walk-on, or a talking head against a background plate. Perhaps your subject has to lean on a virtual set counter, sit in a chair, or peek around the corner.*

With the proper lighting, staging, and prop preparation, you can put the subject into nearly any virtual world or scene. Combining green or blue backgrounds and props with the ability to motion-track subjects and props, you can create interesting and believable compositing effects.

In this chapter, I'll address the prop and staging preparation, special lighting issues, and retaining shadows where necessary.

Shooting with Color-Keyed Props and Furniture

If you're shooting on a green screen stage and you want the furniture to disappear when you key your shot, then you have to make sure it's painted or covered with the appropriate green material. That's only the first step! Other factors such as lighting the scene correctly and focusing enough light on the shadowed areas of the furniture or props are essential to ensure a good key. Otherwise, you may retain the shape and shadows of the object, and they may not match the background over which you're compositing the foreground shot.

With help from Professor Terry Wieser and the students and staff at the Ventura Technology Development Center (www.tdcstudios.com), the green screen stage shown in this section was set up for shooting individual actors to be inserted into a virtual set. It's important to plan for your shot so you have the right amount of furniture and

components set up. For this scene, we needed only a single chair and a high counter surface, which were configured and positioned appropriately for each position in the shoot. In Figure 13.1, you can see that the chair and the boxes stacked for a makeshift counter were all covered with green screen paper, foam, and tape.

Figure 13.1 Simple objects and furniture can be covered with green or blue paper, paint, or tape to blend in with the background

First Things First: Planning Your Project

Planning and setup are the most important factors in a successful composition requiring interaction with the background plate and elements. You must consider exactly what camera angles, lighting, actor positions, and set size and scale you need before you shoot. You need to know exactly what height chairs, tables, and countertops will be in the background plate so you can best simulate these on the green screen stage. You must factor in the lighting in the scene, which can vary on different parts of the set into which you're compositing your subjects. And you need to make sure your props are an acceptable color and lit well to reduce unwanted harsh shadows, so they will key out correctly.

Sometimes, you'll want to retain the shadows on a back wall or object so that when you key out the green or blue background, the natural shadows remain intact. You have to take steps when planning for your shot's setup and lighting and adjusting camera angles to best match your virtual set or composite background. Taking time whenever possible to measure and align your camera's position and angle to best match the background will save you time and frustration in compositing.

Refer to Chapters 9, 10, 12, and 17 for more information about integrating your talent with the background environment and virtual sets.

Just as important as the positioning of the actors and the furniture and props is the lighting around them. The virtual set we composited into for this project had full lighting with strong ambience and some stronger spot lights over the main areas where the actors stood or sat. We used the full built-in lighting on the stage to light the green screen as

well as large soft boxes to get the general lighting on the actors. However, we had to add some simulation of the spots by using Kino Flo BarFlys on high stands.

To help reduce the shadows on the sides of the chair and the podium so a cleaner key could be generated, we used strategically positioned Kino Flo Diva 400s and adjusted the output bright enough to knock down some of the darkest shadows (see Figure 13.2). Here's where having several LED light panels would have come in handy; they can be positioned just about anywhere because they're small and battery-powered.

Figure 13.2 Positioning and adjusting lights to help reduce the shadows on the furniture and props makes keying them out much easier

Using a printout of the virtual set as a visual reference, we put the camera into position for each character's green screen shot and zoomed in to get as much detail as possible. We compared the print-out to the studio monitor from the camera to ensure proper positioning and alignment with the virtual set. When the characters walked across the stage, they took several practice passes to be sure they were traveling within the frame of the camera and in the correct direction for the scene into which they were going to be composited. It's helpful to have your actors watch for small tape marks on the floor, as well as the furniture they're interacting with (see Figure 13.3).

Figure 13.3 Check several times to be sure the actors stay in frame while zoomed in to capture as much information as possible for each shot

Compositing the Shots with the Virtual Set

After you have the shots, it's best to test position and key them on-site in the studio. Then, if necessary, you can do retakes while you still have the stage, lighting, and props available.

Using a compositing program like After Effects, you can draw a mask around the characters to remove any of the shot that doesn't need to be keyed out. You can then scale and position the clips independently to their approximate locations in the virtual set, as shown in Figure 13.4. Not all clips need to be masked if a portion of their boundaries will be covered by other objects such as walls and furniture in the virtual set files.

Using Keylight to key out each clip, you can adjust positioning and scale to make sure the clips fit the set properly. Notice in Figure 13.5 that in this trial run, the characters are all on the foreground layer in front of the walls and furniture. This is typical for virtual set files; you can reassemble them in layers to sandwich in the characters.

Finally, you put the rest of the virtual set layers into place. In Figure 13.6, the character clips have been color-corrected with a slight amount of lens blur, and drop shadows and reflections have been added in the appropriate positions.

For more information about using virtual sets, see Chapter 17.

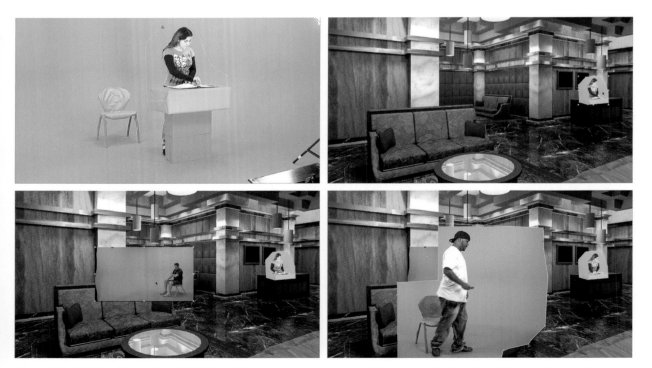

Figure 13.4 *Using the mask tool in After Effects to remove unwanted stage area in the clips before scaling and repositioning into the virtual set*

Figure 13.5 Testing the initial run to make any scale or position adjustments to each character clip

Figure 13.6 The final composite has believable motion, lighting, shadows and reflections to enhance the virtual set

Using a Secondary Key Color on Props

Sometimes, you need to use a separate key color for props and furniture or walls so you can control the keying of the interaction differently from the background. Blue is often used to avoid green spill onto the characters as well as for the retention of drop shadows onto objects and surfaces.

In Figure 13.7, the actress is leaning on a blue-covered box that will later become the edge of a bar-top surface at an outdoor cafe. She is making contact with the top surface of the box, so a separate pass with the keyer is needed to remove the blue but retain the shadows and highlights on top of the box surface; this simulates what would happen on the marble surface of the bar top.

In some cases, an actor is on a full green screen background but has a prop that needs to be motion-tracked and extracted separately. You can only do this by using a secondary color. The object often also needs motion-tracking markers, as shown on the actress's sunglasses in Figure 13.8.

Figure 13.7 *Two passes with the keyer are needed to extract the model from the green screen background and the surface she's making contact with on the blue box*

Figure 13.8 *The blue sunglasses can be motion-tracked and keyed out separately from the green screen background*

Shooting to Retain Wanted Shadows

If your subject must come in contact with a background or prop surface, and you need to retain their natural shadows for the composited effect, then you must be especially careful with your setup and lighting. This is when you may want to choose blue screen over green screen, to avoid green spill onto your actor. It's also the only time I may suggest breaking all the rules of proper screen lighting in order to get the desired effect.

You must be careful taking this on, because your results may be mixed. I have the best results shooting outdoors in direct sunlight with fill cards bouncing light back onto the subject, but it's difficult to control the sun's intensity and angle over any period of time. Of course, this can be simulated in a studio with the right kind of lighting, such as a large direct hot light. Diffused lighting gives you a diffused shadow.

The example in Figure 13.9 used one primary key light source with a wide soft fill directly onto the mannequin's face. That shadow cast on the blue screen directly behind the foliage was a result of the bright key light. The resulting keyed composite against the brick background has a natural look.

Figure 13.9 Using a strong key light to generate the shadow onto the blue screen close to the subject

In a situation where the actor can be positioned far from the green screen background, allowing it to be properly lit, you have more control over the lighting of the subject and the prop in the foreground; the lights on them won't affect the green screen lighting. In Figure 13.10, the character is reaching around and touching the surface, casting a dense shadow on the blue surface on the mock wall. Two separate passes with the keyer easily extracted Santa from the background and the foreground surface, retaining the drop shadows and reducing color spill. (For more information about complex keying and multiple keying combinations, see Chapter 19.)

Figure 13.10 *Two passes with the keyer are needed to extract Santa from the green screen background and the surface he's making contact with on the blue wall*

Shadows on Green Screen

I rarely suggest trying this technique, because of the limited light available to properly light the green screen. This process requires a great deal more care in setup and patience in postproduction, because it tends to create a lot of problems. The biggest issue is higher noise in the green channel, resulting in a grainy matte. This often requires additional masking or multiple passes with the keys on several layers.

The object is to get the strongest light source on the subject and cast a shadow in the direction you need onto the green screen surface, while using smaller fill and rim lights to light only the subject and not the screen if at all possible. I recommend using a stretched fabric such as a Lastolite pop-up screen because there is less chance of bounce-back fill than if you use a painted surface (see Figure 13.11).

When compositing this shot, I had to draw a feathered mask around the subject and her shadow to eliminate the excess noise around the outside of the screen (see Figure 13.12). Because not enough of the screen was evenly lit to pull a good key and still retain the subtle shadows, a great deal of noise remained.

It took a lot of going back and forth with the keyer's adjustments to fine-tune the final composite. But with some experimentation and patience, you should be able to get a decent composition like that shown in Figure 13.13, complete with the source drop shadows.

Figure 13.11 *You must take great care to light the subject against the green screen so that the subject casts a shadow on the surface without introducing green spill back onto the subject*

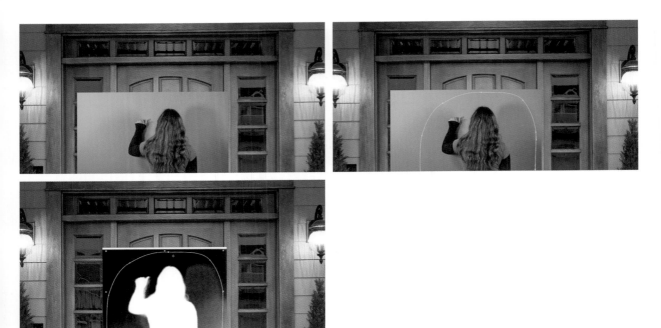

Figure 13.12 The low light from the one primary source doesn't light the screen evenly, so a feathered mask must be applied to confine the darkened areas to the subject and the shadows

Figure 13.13 The final composite with the light-source drop shadows

Where to Learn More?

Products used or mentioned in this chapter:

- **Adobe After Effects:** creative.Adobe.com
- **Virtual Set Works:** www.VirtualSetWorks.com
- **Kino Flo:** www.KinoFlo.com
- **Lastolite Portable Backgrounds:**
 www.lastolite.com/5x6-collap-cromakey-blue-green-lllc5687

Image and footage credits:

- **iStockphoto:** www.istockphoto.com
- **Hollywood Camera Work:** www.hollywoodcamerawork.us
- **Ventura Technology Development Center (TDC):** www.tdcstudios.com

You can find a complete list of references and suggested continued reading/learning from this chapter in Appendix A.

PART III

Compositing the Footage

This is where it all comes together. You've shot your green screen footage, and you're ready to start compositing. Or are you? It's just as important to be familiar with the material in this part of the book before you start planning your project as it is to know how to light your subjects or create a storyboard. If you can avoid the pitfalls of poor production *before* you get to the postproduction compositing stage, then you've made your life a whole lot easier. Of course, even the best planning and production attempts can end up with less than optimum footage, but these chapters may help you figure out a workaround and still get fantastic results.

Kelsea-EiffelTower.psd @ 100% (Kelsea green screen, RGB/8*)

100% Doc: 1.78M/4.16M

Getting a Great Matte

Getting a great matte depends *on many production factors, all of which I've covered previously in the book: lighting setup, screen background, camera and lens, subject staging, shadows and reflections, and so on. Garbage in equals garbage out in most cases, at least if you want a quick-and-easy key to composite after the shot is done. In other words, the more time you spend preparing for a quality shot, the better your matte will work, and the less time you'll spend fixing your shot in postproduction. This chapter will assume that you're working in the best-case scenario, because that is what we're striving for here—doing it right!*

In this chapter, I'll relay a firsthand story of why you want to aim for the best setup from the beginning. Then, I'll set the stage for getting a great key and walk you through some best practices in software matte making.

Bad Lighting + Poor Production = Dreadful Mattes!

As I've already covered ad nauseam throughout the first two parts of this book, it's all about the planning, setup, and execution of the shot. I can't stress this enough—primarily because it's the single most overlooked (and often flat-out ignored) part of shooting green screen on the set. Yet it's possibly the most important aspect when you have the footage ready to composite. Sometimes it's just laziness on the part of the DP or cameraman;

they may figure that anyone can use the magic button in the software keyers to make a shot work. The sad part is, they often get away with that mentality because the poor folks in postproduction are expected to make *everything* they get work and look perfect.

For example, I recently worked on a National Brand commercial featuring a famous model and her new product line. The producers and director were excited because they got to shoot the whole thing with a RED camera and had all 2K footage. The bad part was that they did it without any proper technical preparation, consultation, or input from the postproduction folks. Heck, they didn't even have the REDCINE processing software to properly process the footage they had; they gave a team of about eight editors a bunch of raw footage and left them to fend for themselves in Final Cut Pro.

The footage was horrendous to work with. We couldn't color-correct anything before final color pass, which made color-matching with graphics impossible. But more important, the green screen wasn't lit—it used only available room light, and the ambient falloff gave us a drab, olive-gray background. We were expected to key out the model's fine hair blowing with fans in super slo-mo when we had grainy, noisy raw footage and no solid color from which to even try to get a decent chroma/luma matte.

When I told the producers "No way!" on the provided footage and instructed them to reshoot or lose the footage, they came back with a "solution." They had another editor use Final Cut Pro to blast the green channel and create a mask around the model's head and shoulders in the close-up slo-mo shots. It was laughably hideous, as you can probably imagine. The shots were all scrapped, and we had to hand-roto everything else they shot on a black background as well. I wish I could show you the shots, but I don't have the rights to print them in the book; if you see one of my live seminars or conference sessions, you may get a chance to witness the disaster.

If you've skipped ahead to this chapter because you think you're ready for it (even if you have the footage in your hand and had nothing to do with the original shoot), then please review Chapters 8, 9, and 10 at least. They will give you the groundwork you need to understand *why* a matte will work well for you—and why some won't. If you had nothing to do with shooting the footage, and you weren't part of planning, consulting for, or directing the lighting setup or the shoot, you may not have any idea what the composite is supposed to look like in the end. You also may not have any control over how it will blend with the background. Unless you've selected stock green screen clips and/or background footage, you need to be clued in on the entire production. If that isn't the case, you may want to skip ahead to Chapter 16 to learn how to fix problem shots. You're probably going to need it!

Good Lighting + Solid Production = Great Mattes!

If your production has gone as planned or you were fortunate enough to get good quality green screen footage to composite with, then your job as a compositor is half done. Depending on which software you're using, you can obtain fairly accurate results from just about any keyer if the shot is lit, staged, and executed well (see Figure 14.1). Refer to Chapter 9 for more information about how to get the best results from good lighting.

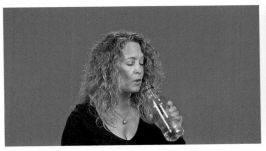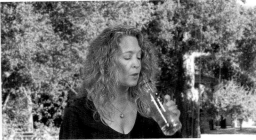

Figure 14.1 Properly lit green screen footage makes matte extraction a snap

Lighting is the most important aspect of shooting your green screen footage, but the setup is also vital (see Figure 14.2). How does your subject work with the camera? How do they interact with props, furniture, and other actors? Do you have to consider shadow details on chroma-colored props, furniture, floors, or panels? How about reflections? See Chapters 13 and 19 for more information about working with these special kinds of staging scenarios.

Figure 14.2 Good lighting plays a significant role in complex matting scenarios, especially given shadows and interaction with walls and objects

Getting the right amount of light on the green screen while avoiding unwanted spill on your subject is hard enough with full studio lighting, but trying to key out your subject with very low model lighting and then composite them onto a dark background can be a real challenge (see Figure 14.3). Even if you've lit everything properly, the composite can still be tricky, as I'll cover later in this chapter. The primary element of getting a composite to work extends beyond the extraction of the subject from the background and the quality of the edges of the cutout—it lies in the exposure and color temperature of the foreground and background plates. If your background plate is a cool moonlit sky and your foreground green screen shot is a warm, saturated shot in low light, then you need to apply some color correction and artificial lighting techniques to your plates, as discussed in detail in Chapter 15.

Figure 14.3 A composite like this would be nearly impossible if the green screen and subject weren't lit properly

Best Practices in Software Keying and Matte Extraction

Depending on which software you're using to create your composites—After Effects, Final Cut Pro, Premiere Pro, Sony Vegas, Photoshop, Avid, and so on—you must consider some of these basic steps and principles for getting the best keying results. The key is all about the matte that is created when you extract your foreground plate from the visible green (or blue). The amount of spill onto the subjects you're isolating determines how clean a matte you can extract and how much cleanup you need to do with your composite. Again, if the lighting was done right and the camera captured a quality shot, then this process should be simple.

Because I can't show examples in every application or software plug-in, I'll use Keylight in After Effects and Primatte in Photoshop to demonstrate some of the settings and matte-making principles you should keep in mind as you pull a matte.

Create a composition in After Effects that matches the final desired production resolution and import the background and foreground plate files (in my case, a single frame from two different HD videos); see Figure 14.4. Place the background plate under the green screen layer, and position them generally where you want them to be in the final composite.

Figure 14.4 Setting up the position of the foreground and background layers for the composition

Select the foreground green screen layer, and apply the Keylight plug-in from the Effect pull-down menu by choosing Effect ➤ Keying ➤ Keylight. Using the Screen Color eyedropper, select the most neutral part of the green in the background behind the subject. As you can see in Figure 14.5, this gives you an instant preview of the composite as the matte stands from the single click, but you need to do more refining to the matte.

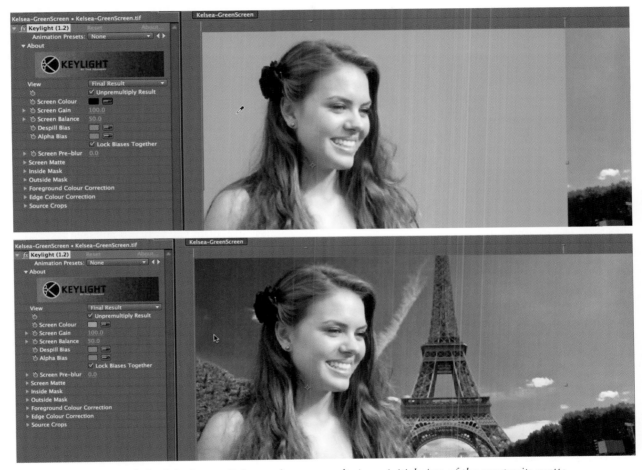

Figure 14.5 *A single click of the Screen Color eyedropper results in an initial view of the composite matte*

Choose Screen Matte from the View drop-down menu. You can see that the matte needs some fine-tuning to be accurate (Figure 14.6). Currently there is some noise in the background behind the model (light noisy areas), and she may have some slight transparency in her face and arms (dark noisy areas).

You could try adjusting the Screen Gain up slightly to clean up the background (black) and the Screen Balance down some to clean up the mask (white), but I've found that doing so often leads to strange color shifts. So, leave those alone for now, go to

Screen Matte, and click the triangle beside to it reveal the setting options. On a clean green screen shot such as the one in Figure 14.6, you'll most likely have to adjust only two settings here: Clip Black and Clip White. Start by clicking the numbers beside Clip Black (the default is at 0.0), and drag to the right slightly just until the light noise in the background disappears. You can slide this back and forth until you're sure you've found the sweet spot. Continue with the Clip White setting (default 100.0), and drag it to the left just until the dark noise inside the mask area is back to white. I often allow a tiny bit of noise around the hair—you want a soft, natural look in your composite.

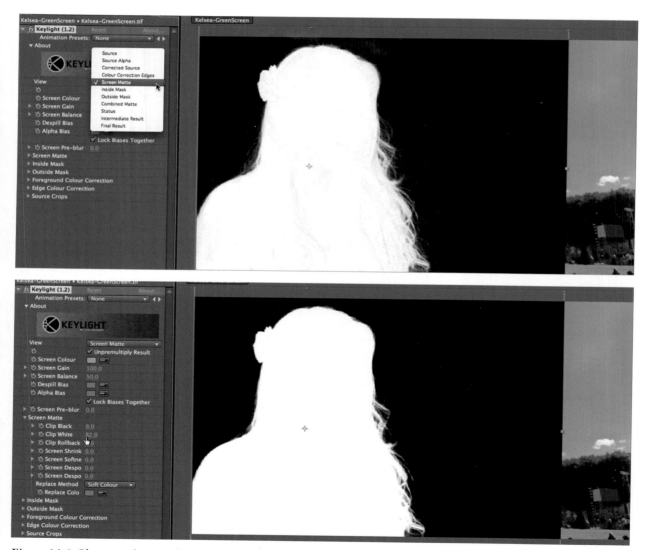

Figure 14.6 *Changing the view from Final Composite to Screen Matte reveals the need for some adjustments to the matte*

In most cases, with good strong lighting and an even, balanced green screen, that's all you need to do. Even zoomed in to 400 percent, as in Figure 14.7, the strands of hair are still visible and don't show any signs of color bleed or spill—nor are they cut off as you often see in poor chroma key work.

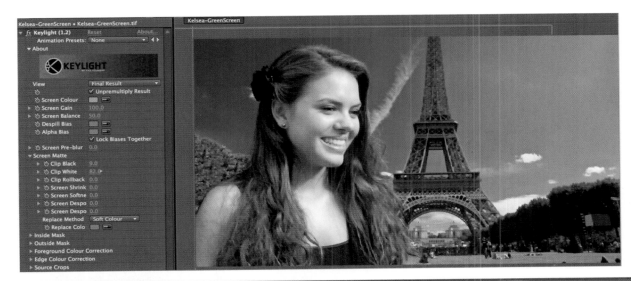

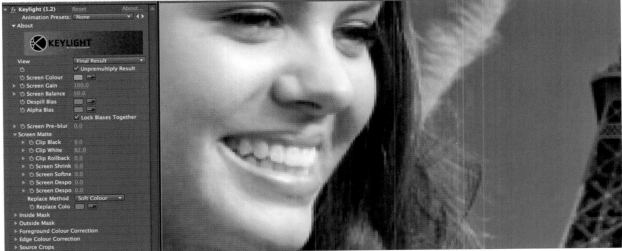

Figure 14.7 *The final composite is clean and detailed—even when zoomed in to 400 percent*

A good example of a more intuitive user interface for compositing is the Primatte keyer plug-in for Photoshop from Digital Anarchy (www.DigitalAnarchy.com/primatte/main.html). You can apply this plug-in to single still images like the example; or, if you convert video footage to a Smart Object layer in Photoshop, you can apply the Primatte effect to the entire video layer.

Start with two layers in Photoshop with the background layer on the bottom, as I did in After Effects in Figure 14.8.

Figure 14.8 *The foreground layer is positioned and scaled above the background layer in Photoshop*

When you launch the Digital Anarchy Primatte plug-in from the Filter menu, it opens in a full-screen user interface. Click the Step 1 Select button, and then choose a portion that represents the green screen. You can see in Figure 14.9 that the plug in tends to be overly aggressive in its initial color selection. This is even more evident when you click over to View Matte mode.

Next, click the Step 2 Clean BG button, and select the area where there is noise in the background (black area). Then, click the Step 3 Clean FG button, and select everything inside the foreground (white) area (see Figure 14.10).

Figure 14.9 *Applying the first click of the color selector in Primatte over-selects the color palette*

Figure 14.10 *Use the Clean BG and Clean FG buttons to select areas of the inside and outside to get a cleaner matte*

It helps to use the Zoom and Pan tools on the right to get a closer look at what's happening in the edge details. Primatte has some tools to help correct spill and bleed; in Figure 14.11, I've used the Spill Sponge and selected only a few pixels of the green hair on the edges. If you select too large an area, the plug-in will work too aggressively and try to colorize too much data, leaving a bad posterization on your image.

Figure 14.11 *Using the Spill Sponge to remove the green cast in the model's hair*

Finally, the composite is complete. In Figure 14.12, the hair detail is retained and looks great even when magnified to 400 percent.

Figure 14.12 *The final composite is clean, with great edge details*

The concept is pretty much the same with all software keyers. Select the background color, and clean up the background (black) and foreground (white) parts of the mask. If your software keyer doesn't allow you to view the process in matte-only mode, then find a different keyer; this is nearly impossible to do if you're previewing entirely in composite mode. Many keyers also have options like Light Wrap and color correction/color matching. We'll get into those in the following chapters.

Of course, you'll encounter various conditions and lighting scenarios, which I'll address much more in the following chapters. This chapter should get you started with the process and set a benchmark for the results you can achieve.

Where to Learn More?

Products used or mentioned in this chapter:

- **Adobe After Effects, Photoshop, and Premiere Pro CC:** creative.adobe.com
- **Apple Final Cut Pro:** www.apple.com/final-cut-pro/
- **Avid:** www.avid.com/products
- **Sony Vegas:** www.sonycreativesoftware.com/vegassoftware
- **Primatte for Photoshop:** www.DigitalAnachrchy.com/primatte/main.html
- **RED cameras and software:** www.red.com/products

Image and footage credits:

- **iStock Photo:** www.istockphoto.com

You can find a complete list of references and suggested continued reading/learning from this chapter in Appendix A.

Color Balancing the Subject and Background

No matter how great the matte *is*
*that you get from your green screen shots, if the colors of the foreground
subjects don't blend well with the background, then it will look like
you've shot those subjects in front of a giant flat-panel video wall. In other
words, it just plain won't look right. Of course, you want to try to nail the
lighting and white balance on your camera before shooting; but often, as a
compositor, those factors are out of your control.*

 *In some cases, you shoot a green screen character to fit in an existing
environment or footage and need to color-match the foreground plate to
the background plate as closely as possible. This is generally achievable by
applying the color adjustments to the foreground footage, using filters and
plug-ins to tweak the colors by sight until they match. Other times, you
may want the colors of the background plate to more closely match the
foreground. Sometimes you adjust both to meet somewhere in the middle.
You can even change the time of day and the seasons with a color adjust-
ment. It depends on the shot and what it must match on either end of your
effects clip. I'll show you a few examples in this chapter, and a professional
colorist will talk about how it's done in big studio productions.*

Refer to Chapters 16 and 19 for more information regarding working with problem shots and complex compositing issues.

Matching Foreground Plate to Background

It's not always possible to perfectly match the color temperature of your lighting on the green screen stage and on your background plate. Postproduction color correction is often required to resolve these differences.

Figure 15.1 shows an example of a very simple composite in which the lighting of the green screen and subject were very close to what I needed in the final composite. In this example, I wanted to retain the warm incandescent lighting of the lounge in the background plate, so I needed to adjust the foreground plate to match the color temperature. As you can see, the subject was lit with a single key light from upper right and a very soft back fill that was close to ambient. The shot had no back light because the actress would be sitting in a dark environment with spot lights above a bar. The first stage of the composite involved matting out the green screen. I used Boris Continuum Complete Chroma Key Studio in Final Cut Pro 7 for this project (www.BorisFX.com). The original studio lighting was close on the actress to work with this shot, but the color temperature of the light on her skin was too cool. The light on the left side of the screen in the background plate was cool and came from outdoors, but it wouldn't be able to reach our actress if she was originally filmed in this setting. Only the lights above the bar would have lit her.

I used RGB Balance because it gave me full control over the ranges of color temperature in all three channels. Adjusting the red and blue channels, I was able to warm up the blacks to better match the background as well as the lighting on the skin tones. The final result was a nice, warm, film-like effect.

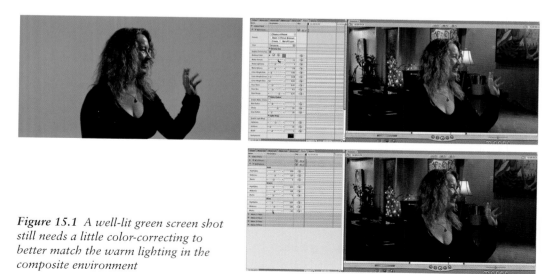

Figure 15.1 A well-lit green screen shot still needs a little color-correcting to better match the warm lighting in the composite environment

This project was shot in HD using a Panasonic HVX300, and the P2 workflow was great for these dark shots. It held the details in both the background plate and the green screen shot. For more information about the professional line of Panasonic cameras, visit `www.panasonic.com/business/provideo/cat_camcorders.asp`

Processing Both Foreground and Background Plates

Many composite projects need both the foreground and background plates color-corrected and processed to give you the final result you're looking for. In the example shown in Figure 15.2, I needed to warm up and soften both the background and foreground plates to match each other and give a more film-like look. The background was shot with a consumer-grade HD camera, so it was a bit high-contrast and harsh,

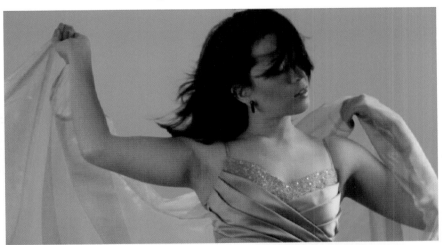

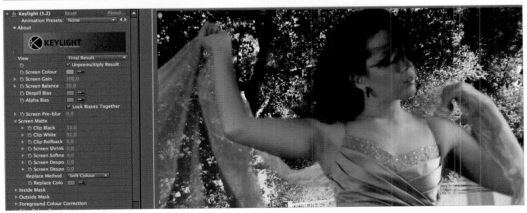

Figure 15.2 *The initial composite looks okay, but the contrast is high and too dark*

whereas the foreground green screen clip was provided by Hollywood Camera Work (www.HollywoodCameraWork.us) as stock footage. I had to match these two pieces of footage somewhere in the middle and make them look like one piece of footage in the end.

In After Effects, I used Keylight to extract the model from the green screen, resulting in a decent matte—but without correction it looked dark in contrast, very much like it was shot on video, and as if it was probably a composite. Such a result may be acceptable, but if you want your footage to have a professional film-like quality that shows well in broadcast or on a computer screen, then you need to color correct.

I first wanted to adjust the background plate until I was happy with it before attempting to match the foreground to it. I applied the Levels filter, brightened the midrange, and warmed up the midrange and darker tones with the red and blue channels. I also wanted to give the background a softer look, as if it were shot with a shallow depth of field and a bit out of focus, so I applied the Lens Blur filter to an Iris Radius of 10 (see Figure 15.3).

Figure 15.3 Adjusting the background plate to be warm and soft, and using Lens Blur to take it slightly out of focus

Now that the background was set, I could match the foreground to it. I applied the Levels filter to the layer and adjusted the over-brightness up in the midrange. Then, I warmed up the hair and skin tones using the sliders in the red and blue channels. The end result was a soft, warm, film-like quality that looks good on any screen (see Figure 15.4).

Figure 15.4 *Adjusting the foreground plate to match the color of the adjusted background creates a warm and soft film-like effect in the composition*

Making Adjustments in the RGB Channels

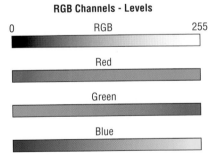

When you make levels adjustments in RGB, you need to consider three major areas. The complete RGB range (including Red, Blue, and Green) has values from 0–255. In all three channels, 0 is the absence of any gamma and creates black. A value of 255 presents the full gamma of each channel and results in white. Any variation of a single channel changes the overall appearance. This includes an adjustment of the RGB channel (all three), which is the range where you control brightness and contrast. If you adjust the red channel alone, then you can slide-add more red; or, you can go the other direction to add more green (or, effectively yellow/orange, if you don't adjust the blue channel as well). To warm up a shot's midrange, you can slide down the mid-red channel slightly and slide up the blue channel toward yellow. Think of it as working with complementary colors on the color wheel.

Changing a Scene's Lighting and Environment

Sometimes you may need to turn day into night and spring into winter with the color palette you use to create your composite scene. Most of the time, your green screen footage is shot in a studio: you have to create the atmospheric effect to match the background or adjust both foreground and background to complement each other.

The example shown in Figure 15.5 uses stock footage from both Hollywood Camera Work and iStock Photo to demonstrate several effects. To sell the composite, I had to get creative with the color correction on the front plate. The original green screen foreground was broadly lit, and the background was a warmly lit night shot with reflective light from several incandescent sources. The initial composite looked terrible and desperately needed color correction to make it remotely believable.

Figure 15.5 *The initial composite between the green screen plate and background doesn't match*

I adjusted the red and blue channels as well as the brightness and contrast of the foreground to simulate the warm lighting from the tree and the candles as the primary room light source (Figure 15.6). You'll see this project in detail in Chapter 18; here I've forced a faux-focus in the track to simulate the lens's zoom.

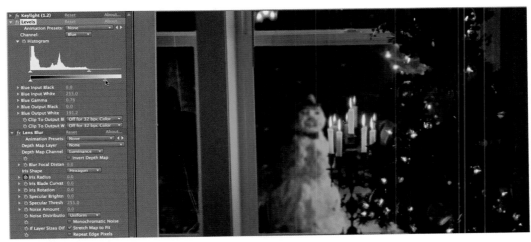

Figure 15.6 *Warming up the colors and bringing down the exposure of the foreground plate sells the composite shot*

Using the same front plate again, I chose a very different background environment for another example: a high-rise metropolitan skyline on a clear day near dusk. By adding snow particles and color-correcting the background first, I was able to simulate a winter snowstorm outside. Unfortunately, the foreground still didn't look like it belonged (Figure 15.7).

Figure 15.7 *Again, the composite elements don't match*

I first made adjustments to the levels to warm up the colors, keeping in mind that the light from outside was cooler and cast some reflective blue in the midtones. But I didn't want it to go pink, either. I gave it a little less contrast than the previous example (see Figure 15.8).

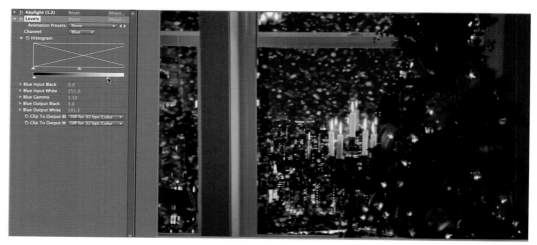

Figure 15.8 Adding some contrast and warming up the colors of the foreground plate

I decided that I didn't want to give the room so much ambient light. So, I duplicated the foreground plate, applied a mask over the left side, where the window's left frame is, and feathered the mask about 100 pixels. I then brought down the brightness of the duplicated layer significantly to give the appearance that the only light in the room was from the candles and the tree. Notice how the deep orange complements the purple-blue of the dark city beyond the window (Figure 15.9).

Figure 15.9 The final composite warms the room against an otherwise cold, harsh metropolitan landscape

Creating a Classic Movie Effect with Lighting Tricks

I originally shot the green screen footage shown in this section with a different background scene in mind. But when I saw the footage, I decided to leave out the other background and foreground elements and re-create a classic film look from the 1950s. And I primarily used Layer Styles in After Effects to give the look I wanted!

I shot the background plate a couple of weeks after shooting the green screen footage. It was a beautiful clear night in Ojai, California, where I live. I had an amazing Panasonic camera just sitting there, so I took it out in the yard and shot the moon through the big, 400-year-old oak tree that looms over our house. The zoom was great on the camera, but I had to choose between having the moon or the tree in focus; I shot two clips, one of each in focus, and composited them together. Obviously, even a pro HD camera can't capture all the stars in the sky, so I added them by painting them on a layer in Photoshop.

Figure 15.10 shows the initial shots and first composite. Notice how clean the green screen matte is, with no green spill even though I had barely any light on the subject. I was aiming for a street-light glow when I originally shot the footage, which is why I changed things for this project. This example also shows that you can shoot a green screen footage clip with a specific lighting setup and use it in many different scenarios.

Figure 15.10 *The initial composite of the green screen plate and the background*

To begin, I applied a Layer Style effect to the foreground layer, chose Inner Shadow, set the color to the deep blue around the moon in the background plate, and changed Blend Mode to Screen. I adjusted the angle of the light source (or shadow) to match the direction of the moonlight in the background (see Figure 15.11).

Figure 15.11 *Adding a Layer Style of Inner Shadow, and changing the shadow to a light effect*

I then added an Outer Glow Layer Style, using the same deep blue color and adding a little noise to keep the glow from having gradient banding artifacts (see Figure 15.12).

Figure 15.12 *Adding a little noise to the Outer Glow Layer Style keeps it from banding around the edges of the subject*

Next, I applied one more Layer Style to this layer, choosing Color Overlay with the lightest pale blue selected from the moon background layer. Adjusting the Opacity of the overlay color and setting the Blend Mode to Color affected only the midrange pixels on the foreground plate, giving an overall bluish cast from the moonlight (Figure 15.13).

Figure 15.13 *A color overlay layer style can colorize the entire layer where applying a plug-in effect cannot*

Now I needed a stronger light glow around the top and right edges of the subject, and I also wanted a soft, movie-like glow all over her. To do this, I duplicated the foreground layer and removed the Layer Styles from the duplicate. I then added a strong Gaussian Blur to the layer and applied an Inner Shadow with the blue again. This time, I increased the size significantly and placed the angle directly in line with the moon in the background, as shown in Figure 15.14. I adjusted the opacity of the duplicated layer to allow for the light but only give a glow effect without overpowering the original layer. The end result was a clip with the subject singing in the moonlight in a classic old-style musical environment.

Figure 15.14 *By creating a duplicate layer with a blurred glow effect over the original subject layer, you can achieve a warm, classic film look*

Real-World Postproduction: *Haven*

I first introduced James Parris and his movie project *Haven* in Chapter 12. He originally shot most of this scene on location but had limited access for only one day. When he had to get a couple of pick-up shots later, he needed to turn to the green screen studio to re-create parts of the scene. This is where planning paid off for him. He took clean background plate shots of the entire original set, just as it was lit and from the same camera angles, in case he had such a need. As a result, it was much easier to re-create shots with the same camera angles, lens, focal distance, lighting, and so on.

In this case, Parris decided to have a slight zoom on the shot, so he placed markers on the green screen wall for tracking in the composite. He also positioned a tennis ball on a stand, off to the side, to help with any match-moving alignment and scale. In Figure 15.15, notice that the tracking done in After Effects used a multinode tracker to capture not only position but also scale. This technique works great as long as the points aren't obscured by an actor's movement and there isn't much motion blur in the shot. When the tracking was complete and applied to the background plate layer, a simple crude mask was drawn around the two actors, creating a garbage matte on the green screen layer; the matte was extracted using Keylight.

Figure 15.15 *The green screen footage is tracked, garbage-matted, and matted with Keylight*

When the composite was complete, the foreground had to be color-matched to the original footage that was shot on location. The lighting technicians did a great job of

matching the correct light sources to the original location. Note that the key light on the woman was brighter and cooler on the left side, where natural window light came in; warmer, incandescent lights were used as fills on the right (see Figure 15.16).

Figure 15.16 *The foreground footage needs to be color-corrected to more closely match the footage that was originally shot on location*

The final composite looked like it was shot on location (see Figure 15.17). When it was edited in with the rest of the scenes, it was impossible to tell from the live footage.

This is a common practice in movie making. A director's decision whether to re-create a scene this way versus going back and shooting on location is easier with today's more powerful computer technology.

Figure 15.17 *The final composite*

Where to Learn More?

Products mentioned in this chapter:

- **Adobe After Effects:** creative.adobe.com
- **Apple Final Cut Pro:** www.apple.com/final-cut-pro/
- **Panasonic HVX300 Pro HD Camcorder:**
 www.panasonic.com/business/provideo/cat_camcorders.asp
- **Boris Continuum Complete:** www.BorisFX.com

Image and footage credits:

- **Hollywood Camera Work:** www.HollywoodCameraWork.us
- **James Parris, Paper Tiger Films:** www.PaperTigerFilms.com
- **iStock Photo:** www.istockphoto.com

You can find a complete list of references and suggested continued reading/learning from this chapter in Appendix A.

Fixing Problem Green Screen Shots

Sometimes things go wrong.

What if you didn't follow instructions in the previous chapters and recorded something poorly lit? What if someone walks off the green background for a few frames? Well, it probably wasn't your fault, was it? You were given that lousy footage and told that you needed to make something from it! Yes, that has happened to me time after time—some hotshot director decided it was sufficient to throw a piece of green material way back in the background. Or perhaps they thought it was fine to let available light from the rest of the set illuminate the green screen. You're now faced with having to composite the result.

The first step in fixing poor shots is to educate the people who are shooting them. Giving them a copy of this book is a great way to pass on the message and ensure that they won't repeat the offense. The next step is to check out the scenarios in this chapter and learn how to best address some common pitfalls. You can also reach me through my blog at www. PixelPainter.com if you can't find a solution for your particular issues.

Common Problems with Poor Shots

The most common problems with poor green screen or blue screen shots result from improper lighting, poor positioning, and the use of backgrounds that are the wrong color. You can avoid all of these issues with proper planning. The preceding chapters addressed

all these concepts, and if you've learned from them and followed their instructions correctly, you probably don't need to read this chapter. Nevertheless, stuff happens—sometimes you get footage from another source that someone else shot, and you're stuck with fixing it.

As mentioned in Chapter 1, the biggest mistake made in production today is rushing through lighting, setup, and shooting—in other words, sloppy camera work (often caused by a sloppy director/producer) and incomplete planning. The misnomer that a shot can always be "fixed in post" has sent some lazy directors back into the studio to reshoot shots that couldn't be salvaged. Don't be afraid to "send your plate back to the kitchen" when the order is just plain wrong. If you're asked to do the impossible with someone's crappy footage (which is rare in this digital age), let them know that you can't polish a turd. But if you can't reject the footage, maybe some of these tips will help.

All the examples in this chapter use Keylight in After Effects, because it has the best compositing tools available for the general public.

Poor Lighting Issues

This has to be the number-one reason for bad green screen shots. As I've outlined in several chapters (primarily in Chapter 9), good lighting is the key to getting a great shot with which to composite. In most cases, the photographer either attempts to light the background but fails to light it evenly, or doesn't scope the shot through the camera and lights it too bright or unevenly.

In some cases, the shot is too washed out because the background wasn't lit independently in the studio and the wrong color backdrop was used. Perhaps the studio used a green cloth that wasn't intended for green screen or tried to cut corners by making a run to the hardware store for a couple gallons of paint. But that's OK, because when they get your bill for dealing with all the compositing hassles, they may not make those mistakes again.

Case Study: Poor Lighting

Figure 16.1 shows an example of a close-up shot for a major commercial I was working on. It has all the elements of a crappy green screen lighting issue. I can't tell exactly what the studio used for a backdrop, but judging from the lighting in most of the shots, it looks like the cheap muslin I tell people to stay away from. They used available ambient light, and there is motion blur on the actress's face and hair—not to mention that the color processing is way off. Even for a preliminary production phase, it's totally flat and overexposed. This is what happens when inexperienced photographers get their hands on a RED camera without understanding the workflow.

I first tried Keylight in After Effects to extract whatever green I could. It got the general area, but when I adjusted the matte it appeared that the footage was too noisy to extract the hair properly (see Figure 16.2). I'm surprised it managed to maintain some of the fine hair without looking like the actress was wearing a hair net.

Figure 16.1 Original frame from the poorly shot green screen

Figure 16.2 The first pass with Keylight reveals noise on the model's hair and face

I then duplicated the original layer and eliminated the Keylight effect from the duped layer. Using the Pen Tool, I drew a mask around the hair where some of the green started to show through and feathered it about 25 pixels (see Figure 16.3). This mask had to be adjusted over time with keyframes. See Chapter 4 for more about this roto technique.

Figure 16.3 *Creating a roto mask to follow the original layer's hair just inside the green spill*

I then selected the keyed layer and adjusted the Screen Balance to allow the colors to blend slightly between the keyed layer and the roto'd layer. I applied a lens blur on the keyed layer to match the original footage motion blur. The result was fairly seamless: without affecting the actress's face and hair, I obtained a usable key (see Figure 16.4).

You must take great care to watch the roto mask as well as the amount of lens blur you apply over the timeline, to match the original footage as close as possible. Remember, in After Effects, anything that can be keyframed can be changed over time.

Figure 16.4 *Using the Lens Blur effect to blend the roto mask layer with the keyed original*

Figure 16.4 (continued)

Shot Too Dark

In some cases, if a shot is underexposed and the screen isn't properly lit in the background, the result is a great deal of visible noise on both the green screen background and the actors, even in HD. The same is true if you use the wrong color green or blue for the background materials. If the shot is too noisy, there's little you can do to fix it without it looking like it's over-processed and filtered. But if the foreground is salvageable, then you can work the green screen background if you can pull a decent key. It may depend on the footage used as the background plate in the composite.

In the example shown in Figure 16.5, I purposely shot the scene dark and left the green screen lights off, with the green screen background illuminated only by the actors' lights in the studio. The actors are about 15 feet from the background in this shot. (Honestly, I've received much, much worse footage from clients, but this is as bad as I could try to make it.)

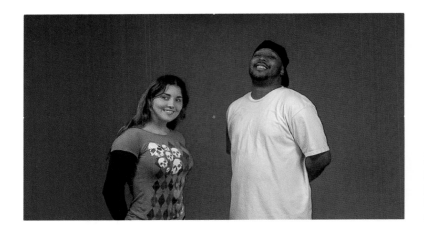

Figure 16.5 *A dark-lit green screen shot can produce a great deal of noise and make compositing difficult*

The first application of Keylight in After Effects produced an extremely noisy and uneven matte. When I tried to adjust the matte clipping to normalize the background and foreground matte and get rid of the noise, I clipped the edges too abruptly and created nasty artifacts around the edges, as shown in Figure 16.6.

Figure 16.6 *Trying to adjust the matte to reduce the noise yields poor results*

The next step was to try to get a decent key around the actress by adjusting the matte settings. It wasn't perfect, but it was enough to work with. Looking at Figure 16.7, it's easy to see that the same settings for the girl won't work on the guy in this shot. He has a dark ridge around his right side and needs to be processed separately, not to mention the noise in the background.

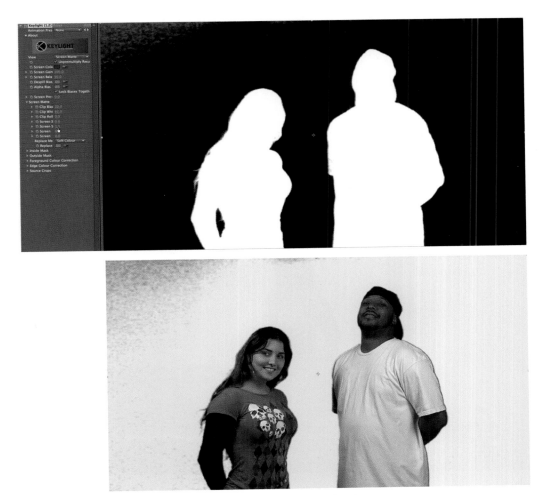

Figure 16.7 The Keylight matte has been adjusted enough for the actress

I duplicated the original layer and drew a roto mask around the girl in the early frames of the clip, using keyframes down the timeline to track her movement. This allowed me to create a garbage matte to reduce the background noise, at the same time isolating the girl on her own layer (see Figure 16.8).

Figure 16.8 *Using a roto mask around each actor in a scene and isolating them on their own layer*

I then masked the duplicated layer around the guy in the clip and keyframed the roto mask along the timeline to track his movement. After he was isolated, I adjusted the Keylight for him separately and removed the bad edges (see Figure 16.9). In this case, the screen shrinkage adjustment setting in Keylight was all that was needed to remove a pixel of hard edge around him.

Figure 16.9 *Creating a roto mask for the second actor, and applying the Keylight adjustments for his layer separately*

The end result looks pretty good, even though the scene wasn't lit properly for the intended background plate (see Figure 16.10). Again, this is where proper planning and setup could have made a simple keying job a matter of a couple clicks and letting it run.

Fixing Mistakes

Some shots have spill on them; it's inevitable. How do you fix this issue without the subject looking green or fading into the background? A combination of masks, mattes, and layers will get you out of most such problems.

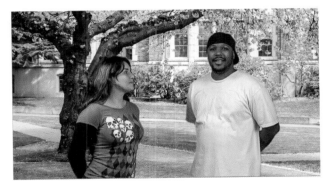

Figure 16.10 *The final composite is acceptable, and the shot is saved*

Correcting Difficult Spill

Many software keying plug-ins have some kind of spill suppression that you can adjust when you're keying your subject. This alone is usually enough to knock out any spill you may have on your subject; but sometimes it doesn't, or the process is too complicated to figure out and get a decent composite. Again, you have to use layers and masks, as well as a few tricks, to get an acceptable result.

The example in Figure 16.11 shows some footage shot with a blue LED LiteRing Reflecmedia system. There is some blue spill on the model's hair and sweater, caused by

her proximity to the background screen. The footage was also shot in standard definition PAL and has interlacing in the individual frames. This can cause other issues because you can't ramp up the matte controls as far as you might with DV, so you get more problems in the background when you adjust the matte.

Figure 16.11 *This shot has a blue screen spill as well as video interlacing, making the matte difficult*

I first had to create a roto mask around the model and track along the timeline to be sure it followed her shape, as shown in Figure 16.12. This was important because I needed to duplicate this layer and didn't want to redraw the mask on every layer.

Figure 16.12 *Creating a roto mask for the model and tracking it along the timeline*

I then hid the background plate so I could focus on the layers I was working on. I adjusted the Levels in the red and blue channels to warm up the model's hair and sweater considerably. I then applied a Hue/Saturation effect and pulled down the saturation so she didn't glow (see Figure 16.13).

Figure 16.13 Adjusting the color levels and saturation to the model's layer

Duplicating the layer and hiding the original, I deleted the Levels and Hue/Saturation effects and adjusted the Screen Shrinkage to –10 and the Screen Softness to 5.0. This acted as an overlay of the model's base coloring facing the camera, no matter how she moved in the frame (see Figure 16.14).

Figure 16.14 Duplicating the model's layer and contracting a new top layer to produce the forward-most correct color

Next, I made the background plate visible again to check the color balance. The hair particularly still had a grayish-blue tint in places. I duplicated the original model's layer and removed the mask and the Levels effect, while selecting Reset on the Hue/Saturation effect. I drew a new mask around only her head, selected the Colorize feature in the Hue/Saturation panel, and adjusted the Hue setting until the color of her hair on this layer matched the hair on the layer below (see Figure 16.15).

*Figure 16.15 Creating a new
layer and mask, and colorizing
them to match the hair color
of the bottom layer*

I turned on all the layers, and the finished composite looked great (see Figure 16.16).
This isn't a technique I suggest if you have a very long clip, because the process is time-
consuming, but it does solve several issues at the same time.

Figure 16.16 The finished composite looks seamless

Fixing Transparency Issues

Sometimes the shot is lit correctly and everything is in order, but you have an issue with transparency or reflectivity that puts holes through your subject. Transparent items can disappear against the green screen.

If you're faced with shooting something transparent, it's best to try to get as much side and top light around it as you can, so the edges light up wherever possible. Not only the distortions through the object but primarily the reflected light highlights give it shape and dimension.

For the example shown in Figure 16.17, a transparent Lucite award was shot on a green platform at an angle appropriate for a desk it would eventually sit on. The engraving in the Lucite was lit with direct light from above and to the sides, and the bevels helped diffuse the light around the edges. In the figure, notice the slight darkening of the green background looking through the award. This appears in the Keylight matte as slight noise, but this time I wanted to keep it intact to add substance to the object.

Figure 16.17 *The award shows reflection and diffraction in its surfaces*

I drew a roto mask around the base of the award and its shadow because I couldn't adjust the Keylight matte too much without losing the details in the Lucite. Because the background image has a shallow depth of field, causing the chair and surfaces in the background to be blurry, the translucent award stands out and looks like it's on the desk (see Figure 16.18).

Figure 16.18 *The finished composite looks believable*

Fixing Reflectivity Issues

When your subjects are wearing something shiny or using a reflective prop, it can pick up the green screen around it—and suddenly you've got holes in your matte. You can try to mask out the area and not let the keying software matte it, but then it will show up green.

The solution is to create a patch for the hole that's created and fill it with a color or texture that is suitable for the object's surface. In the example shown in Figure 16.19, the character is trying to show a metallic electronic audio device; but it's reflecting the green off the side of the stage, creating a hole in the matte.

Figure 16.19 *The reflection in the metallic device creates a hole in the matte*

I created a new white solid layer and drew a mask that was larger than the hole I needed to fill. You can roto mask this layer to keep it aligned with the box as it's visible on-screen; or, if it's a longer clip, you can motion track it to keep its position with the footage. I moved this layer below the subject's layer and turned on the background to test it. After some fine-tuning on the matte in Keylight, the scene worked great (see Figure 16.20).

Figure 16.20 *Creating a new white solid layer, and using a mask that is larger than the hole*

Where to Learn More?

Products used or mentioned in this chapter:

- **Adobe After Effects:** creative.adobe.com
- **Reflecmedia LiteRing:** www.reflecmedia.com
- **RED Cameras** www.red.com/cameras/

Image and footage credits:

- **VirtualSetWorks.com:** www.VirtualSetWorks.com
- **iStockphoto:** www.iStockphoto.com

You can find a complete list of references and suggested continued reading/learning from this chapter in Appendix A.

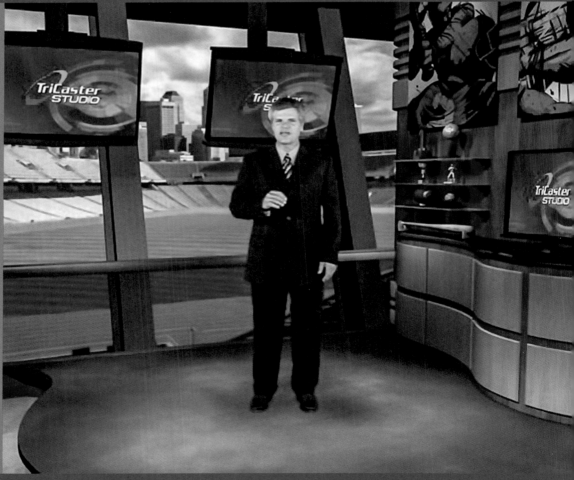

Working with Virtual Sets

Virtual sets are digitally created *scenes* *into which you can composite matted subjects. In most cases, they're computer-generated 3D studios, such as you see on the evening news and special programming on* CNN, Fox News, 60 Minutes *and* COSMOS: A Spacetime Odyssey *or in the many various sports programs. In most cases, you may not even know you're viewing a virtual set behind the on-screen talent.*

With the advancements in technology in the past decade, virtual sets are commonplace in the commercial television and corporate video production landscape. With more realism than ever before, including live-motion control camera rigs and advanced hardware compositors, it's often difficult to distinguish between a sophisticated studio set and a virtual set.

In this chapter, I'll cover some examples of how virtual sets can be used on any budget, starting with static rendered scenes. I'll also explain how big productions are done with a studio setup for live broadcast television.

What Is a Virtual Set?

A virtual set is an environment that is artificially created to composite matted subjects into. In most cases, this is a computer-generated 3D "studio" that is rendered: newscasters, reporters, and actors are shot on a green or blue screen stage with a real video camera and composited into the virtual set using the same angle and focal length as the 3D camera.

In some situations, the virtual set is an expansive high-resolution rendered image that allows the compositor to pan and zoom to match the live-action camera to create the composite. This is how Adobe Ultra works: automated pans and zooms are built into the software. Other, more sophisticated systems use motion-control camera rigs that feed data through a processor that in turn "moves" a virtual 3D camera to match the movements on the virtual set stage. This is done in many high-end sports, news, and talk show programs on television.

In addition to computer-generated sets, a virtual set can consist of any video or still-image background that acts as a remote set for video green screen, giving the illusion that the subject is somewhere else. This is often done for news interviews in remote locations where the network wants to give the illusion that a correspondent is, for example, seated in front of a window overlooking the U.S. Capitol or perhaps in a city under siege in a war-torn country where it would be unsafe to actually shoot on location.

In the everyday corporate world, technology is rapidly advancing to include interactive real-time video conferencing with virtual whiteboards that can place the presenter into any environment or background. Recently iMatte (a division of Ultimatte) has introduced SightDeck, an interactive projection, matting and streaming system that places the presenter (or multiple presenters at different locations) on the screen with full interactivity with the screen content and the viewing audience will assume they're all in the same room against a giant-screen video wall.

Virtual sets can also be constructed in the early storyboarding and development phases, otherwise referred to as pre-viz or previsualization. A virtual set can serve as a model from which a real set can be constructed after a project is approved and budgeted for. For more information on working with virtual sets and motion control, see Chapters 12, 13, and 18.

Using a Basic 3D Virtual Set

Several designers and suppliers have prerendered virtual sets available online these days, and many offer free download samples. One such provider is VirtualSetWorks.com (www.virtualsetworks.com). These sets are affordable and come with several camera angles with alpha channels to extract objects such as furniture and railings that your subjects can sit on, stand on, or walk behind. Figure 17.1 shows a complete virtual set background image with predefined alpha channels that can easily extract the video monitors on the wall as well as the reception desk in the foreground in Photoshop.

You'll need to use these background images as guides when you shoot the green screen footage to be sure your subjects are aligned properly by camera angle, scale, and position. You can either print out a frame of your virtual set background and make adjustments to the camera while viewing the studio monitor, or import the image into Final Cut Pro and do a test composite while the green screen stage is set up to check for alignment. To see more of the project shown in Figure 17.2, refer to Chapter 13.

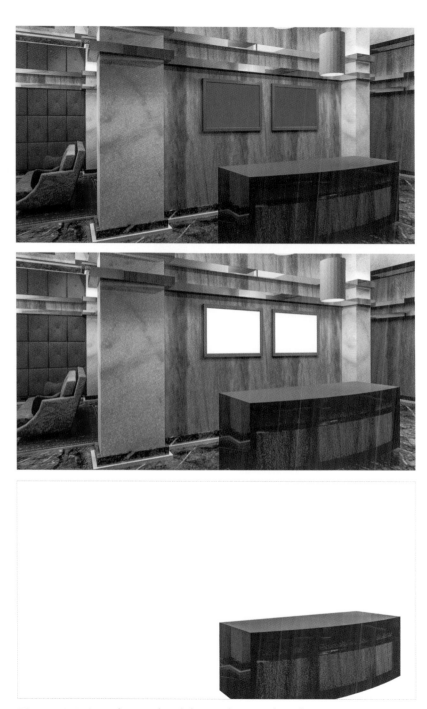

Figure 17.1 A single-view breakdown of a virtual set frame

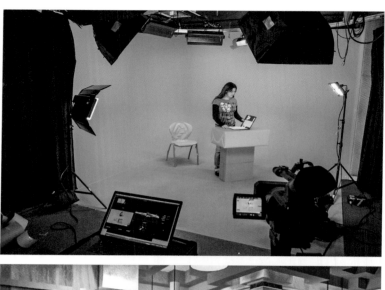

Figure 17.2 *Use the rendered virtual set frame to position your camera on the green screen stage to properly align the subjects*

Some virtual sets are rendered as video loops instead of static images, such as the example from iStockphoto.com shown in Figure 17.3. The file is a computer-generated animation with effects and rotating lights to add fun and excitement to the set. The person and the text on the screen are composited in. You can find numerous sources for animated virtual sets and backgrounds online.

Figure 17.3 An animated virtual stage being used to produce a show

Creating or Modifying Your Own 3D Virtual Set

If you have a desktop 3D software application in your tool set, then you have everything you need to build your own 3D virtual set—or at least the ability to modify an existing set if you can get the raw data files to work with and they're compatible with your software.

I was able to obtain some very well-constructed and realistic scenes to use as sets from Jonny Kim at PhotonCraft (www.photoncraft.com). These are available to download and edit as you need, including changing or animating cameras to suit your foreground footage. I was able to use one of these scenes in Strata 3D (www.strata.com) and change camera angles to suit my needs. Notice in Figure 17.4 that the geometry of the models appears simple when viewed in the wireframe mode, but when the scene is rendered, you can see all the details of the textures, lighting, and reflections. This virtual set could be used for several interior and exterior scenes, depending on where you positioned the camera in the software.

In Strata 3D, I adjusted the camera angle to closely match the angle of the green screen footage clips I had, as shown in the example sequence in Figure 17.5. In this case, I was only able to visually match up the camera focal length, distance, and height, but the results were still pretty close. Rendering quick wireframe views, I could match the clips in Photoshop and make adjustments as necessary before creating a high-resolution detailed render.

Figure 17.4 *Changing the camera angles in Strata Studio Pro to preview the wireframe models and rendered frames*

Figure 17.5 *Changing a camera angle in Strata Studio Pro to match the angles of the green screen subject clips*

Figure 17.5 *(continued)*

Figure 17.5 (continued)

I masked a layer in the composite of just the foreground furniture that would be in front of the actors and lined everything up against the wireframe rendered layer to ensure that I had good alignment between the layers. Because the model has a blue background for the default, I keyed out the blue to put in my own background environment. Alternatively, you can put the background planes in your 3D scene and let the natural reflections and ambient lighting be rendered right into the finished scene.

Virtual Sets in Real Time

Using motion-control camera rigs along with sophisticated hardware, many television productions today utilize virtual sets for news programs, sports, talk shows, and infomercials. High-end 3D sets are created and animated with design textures, lighting, and cameras that can be controlled virtually from the data of the live cameras on the green screen set where the actors are positioned. Some systems are integrated with several cameras, and it's nearly impossible to tell the show isn't shot on an elaborate and lavish sound stage.

In the example in Figure 17.6, the actor is shot on a green screen stage with a motion-control camera feeding data to the computer and syncing the 3D cameras of the virtual set with the live camera. The composite is generated live using an Ultimatte compositor, and the virtual set is rendered on the fly. Everywhere the live camera goes, the background set follows seamlessly in 3D space.

Figure 17.6 *An example of a simple live-camera move composited with a 3D virtual set*

This technology didn't exist a few years ago, because the 3D software and hardware processing power needed to render in real time couldn't keep up with the demands of the live-camera data feed.

Some news networks, such as Global Television in Canada, have the local news anchor sitting at a real desk in a 180° green screen room. Motion-control cameras are programmed to produce certain repeatable pans, zooms, and moves matched with the virtual set, which maintains corporate branding through the country. Global uses the Ultimatte system to create the live composite. The cameras are unmanned and robotically motion-controlled to match the prerendered 3D virtual set backgrounds with the live news anchors. You can find examples of such setups on the web site for Full Mental Jacket, the company that produced the virtual set for Global Television: www.fullmentaljacket.com/projects/global-local/

A great example of this process was shown live at the 2009 National Association of Broadcasters (NAB) show in the Ultimatte booth. The company had a 180° blue screen set up, with a woman sitting at a glass desk, lots of detail, reflections, and so on. Using a motion-control rig, they shot live video of the set, sent data from the cameras to the computer with the virtual set from Full Mental Jacket, composited the live scene, and displayed the results on high-definition monitors around the booth.

Tradeshow attendee Jared Hanson shot the image of the booth shown in Figure 17.7: it shows both the blue screen with the subjects and the screens outside with the composited result.

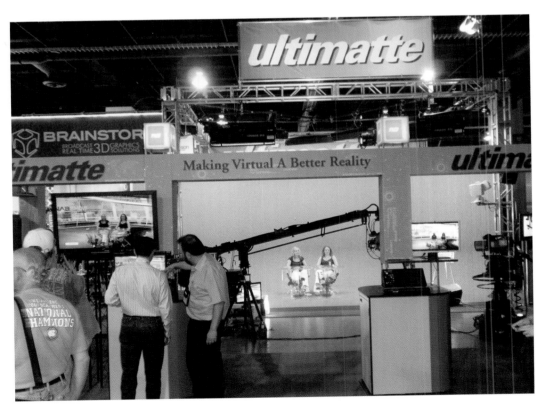

Figure 17.7 Ultimatte's booth at NAB 2009

The series of images in Figure 17.8 shows the blue screen model as shot through the lens of the camera and the composite matte generated by Ultimatte with the final result rendered live.

Another great system for incorporating live green screen footage with a 3D virtual set is the NewTek TriCaster system (www.newtek.com). This is a complete production system that combines hardware and software to deliver multicamera switching, compositing, character generation, a motion graphics generator, and LiveSet integration. The LiveSet technology allows you to use NewTek's virtual set designs in a live broadcast.

The software interface is an intuitive broadcast-switcher design packed with features that give smaller production studios the same power and benefits that usually only larger hardware solutions can provide (see Figure 17.9).

Figure 17.8 Using the Ultimatte compositor with a live virtual set at the NAB Show

Figure 17.8 (continued)

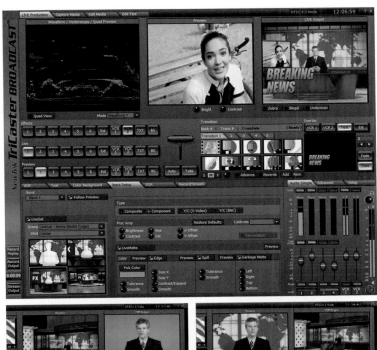

Figure 17.9 *The interface of the NewTek TriCaster STUDIO is intuitive and feature-packed*

The LiveSet technology TriCaster STUDIO lets you select several cameras positioned around your green screen subject and align the virtual set to switch from camera to camera. As shown in Figure 17.10, TriCaster STUDIO can place live, simulated shadows and reflections onto desk and background surfaces from the matted live video feed, providing a realistic composite.

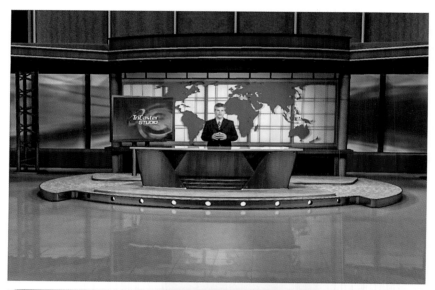

Figure 17.10 *TriCaster STUDIO can create realistic virtual set composites with the LiveSet technology*

Another amazing technological breakthrough is the iMatte SightDeck system (www.imatte.com), developed by their parent company Ultimatte. I was fortunate enough to see the early testing stages of this technology in Paul Vlahos' office before it went public and I'm still impressed at how it works{. . .}and it doesn't use a green screen!

The presenter/actor/talent stands in front of a special wall that looks like a normal white screen, and using a special projector/camera combo at the back of the room, the computer/video content is projected onto the wall, but the system sees/detects the outline of the talent in front of the wall and extracts a matte around them, so the screen appears to be a rear-projection wall when viewed in front of a live audience. Additional systems and locations can be connected allowing multiple presenters from other locations around the world to share the screen time and take control of the content on the interactive wall behind them. The viewers watching this video stream online see the perfectly composited collection of the various talent, plus the digital content directly, so it's clear—not just a video of a projected screen on the wall.

In the examples in Figure 17.11 we see Paul doing a live demo, showing the composited image and a photo of his live presentation. We also see some examples of various presenters/talent using the system from different locations, though they appear to be in front of the screen in the same location. The software also has the ability to set layer control to make graphic objects appear to be in front of the talent as well.

While this product is aimed at big corporate business and government/technology I can see it expanding eventually to broadcast TV streams and scaled down for more common uses in the not too distant future.

Figure 17.11 Inventor and developer Paul Vlahos shows how the iMatte SightDeck system allows multiple presenters to collaborate on one streaming screen to their audience over a network

Figure 17.11 (continued)

A Nonvirtual Set for CG Animation

I ran across the amazing production shown in Figure 17.12 while researching a filmmaker who is creating a miniature set into which to composite CG characters after shooting the scenic plates. Sunit Parekh-Gaihede and his group of amazingly gifted artisans at Hydralab are creating a film short called *Machine* that uses CG characters composited onto stop-motion footage of a miniature set. They're building intricate miniature models in a city block scene and filming in detailed interior rooms. What makes this project unique, besides the incredible detailed miniature work, is that it's all shot in stop-motion with a digital SLR and long exposures with a tight iris to get a forced shallow depth of field. The camera is mounted on a homemade motion-control rig made from Lego on rails. The background is shot against blue screen and composited with the CG characters after all the scenes are shot in stop motion. For more about this project, see Chapter 7.

Throughout film history, many special visual effects were originally done with clever camera positioning, matte paintings, and, of course, miniatures. We've all seen the miniature sets used for early productions such as Ray Harryhausen's *Jason and the Argonauts* and the *Sinbad* movies. Much of the stop-motion VFX were predecessors of today's CG characters and virtual environments. Many of the disaster films from the 1970s, like *Earthquake* and *The Poseidon Adventure,* were done with miniatures shot at higher film speeds and then slowed down to simulate, for example, the mass of moving water.

Today, such effects are primarily done digitally, so it's refreshing to see such painstaking detail go into a project like *Machine*.

To see more examples of filmakers using virtual sets and background plates, see the projects listed in Chapters 7, 8 and 12.

Figure 17.12 A unique approach to creating a nonvirtual set for virtual characters is shot in miniature stop-motion

Figure 17.12 (continued)

Where to Learn More?

Products used or mentioned in this chapter:

- **iMatte SightDeck:** www.imatte.com
- **VirtualSetWorks.com:** www.VirtualSetWorks.com
- **Full Mental Jacket:** www.fullmentaljacket.com
- **PhotonCraft:** www.photoncraft.com
- **NewTek TriCaster:** www.newtek.com

Image and footage credits:

- **Machine short film (production):** www.blog.machinefilm.com
- **iStockphoto:** www.iStockphoto.com

You can find a complete list of references and suggested continued reading/learning from this chapter in Appendix A.

Motion Tracking and Matchmoving

Many times, you'll need to *incorporate*

your green screen subjects into an environment that is moving—either
because of handheld camera shake or a panning/zooming camera shot;
or if the environment was professionally shot in a studio, you may have
to composite a dolly, jib, or crane shot as well. Obviously, unless you're
prepared to motion track your composite, it's best to avoid this if possible
when you're planning your shots. But with modern tracking software such
as Adobe After Effects and Mocha, you can accommodate these moves

and, in some cases, add to the believability of the composited plates.
Today, advanced hardware and software technology, motion-control rigs,
software matchmoving, and tracking capabilities can accommodate almost
any kind of shot imaginable. Of course, if you're compositing under these
conditions, then you'd better plan ahead, or the result may not be what
you expect.

 In this chapter, I'll show you some examples of the hardware used for
various motion-control techniques. I'll also give you some tips for software
trackers, plus a few secrets for "faking it" visually. You may also want

to simulate camera moves after the fact, which you can learn about in
Chapter 19.

Motion-Control Hardware

The main reason to use a motion-control rig is that your shot requires multiple passes that have to line up exactly with each pass of the camera. You won't always need a computer-controlled piece of hardware to get the results you require.

The reasons for needing a motion-control rig vary as much as the rigs themselves. For instance, you may need a motion-control rig with recordable data if a background is shot with a particular camera move and the green screen foreground and subjects need to be shot in the studio under the same conditions and match the motion of the camera and lens. Often, the camera data is recorded and then inputted into a "software camera" in a 3D application such as Maya or 3ds Max (or, more commonly, a large studio has its own custom software) in which the recorded green screen footage is composited into a 3D virtual environment. And unless you're a big studio with a big budget for a project, chances are you'll have a harder time trying to obtain a complicated hardware rig.

Motion-control rigs are also used in stop-motion photography, where the action is changed slightly between the frames shot. Often the camera is also moved slightly on each frame to create a pan, zoom, or dollying effect once it is set into motion.

Live-action control rigs used in television stations and studios can capture the green screen live through the camera, match the hardware composite through an Ultimatte hardware compositor, and match a 3D virtual studio in live composite. The virtual set is prerendered, and the computer predetermines the tracking of the camera so it only accesses the available moves that were created and doesn't move outside those boundaries. You can learn more about working with virtual sets in Chapter 17.

If you're only looking for a smooth-moving trackable footage clip, then often a simple dolly track or jib/boom operation is all you'll need—provided you've properly placed markers in your shot to track with software in postproduction. Also, the wise use of wide-angle lenses can enhance the sense of motion—as long as you can match the barrel distortion correctly in your compositing software, or you're shooting both the foreground and background plates with the exact same camera and motion control rig. You can learn more about cameras and lenses in Chapter 11.

Camera Rig Options

Various companies manufacture motion-control camera rigs; most are very expensive to rent and operate, let alone own. I've seen a few techno-geeks develop their own homemade rigs with varied results. Some simulate the functionality of an automotive factory robot, whereas others are made from Legos with a rolling chassis on a small track. There are some working solutions available for rent as well as some creative DIY rigs that can get the job done.

As shown by the artists at Hydralab (blog.machinefilm.com/?tag=motion-control) in Figure 18.1, sometimes developing a simple homemade solution that is customized for your particular project or shot is the best way to go. They developed a couple of variations on a rig built on rails with Lego bricks and components. The stability was very acceptable for their stop-motion short film project, *Machine*. You can learn more about this project in Chapter 7.

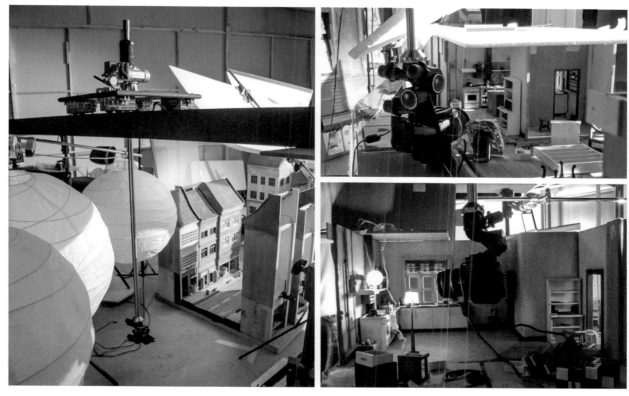

Figure 18.1 *A custom homemade camera rig made with Lego—and a lot of ingenuity!*

A motion-control camera rig basically has four components:

- The mechanical structure or rig that supports the camera and motor system—usually either a freestanding turret with an arm or a rig that rides on a track.
- The motorized drives that move the robotic arms and the rig along the track rails.
- The computer-controlled system for the rig's drive motors.
- The computer-controlled system to handle the camera's zoom, focus, and shutter controls.

At the high end of the scale, you may have a heavy, complicated system that allows for complete control of the camera on all axis rotations, such as the Cyclops or Milo control rigs from Mark Roberts Motion Control (MRMC, www.mrmoco.com). These units are designed for major motion-picture productions and can cost hundreds of thousands of dollars to rent. They offer 13 axes of control and have a long range of extension and movement, with the ability to handle large, heavy camera gear. MRMC also has smaller units available to rent or purchase if you need only a few axes of movement.

As shown in the series of images in Figure 18.2, their versatility and wide range of motion makes the MRMC motion control rigs the first choice in big-budget commercial and motion-picture productions.

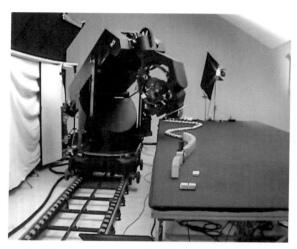

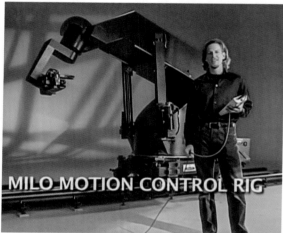

Figure 18.2 The MRMC Cyclops and Milo are high-end motion-control rigs for the film industry

Figure 18.2 *(continued)*

Figure 18.2 *(continued)*

Figure 18.2 (continued)

Some more portable (and affordable) options are the automated boom motion-control systems from General Lift (www.general-lift.com). This is an option that Hollywood filmmakers have been using for some time, and it's available for sale or rent as well. General Lift offers packages that include the ArriHead with digital encoders for precise CGI tracking. Shown in Figure 18.3 is the portable and popular GenuFlex Mk III system.

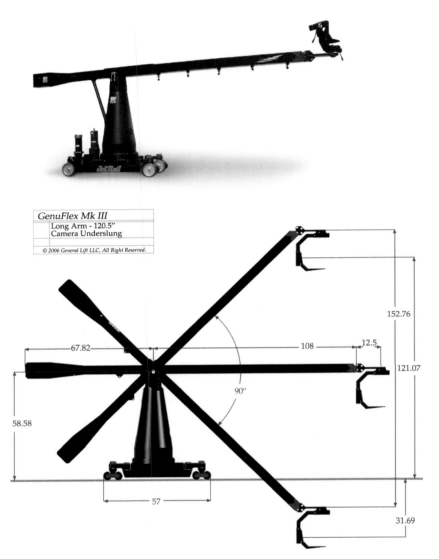

Figure 18.3 General Lift motion-control systems also offer complete packages with digital encoding for CGI tracking

The German engineered CMOCOS system (www.cmocos.com) is unique not only in its somewhat organic design structure but also in the ways you can input and record data. A traditionally trained jib camera operator can use familiar manual controls to move the camera as the data is recorded to reproduce precise axes and motion. The output data can be imported into CGI software for tracking, compositing, and 3D environments. Figure 18.4 shows one of the early prototypes.

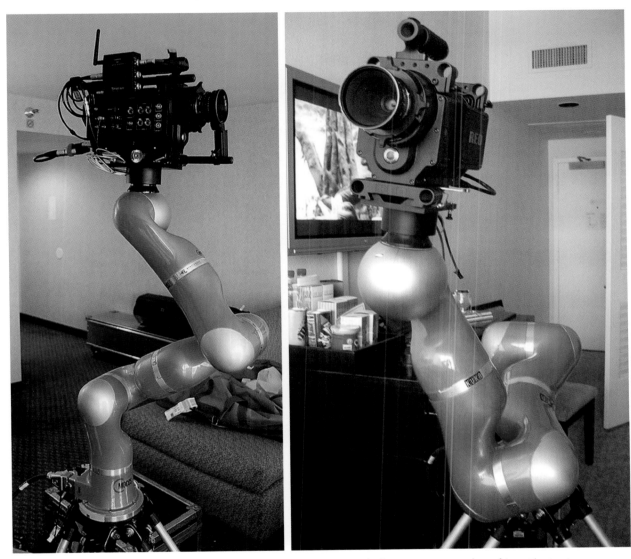

Figure 18.4 *The CMOCOS tracker with the RED ONE camera includes camera controls and input/export of tracking data*

There are a few other jib/dolly combinations for recording and motion control for smaller/lighter cameras. The Techno-Jib by Telescopic LLC (`www.telescopicjib.com`) offers simple movement and ease of operation by a single operator with memory-controlled input. Figure 18.5 shows the ease of use and ultra portability features of the Techno-Jib.

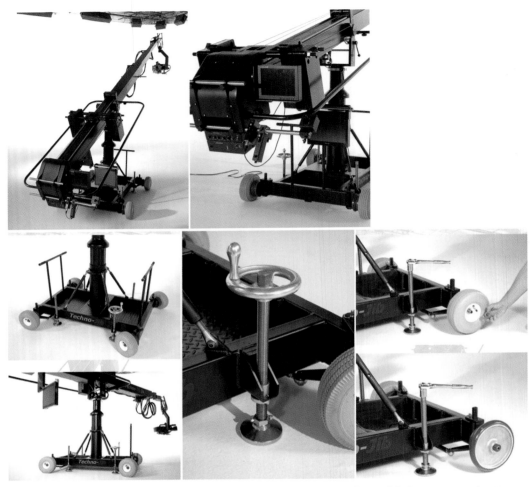

Figure 18.5 *Techno-Jib motion-control units are designed for smaller and lighter HD production cameras*

The more advanced TechnoDolly (www.technodolly.com) was designed for use with motion-control data export for virtual studios in TV stations and live green screen studios (see Figure 18.6). The jib arm can be configured on a rolling dolly or a track or can be suspended on rails in a studio.

There are many new emerging technologies for pan/tilt and motion control on a budget, such as the OConnor 120EX and 120EXe (www.ocon.com). Encoding fluid heads record and control pan and tilt from manual input or data alone. Although somewhat limited in comparison to multiple axes systems, this product is valuable for use in 3D virtual sets and tracking environments.

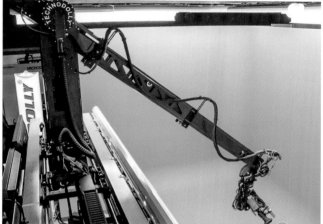

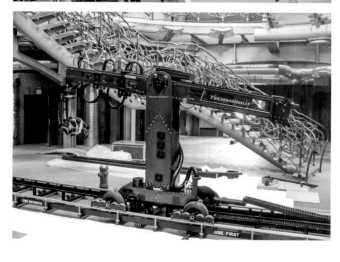

Figure 18.6 *TechnoDolly motion-control units are designed for moderate-sized productions*

Many indie filmmakers resort to designing their own rigging to suit their needs (and budget). Examples of this are available in DIY blogs all over, including Dan Thompson's *The Long Way Home* (www.danthompsonsblog.blogspot.com/2009/04/diy-motion-control-rig.html), where he outlines the process of designing his own MOCO rig on a budget.

Motion Tracking and Matchmoving Techniques

So many great examples of tracking and matchmoving are available, including books and training videos on the subject, that I'll only touch on a few examples in this chapter as they pertain to green screen. I've primarily used Adobe After Effects with Mocha for AE to do most of the tracking in these examples. Matchmoving involves a combination of math, geometry, and a good eye. Sometimes the best trackers still need a little nudge with some manual controls, and nothing beats the human eye to tweak something until it just looks right.

Matchmoving is a process that involves using computer software to track and match virtual elements or backgrounds to live footage. Tracking and virtual sets are covered in greater depth in Chapters 10, 13, 17, and 18. I also highly recommend a book from a colleague and author, Tim Dobbert, titled *Matchmoving Advanced Production Techniques*, especially if you're doing a lot of 3D CG modeling and compositing.

As Hollywood Camera Work shows on their website (www.hollywoodcamerawork.us/greenscreenplates.html), they've used a series of odd-shaped tracking marks on the green screen walls and floor of the studio in Figure 18.7 to capture the original footage of a girl walking and sitting down in a chair. The trick in this shot is that they're moving the camera on a dolly track toward her and panning the camera to point directly at her while it's in motion. Trackers in 3D software such as Maya can follow these points and position a virtual camera in your 3D scene to match this motion, creating a virtual set to match. You can download this footage from the Hollywood Camera Work URL and experiment with the software you're familiar with.

Figure 18.7 *The green screen walls and floor are marked with tape markers to track during the dolly-in move from the camera*

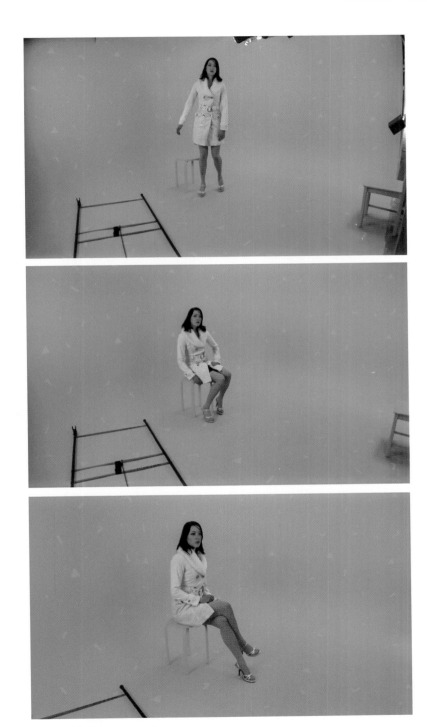

Figure 18.7 *(continued)*

Simple Panning Motion Track

I wanted to create a crowd effect by placing multiple clips of a single woman on green screen in this project (www.hollywoodcamerawork.us/greenscreenplates.html) and using a panned piece of footage I shot at our city park's fountain. Using a single source point in the background video footage in After Effects, I was able to track the group of women in a 60° pan sweep. There is a little float where their feet touch the ground, which could be corrected with some fine tuning in After Effects on the layer positioning. This is a great way to create crowds in your scenes—especially if you use a variety of individuals and group them into small groups with varying wardrobes and positions. (This particular project looks like a creepy clone experiment!)

I started by building a composition of about 14 separate clips of the woman on green screen and applying Keylight to extract them, as shown in Figure 18.8. I adjusted the scale and position to create a wide panorama for tracking over the panning background.

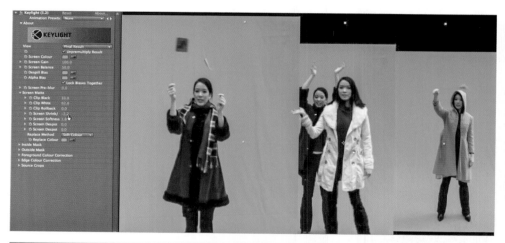

Figure 18.8 Several individual clips are scaled, positioned, and keyed to create the panorama overlay

I created a master composition and placed the background panned footage on a layer below the group comp. Using the built-in Motion Tracker in After Effects, I selected a contrasting sharp spot in the footage that stayed constant through the length of the camera pan, as shown in Figure 18.9. I then chose Analyze Footage and applied it to the group comp layer to generate the appropriate tracking. I repositioned it where I wanted it by adjusting the Anchor Point positioning, which doesn't affect any of the layer positioning keyframes created by the motion tracker.

Figure 18.9 Using the built-in motion tracking in After Effects applied to the group comp layer

Figure 18.9 (continued)

I then duplicated the tracked group layer, adjusted the scale down slightly, and repositioned it behind the original group comp layer. This created the illusion of yet more women in the group. I did this twice and offset to opposite sides of the frame so there was no visible repetition in the women's motion. You can also offset the individual layers by a few frames, which enhances the effect of random movement.

I also duplicated a single group comp layer, applied a Color Overlay layer style in 100 percent black, and applied a Gaussian Blur on the layer to soften the edges. This layer was set to the bottom of the layer stack in the Timeline panel, just above the panned video layer. I then applied the Transform effect, adjusted the Skew Axis and amount to match the direction of the shadows in the original footage, and reduced the Opacity of the layer to about 25 percent to blend in better, as shown in Figure 18.10. Properly created and placed shadows always help sell a composition.

As you can see in the finished video in the Chapter 18 media folder, a slight movement of the group comp layer during the tracking creates the illusion of the women floating or sliding across the surface. It would require some manual matchmoving repositioning at keyframes to keep them planted firmly on the ground from this point (Figure 18.11).

Figure *18.10 Multiplying the number of group layers adds to your crowd scene—and shadows help bring it all together*

Figure 18.11 The final project reveals some sliding motion of the group's feet during the pan

Handheld Motion Track with Green Screen

I use the After Effects built-in tracker a lot to do simple motion tracking. I also like to keep my tracking markers simple when I'm confident they'll be easy to mask out and not interfere with my foreground subject. I'll use black gaffer tape lightly placed in positions around my subject so they'll be easy to track in After Effects.

In this example I wanted to create a simple handheld camera composite with my model in a night scene on a city street. I placed a few black markers around her on the green screen background and picked up a camcorder to shoot the handheld footage.

The black markers are easy to track and are also masked out with a garbage matte before creating my composite. The tracking data controls the movement of the background video layer and the result is a very believable composite.

I originally shot the green screen plate shown in Figure 18.13 with a different project in mind, but I was inspired during a local off-road photo excursion recently to create something new. I used a single photographic image and animated a portion of it before compositing it into a complete scene with a locked-off green screen shot of my subject and a hand-held video clip for my background plate. As you can see in Figure 18.13, my model was pointing to something interesting in the sky and had a primary light source over her shoulder to the right, in a relatively low-light setup. This was originally shot with only two Kino Flo BarFlys and the Reflecmedia LED LiteRing system.

The point of interest in this scene was a low-flying USAF C130 that surprised me when I was driving down a mountain one afternoon. I was able to capture only a single snapshot, but it was the inspiration for my project.

I took the image into After Effects and created a comp that had two duplicated layers of the original aircraft image. The first image was masked out with the Pen tool around the props of the plane. I then created a direction blur rotation of the props to simulate prop motion. In the second copy of the layer, I used Keylight to extract the plane from the sky so I could move it against the sky in the background footage plate (see Figure 18.14).

Figure 18.12 *Placing tracking markers on the background screen and compositing the video footage into the background, with the tracker in After Effects*

Figure 18.13 *The original green screen footage shot for a night scene*

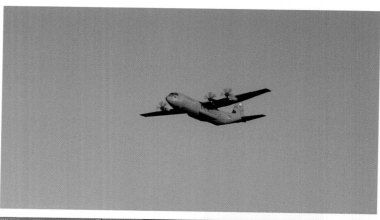

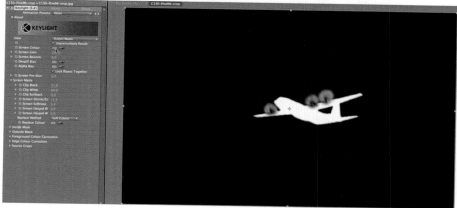

Figure 18.14 *Using Keylight to extract a mask around the aircraft against the blue sky*

I used the built-in motion tracker in After Effects to track a bright, sharp highlight on the tailight of my truck. I applied it to the keyed-out green screen layer of my model, which I positioned at the back of the truck, pointing to the sky off to the left of the camera (see Figure 18.15). I planned this camera move for this scene specifically, knowing what footage I had (plus I carried a color print from a single frame of the green screen footage to match the light source and camera angle to the scene).

Figure 18.15 *The built-in motion tracker in After Effects is used on the background plate to position the green screen model to the scene*

Because I had planned this shot in my mind and knew approximately what angles I needed to shoot for, I took several shots that I could choose from to make this composition work. As the camera panned slowly from the front of the truck and out over the valley below, I pretended my model was trying to get my attention and pointing to something in the sky. I then panned up and off into the left of the sky with the video camera. In this section of footage, I manually matchmoved the position and scale of the plane comp layer into view. For an added effect, I varied the shake of the camera pointed on the plane, adjusted the scale, and added a Lens Blur effect in and out to simulate the autofocus of the camera trying to keep up (see Figure 18.16).

Figure 18.16 *Hand matchmoving the position, scale, and focus of the aircraft comp layer to simulate camera movement, zoom, and focus*

The final sequence was a fun composite of several elements, incorporating green screen, blue "sky" keying, motion tracking, matchmoving, and simulated zoom and focus effects (see Figure 18.17).

You may notice in the video that the subject's finger went off the screen in the original foreground footage and is slightly cut off in the final composite. This is an example of why it's important to plan your shots to be sure you capture all of the required image area that you'll need for your composite.

Figure 18.17 *All the elements of keying, tracking, and matchmoving are utilized in this sequence*

Planar Tracker Video Insertion

In the example shown in Figure 18.18, I used Mocha for AE along with After Effects to insert a simulated video on the screen of an iPhone. I originally set the iPhone's screen to 100 percent green so I could insert the tracked and distorted footage properly on the screen area and still retain the reflections and the finger moving in front of the screen. This would be nearly impossible without using both the planar tracker and the green screen technologies in the same shot.

I started by timing the original video footage at the point where the finger went over the screen as if to slide open a video clip on the iPhone. I created a short subcomp consisting of the Adobe MAX conference logo that pans to a simulated running video clip with the iPhone player controls. This was the inserted footage comp.

I opened the original background footage clip in Mocha for AE to start creating my planar tracking. Selecting the Roto Spline tool, I drew out an area all around the edges of the iPhone. This way, the tracker ignored my hand and finger going over the surface of the screen and looked at more data of the shape of the iPhone. I positioned the Surface data corner points to the corners of the iPhone screen and made adjustments to the tracking keyframes along the timeline.

After exporting the tracking and corner pin data to the clipboard, I pasted it into the insert footage comp at frame 0 and made alignment adjustments to the position of the iPhone screen using the Anchor Point positioning (see Figure 18.19).

Figure 18.18 *Using Mocha to track the position, skew, rotation, and scale of the iPhone in the video clip and create planar corner pin data for the screen*

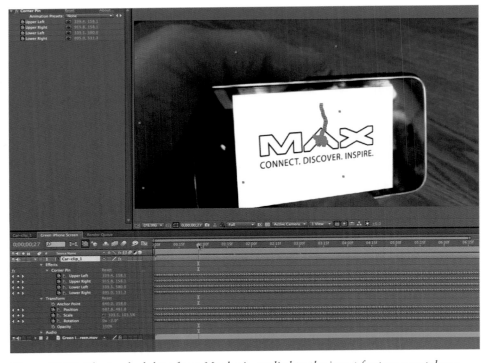

Figure 18.19 *The tracked data from Mocha is applied to the insert footage comp layer*

I then placed the original footage layer on top of the insert footage and applied Keylight to create a green screen matte, revealing the finger moving across the screen and the reflections on the surface (see Figure 18.20). Applying some correction with the Levels effect helped to make the composite believable (see Figure 18.21).

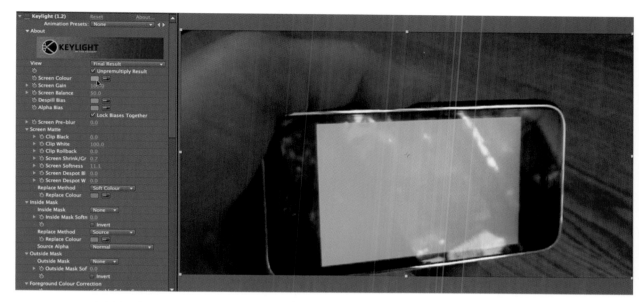

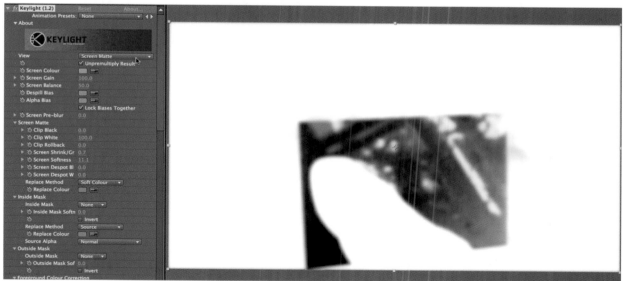

Figure 18.20 *Using Keylight in After Effects, the green screen on the iPhone is matted to reveal the tracked layer beneath*

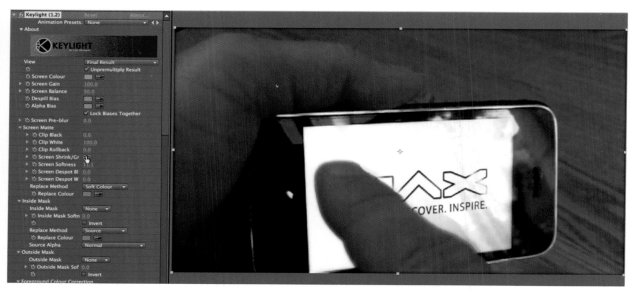

Figure 18.20 (continued)

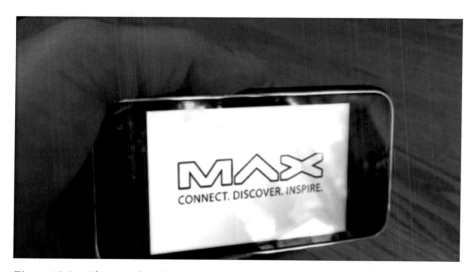

Figure 18.21 *The completed sequence with the insert footage tracked and keyed onto the surface of the iPhone screen*

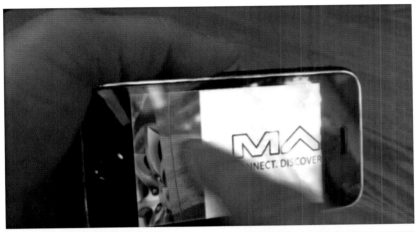

Figure 18.21 (continued)

You can view the finished video examples in this chapter in the Chapter 18 media folder.

Where to Learn More?

Products used or mentioned in this chapter:

- **Adobe After Effects:** creative.adobe.com
- **Mark Roberts Motion Control (MRMC):** www.mrmoco.com
- **General Lift, GenuFlex Mk III:** www.general-lift.com
- **CMOCOS:** www.cmocos.com
- **Techno-Jib:** www.telescopicjib.com
- **TechnoDolly:** www.technodolly.com
- **OConnor:** www.ocon.com
- **Tim Dobbert, Matchmoving Advanced Production Techniques:** www.thegnomonworkshop.com/store/product/345/Matchmoving-AdvancedProduction-Techniques

Image and footage credits:

- **Hollywood Camera Work:** www.hollywoodcamerawork.com
- **Hydralab:** www.blog.machinefilm.com
- **Dan Thompson's blog, The Long Way Home:** www.danthompsonsblog.blogspot.com/2009/04/diy-motion-control-rig.html

You can find a complete list of references and suggested continued reading/learning in appendix A.

Happy Holidays

Complex Composites

Most of the green screen *or blue screen matte extractions that you encounter will be simple and straightforward, needing only to key out a single colored background and replace it with background footage or a virtual set. However, there may be times that both green and blue are shot simultaneously to provide for different levels of matting, such as a background and foreground plane. This creates a sort of sandwich between the two planes and the subject and retains the shadows on the object. This technique also works for foreground objects such as furniture and contact items such as tables and counters that aren't necessarily part of the background. In addition to compositing multiple screen colors, you can incorporate other elements such as particle generation and simulated camera motion to add depth, scale, and realism to any composition. Other projects may require a combination of several techniques to get a good composite, including mixing keying, masks and roto layers. This chapter will give you some insight into how you can achieve these effects using Adobe After Effects.*

Combining Green Screen Background with Blue Screen Foreground Elements

Sometimes it's necessary to extract your subject from between two surfaces or interact with the surfaces in some manner, retaining the shadows on the surfaces. Often you can do this with a single color that can be matted out and elements that can be composited

in as if they were on separate planes, but it may be difficult to capture true interaction (primarily shadows) with furniture and objects if they're the same color as the background.

You should only consider using multiple colored elements to matte out if you can plan the conditions perfectly. You need to be certain that the subject won't include any close variation of either of the colors you're trying to matte out, such as blue and green. This is difficult to judge because flesh tones naturally contain some green and blue, and even white or silver textures. However, if you can ensure that the background is lit fully and evenly and the foreground objects and your subject are all lit evenly, you may be able to pull off a multicolored or complex matte extraction.

In some instances, you have a nonhuman element to matte out, such as a model of a motion-controlled spaceship or a shiny green monster, where neither blue nor green backgrounds will work and you'll need to shoot against a red screen. This is perfectly acceptable if it's set up and lit correctly like either a blue or green screen. But note that there is a very specific red background color that works in such a scenario; you can find it through the resources listed in Chapter 3.

Multiple-Color Matting Project

Using a single color for both background and foreground elements, as shown in Figure 19.1, will give you a quick solution for simple matting but doesn't easily allow for believable interaction with the foreground objects. This is stock footage from iStockphoto (www.istockphoto.com) that has been enhanced and rekeyed. Notice the lack of drop shadow and the harsh edges, which won't allow you to get a clean matte without some work. It's best to avoid these kinds of shots whenever possible; when shooting, don't make the mistake of trying to prekey footage by adding a fake green background to the shot for the editor to deal with later. Not all the chroma footage from iStockphoto has been post-processed, so look carefully before selecting footage from any stock video vendor.

The advantages of using a two-color matte selection shot for compositing is apparent when you first see it—matte out the background, and then matte out the foreground elements. Although this may be a simple concept, it's often a not-so-simple process to execute. Depending on your subject, it may not be possible to extract a wide range of color in the green and blue spectrum to accommodate such a composite.

In the example shown in Figure 19.2, the subject is primarily covered in the red channel, with the Santa suit and a rosy-red face. This allows more of the green and blue to be extracted without major image quality loss during the matting process. This footage was provided by iStockphoto as well, but it hasn't been post-processed and has retained all of its original screen attributes.

You can follow along with this After Effects project in the Chapter 19 media folder; the file name is SantaGreenscreenProject.aep. Start with the composition labeled Ready to Matte.

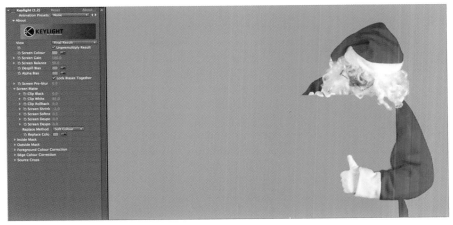

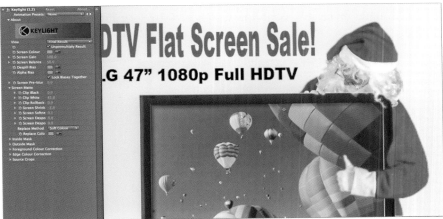

Figure 19.1 *Stock video with green on green doesn't allow for shadows on the foreground surface*

Figure 19.2 *The subject in this shot has enough separation from the green and blue channels to be easily extracted*

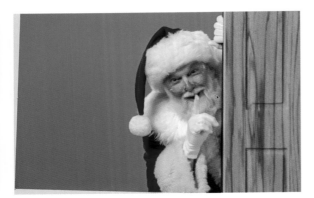

Figure 19.3 Align the video layer's position and rotation to the edge of the door layer

I first aligned the subject video layer to match the door layer by moving the door layer to the top and adjusting the position and rotation of the video layer to line up with the edge of the door, as shown in Figure 19.3. This ensured that the door was in position after the mattes were extracted with Keylight. When the video layer is aligned, I returned the door layer to just below the video layer.

I then applied the Keylight effect (Effect ➢ Keying ➢ Keylight) on the video layer and selected the green background. Then, selecting the Screen Matte option on the View pull-down menu, I made adjustments to the Screen Matte settings by increasing the Clip Black to just eliminate the background noise, while decreasing the Clip White to eliminate spill and noise inside the white part of the matte (see Figure 19.4). You can select the Final Result view to preview the effect against the background.

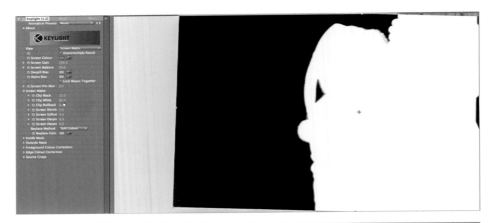

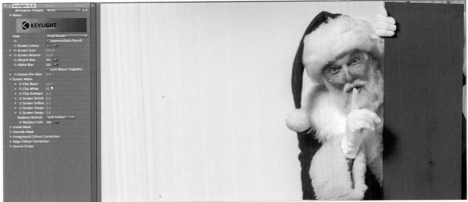

Figure 19.4 Applying the Keylight effect to the green background on the subject video layer

Next, I applied the Keylight effect again and selected the blue panel in the foreground to extract a second matte. Changing the View to Screen Matte, I adjusted the Screen Matte Clip Black and Clip White to remove only enough of the background noise on the blue panel to allow the drop shadows from the hands to still be visible. I also adjusted the Pre-Screen Blur slightly to soften the shadow noise in the matte (see Figure 19.5). Again, select the Final Result view to preview the effect against the background.

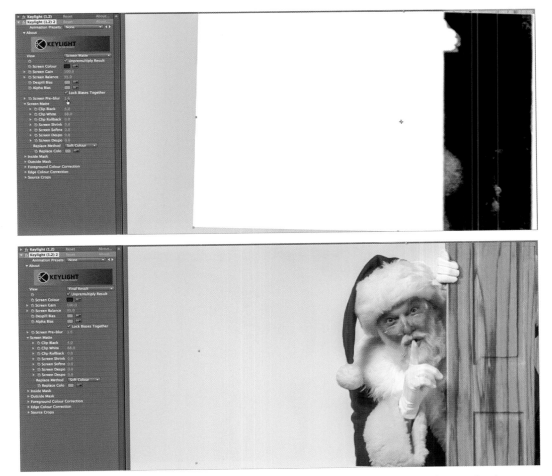

Figure 19.5 *Applying the Keylight effect to the blue foreground panel on the subject video layer to reveal the door underneath*

Because some residual noise around the edges and the right side of the blue panel was still visible, along with some dimples and dents in the painted foamcore that was used in the original shot, I needed to apply a soft mask to the video layer. This is often referred to as a garbage matte. I first adjusted my composition window zoom down to 50 percent so I could see the edges of the mask more easily after I created and started modifying it.

I began by adding a new mask (Layer ➤ Mask ➤ New Mask) and adjusted it so it closed in on the right and left sides; I also expanded its top and bottom edges. I then applied a mask edge feather of 100 pixels (Layer ➤ Mask ➤ Mask Feather) to produce a soft mask that blended into the background (see Figure 19.6). Return the view to 100 percent to see the results.

Figure 19.6 *Applying a feathered-edge mask to the video layer to provide a garbage matte of the unwanted elements and noise around the edges*

Finally, I enabled the other layers in the composition to reveal the rest of the design and color-corrected the video layer to better match the background elements and brighten up the subject. Applying the Levels effects (Effect ➤ Color Correction ➤ Levels), I adjusted the midpoint of the RGB channel as well as the Red channel to warm up the subject (see Figure 19.7).

Figure 19.7 Using the Levels effect to color-correct and brighten the subject on the video layer

Compositing with Particles and Simulated Camera Moves

In many software compositing applications, plug-ins are available to create particles in motion that can simulate rain, snow, smoke, fire, and many other organic elements. These are extremely useful to the compositor to help establish realism in a green screen project.

In this section, I'll show you how to combine several different elements and techniques covered in various other chapters in the book, with the addition of particle generation to add realism and depth to a scene. This is a multiple-step project that requires modifying the green screen video sequence plate in one composition in After Effects prior to compositing with the new background and particle effects layers. Please note that at least intermediate knowledge and experience with After Effects is suggested if you wish to attempt this project. You can follow along with the After Effects project by using the project titled XmasWindows-GS.aep in the Chapter 19 media folder.

Step 1: Correcting the Green Screen Plate

Start by opening the After Effects file, and select the GS Track Window composition. This file includes completed versions of the comps that you may use as references if you get lost or confused by any of the steps. This footage originally came from the free downloads at Hollywood Camera Work (www.hollywoodcamerawork.us/trackingplates.html) and has motion from the camera that tracks and dollies toward the window throughout its duration. But the video has some issues with the tracking marks that were placed on the outside surface of the windows. When the shot was made, the marks were supposed to help place a background beyond the window in position, rotation, and scale, but the cameraperson didn't take into consideration the depth of the background necessary to make it appear to be way beyond the window instead of right at the window's surface. Admittedly, as posted on the website, this issue is a challenge to overcome, and it creates

a real-world correction opportunity. It's up to us to work around it and create our own workflow to track and place a background beyond the window.

The first thing you have to do is cover up the tracking marker tape on the window so you can key out the green screen and retain the reflections on the window. If you didn't care about the reflections, then you could mask out the main area and blow out the subtle reflections and color variations of the green without going through this first step, but because you want all that subtlety, it's important to make the reflections blend in. But how do you do that, when they move along time? You'll set up motion trackers for each patch that will cover the tape and follow along the path throughout the duration of the clip.

To follow along, start with a new solid layer (Layer ➤ New ➤ New Solid Layer), and use the eyedropper to select the darker green area around one of the pieces of tape. Then, use the Pen tool to draw a crude rectangle around the first piece of tape, and give it a feathered edge of 20 pixels to help it blend in more easily, as shown in Figure 19.8.

Figure 19.8 Create a new solid layer, color it green to match the background, and draw a feathered mask around one of the tape pieces

Duplicate the green solid layer, and rename it 2. Using the selection tool, move the mask on the duplicated layer to the lower piece of tape. Continue this process two more times, and then modify the mask over the last piece of tape next to the tree (solid layer 4) so that it's angled away from the branch slightly, as shown in Figure 19.9.

Figure 19.9 Duplicate the solid green layers, and reposition and modify the masks on each layer to cover a different piece of tape

Select the video layer, choose Track Motion from the Tracker panel, and position the track point over one of the corners of the first piece of tape. It's not necessary to cover the entire piece of tape with the tracker—just a clean corner (see Figure 19.10). Be sure to start at frame 0 before positioning and tracking.

Click the Track Forward button in the Tracker panel; be sure the tracker follows the corner of the tape accurately. Select the Source as your first green solid layer (layer 1), and click Apply. The result adds a tracker sequence to the video layer in the Timeline and a string of Position keyframes on the green solid layer 1 (see Figure 19.11). Scrub the Time Indicator down the Timeline to be sure the patch follows the tape accurately.

Continue this process with the remaining layers. I found that I needed to adjust the anchor point of green solid layer 4 over time to better align with the edge of the tree branch without covering up the needles. Some of the tape appears behind it, but it's so subtle that when composited, you really can't see it (see Figure 19.12).

Figure 19.10 *Position the tracking point over a corner of the first piece of tape*

Figure 19.11 *Apply the tracker to the green solid layer 1 to cover the first tape patch*

Figure 19.12 *Repeat the process on the remaining three layers*

Step 2: Matching the Background to the Green Screen Plate

For this project, I used a still image as my background plate, which I could track to the green screen plate in order to create a sense of depth and motion. Because it was a still night scene and I planned to add some particle effects of snow in the final composite, the still image worked fine. The background image in this example project came from iStockphoto and established the lighting and color palette for the entire scene. This part of the project requires several steps, including matting, motion tracking, simulated panning and zooming, lens blurring, and color correction along the Timeline to create a believable composite.

To continue following along, open the file named XmasWindows-GS.aep, start with the comp named Xmas Window Home, and select the layer GS Track Window. This is not a video file but the subcomp I corrected earlier. Apply the Keylight effect to this layer (Effect ➤ Keying ➤ Keylight), and use the eyedropper to sample the medium-dark green in the middle of the window. Change the view to Screen Matte, and adjust the Clip Black and Clip White settings of the Screen Matte only until the

subtle noise is gone in both the black and white regions of the matte. Apply a small amount of Screen Pre-Blur to soften the matte slightly and reduce noise (see Figure 19.13). Change the View to Final Result to see the initial composite and the reflections in the window.

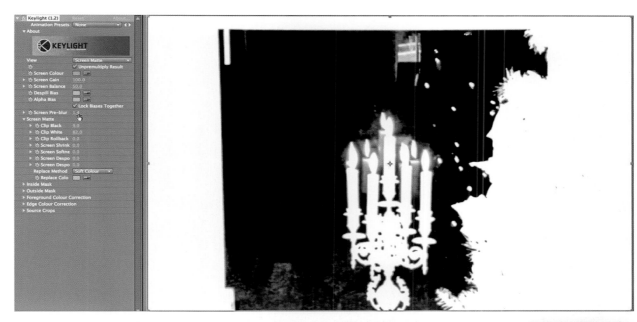

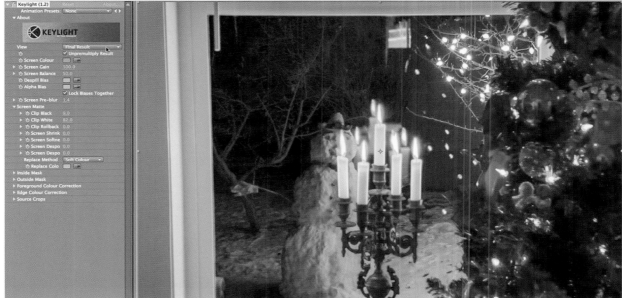

Figure 19.13 *Apply Keylight to the green screen comp layer, and adjust the Screen Matte settings*

Next, you need to track the motion of the camera to the background image so it doesn't appear to be floating in front of it. To do this, select the green screen comp layer, and select Track Motion from the Tracker panel. Align the tracker over the bottom spire of the candelabra, and track forward, as shown in Figure 19.14. Select the background layer as the source and apply.

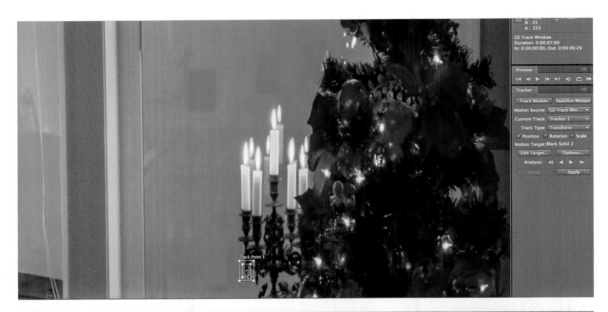

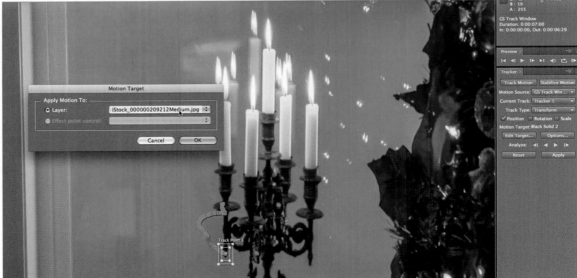

Figure 19.14 *Apply the tracker to the spire of the candelabra, and track the background plate to it*

This process makes the background layer track to the green screen plate, but it still doesn't look entirely correct because it has no panning motion or scale/forward motion to match the camera's dolly moves. You can remedy this by adding some keyframes for Anchor Point and Scale on the background layer.

Scrubbing the Current Time Indicator (CTI) back and forth down the Timeline, you can see where the camera begins to move on the dolly track, which is around one second. Set the first keyframes for both Anchor Point and Scale by moving the CTI to the one-second mark and clicking the stopwatches for both of these transform attributes. Then, move the CTI down the Timeline and near the end, adjust the Scale to approximately 126 percent, and slide the x-axis Anchor point to 985, as shown in Figure 19.15. This creates the panning and forward motion of the camera toward the window and closer to the background plate. Right-click the keyframes in the timeline, and add Keyframe Interpolation to apply an Easy Ease Out to the first keyframes and an Easy Ease In on the last two keyframes, to give the layer a smoother sense of motion.

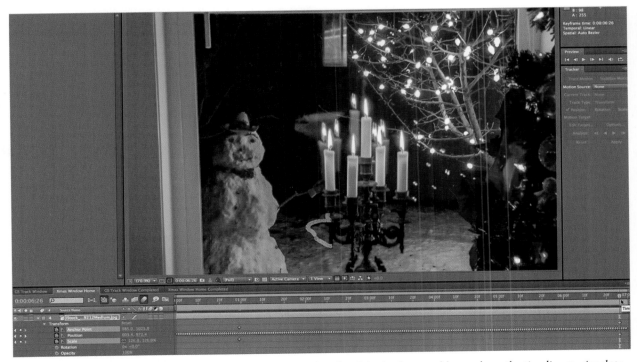

Figure 19.15 *Applying keyframes for the Anchor Point and Scale of the background layer along the timeline to simulate camera dolly-in toward the window*

To enhance the sense of camera motion and to simulate camera focus onto the background plate, apply a slight Lens Blur effect that is keyframed to switch from background to foreground during the final third of the motion path. Doing so gives the composite a sense of realistic camera motion and control.

Moving the CTI to the four-second mark on the Timeline, apply the Lens Blur effect (Effect ➤ Blurs ➤ Lens Blur) to the green screen foreground layer, and set the Iris Radius to 0. Click the stopwatch to set the first keyframe, move the CTI to the six-second mark on the Timeline, and set the Iris Radius to 15 (see Figure 19.16). This makes the foreground appear to de-focus over this period of time. Apply the Easy Ease Out and In Keyframe Interpolations on these keyframes to smooth the transition from focus to de-focus. Repeat the process in reverse order for the background layer, so it appears to be de-focused first and then come into focus at the end when the camera moves in.

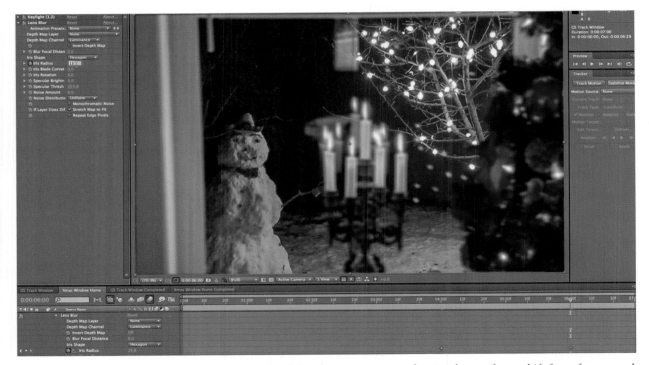

Figure 19.16 *Adding Lens Blur over time to each of the plates in reverse order simulates a focus-shift from foreground to background*

The next step is to color-correct the foreground to better match the warmth and deepness of the background's night glow. I wanted the effect to appear as if the only illumination in the scene came from the candelabra, the lights on the Christmas tree, and the outside lights shining on the snowman.

Apply the Levels effect (Effect ➤ Color Correction ➤ Levels) to the green screen comp layer. Adjust the overall midtone brightness down and the contrast up, and add a bit of midrange red and lower the blue channel's highlights until it closely matches the background layer (see Figure 19.17). Because this is a subjective step and there are no numerical inputs for the sliders in this effect, you may want to experiment until you're pleased with your results. This is a nondestructive effect and can be reset and reapplied indefinitely.

Figure 19.17 Apply the Levels effect to color-balance the foreground to the background plate

Step 3: Adding the Particle-Generated Snow

To add motion, depth, and interest to this composited scene, I added some particle-generated snow on a layer between the foreground and background plates. To make such an effect look believable, it has to match the other two plates in motion, density, color, and focus.

First, select the lower Black Solid layer in the composition and make it visible. Doing so makes the background layer turn black, but don't worry—it will turn to snow momentarily. Then, apply the CC Snow generator effect (Effect ➤ Simulation ➤ CC Snow) to the layer, and adjust the settings according to what feels reasonable for the scene. For this example, use these values:

Amount:	1000.0
Speed:	0.5
Amplitude:	2.0
Frequency:	1.0
Flake Size:	3.0
Source Depth:	100.0 percent
Opacity:	35.0 percent

You may want more or less snow in your scene, so play with these numbers and see what they create for you (see Figure 19.18).

Figure 19.18 *Applying the CC Snow particle generator*

Next, you have to match the snow layer to the background motion. Open the background layer's Transform properties on the Timeline, select all the keyframes, and copy them to the clipboard. Then, select the black solid layer with the CC Snow applied, set the CTI to frame 0, and paste from the clipboard. Doing so places the keyframes in the same position for Anchor Point, Position, and Scale, so the snow matches the background layer's motion exactly (see Figure 19.19).

Figure 19.19 *Copying the keyframes from the background layer and pasting to the Snow layer to match the motion*

The next step is to match the focus of the snow layer more closely to the background layer: apply the Lens Blur filter to the black solid layer with the CC Snow applied. At the four-second mark on the Timeline, set the Iris Radius to 15; then, at the six-second mark, set a new keyframe and reduce the Iris Radius to 7 (see Figure 19.20). Doing so creates a sense of motion and doesn't enable a sharp edge on the snow particles, but keeps them softer. Again, apply the Easy Ease Out/In Keyframe Interpolations to the keyframes.

Figure 19.20 *Adding Lens Blur over time to the snow layer to make it blend in with the scene*

To make the color of the snow more closely match the environment, add some Hue/Saturation (Effect ➤ Color Correction ➤ Hue/Saturation). Select the Colorize option, and set the Hue to 41.0° and the Saturation to 50 percent (see Figure 19.21).

Figure 19.21 *Hue/Saturation is used to colorize the snow particles and help them blend in with the scene*

Because the scene is lit primarily by the outside light and the glow from the windows, the snow seems too harsh across the background. Create a new mask by using the Pen tool to draw out a wide area across the top two-thirds of the frame on the upper black solid layer, as shown in Figure 19.22. Reduce the comp window zoom to 50 percent to see the entire mask outline. Set the Mask Feather to 500 pixels to provide a wide blending path.

Figure 19.22 *Creating a soft mask on the upper black solid layer*

Figure 19.23 *Applying the Alpha Matte to the Snow layer to create a natural light falloff effect*

Then, select the lower black solid layer with the CC Snow effect, and apply an Alpha Matte (Layer ➤ Track Matte ➤ Alpha Matte) to use the masked layer to provide the falloff from the light on the background (see Figure 19.23).

The final composite has a realistic, warm feel. The sense of motion and direct focus from the camera provides a natural shift from foreground to background (see Figure 19.24).

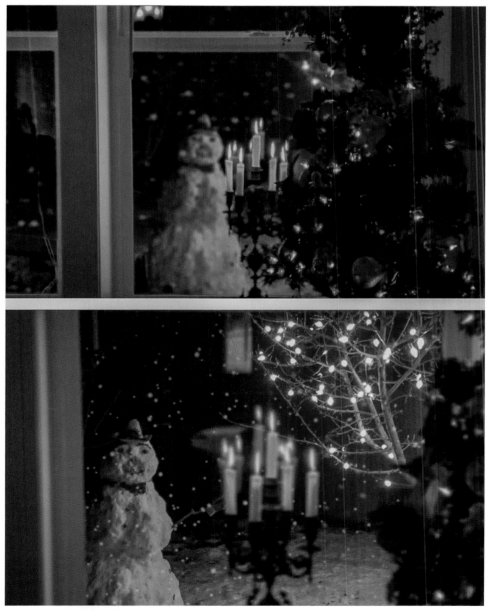

Figure 19.24 *Adding Lens Blur over time to each of the plates in reverse order simulates a focus-shift from foreground to background*

A Real-World Production Composite

Being known as *THE Green Screen Guy*, I'm often contacted by industry folks and colleagues to help them with some particularly difficult shots they need to composite. Sometimes I'm contacted to fix something they couldn't do and other times I'm told there's an "easy" project with a couple dozen green screen shots. This next project started off as the latter – and quickly escalated to over 80 shots that needed to be hand-roto'd and composited with very little useable green screen to work with.

The movie is called *The Courier* (Films In Motion, prod. www.imdb.com/title/tt0995845) and the VFX compositing I worked on was a hostage scene on top of an old abandonded roller coaster (shot in a theme park in Louisiana that was destroyed by Hurricane Katrina). Since they couldn't really make the actors work on the top of the roller coaster for safety reasons, they managed to make a setup on the lowest part and then have me roto/composite to make it match the top in post. Some of the shots were picked-up in the studio on green screen afterwards. You can see a QuickTime movie with a series of before/after shots in the Chapter 19 media folder, along with the actual After Effects project files for this following shot that you can follow-along with, courtesy of the film's production company.

This shot was typical for many that I had to work with on this project. The green screen was almost an after-thought in most cases and very little of it ended up useable in the end (see the before/after frames in Figure 19.25). This is a great example of utilizing several compositing techniques shown throughout the book and some more advanced roto/compositing techniques you may find from one of my videos on my website (www.PixelPainter.com).

Figure 19.25 Before/after frames from this VFX shot

When presented with a shot like this, I first determine if it was handheld or on a tripod. Since this one was on a tripod, the main foreground structure doesn't move, so I was able to just create a spline-based mask using the Pen tool in After Effects around the railings and track of the coaster on a separate layer duplicated from the original footage layer. I ignored the actor or anything else that moved in the scene and only concentrated on the elements I was masking throughout the shot (see Figure 19.26). I also created a mask around the section of railing that breaks-free when he jumps through it and had to account for the motion blur that was in the original shot.

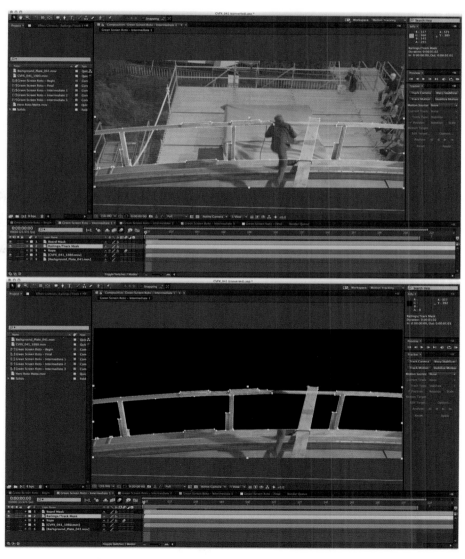

Figure 19.26 *Masking the railings and track with a spline-based mask using the Pen tool*

In Figure 19.27 you can see that I've created a new "rope" overlaying the original one, whipping-around as the hero jumps over the edge to save the girl. This was simply a Shape Layer stroke path with a very slight Beveled Layer Style applied to give it a sense of dimension and match the colors and path of the original rope. This had to be adjusted manually, frame by frame.

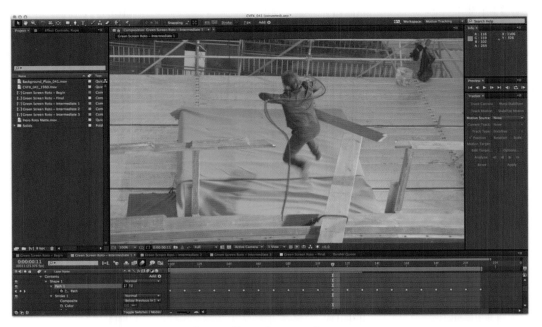

Figure 19.27 *Creating a new rope from a Shape Layer path*

Using the Roto Brush tool in After Effects, I then isolated the actor along the entire length of the shot, allowing some of the green screen to show around the edges that could be keyed out later.

I then rendered-out just the actor isolated against an alpha as a QuickTime movie and re-imported it into the project. This way I could use the Paint Brush to refine the edges of the roto edge in each frame—especially where there was motion blur in the original footage.

I then used Keylight to remove the green from around the actor and then duplicated the layer for a second pass, applying the Track Matte ¬ Alpha Matte mode. Then the first matte could be painted to remove hard edges and refine motion blurpoints without introducing the green background back in.

One final touch was to add back in motion blur to make the shot believable. I find that the motion blur in After Effects really only works on objects and layers that physically move. This worked pretty well on the new "rope" layer as you can see in Figure 19.30, but all the other layers that have been isolated from the original background have sharp edges and the motion blur removed.

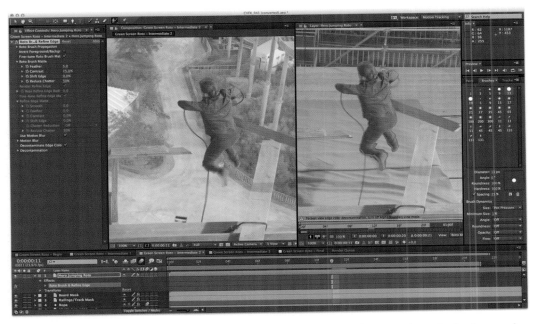

Figure 19.28 *Using the Roto Brush tool in After Effects to isolate the actor from the background*

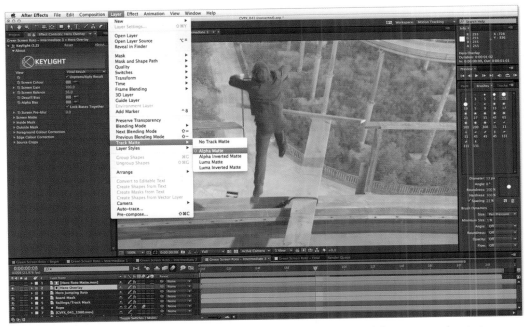

Figure 19.29 *Duplicating the roto'd actor layer with Track Matte ¬ Alpha Matte and painting out the artifacts and rough edges from the matte layer*

I was able to re-create and actually enhance the motion blur effect on all the layers in motion using RE:Vision Effects RSMB Pro (Reel Smart Motion Blur Pro www.revisionfx.com/products/rsmb/). This plug-in effect tracks all the pixels on the layer and determines how much they're moving and only adds in natural motion blur on the areas that move the most. The amount of the blur can be controlled with the plug-in Effects panel settings and the results compared are shown in Figure 19.30.

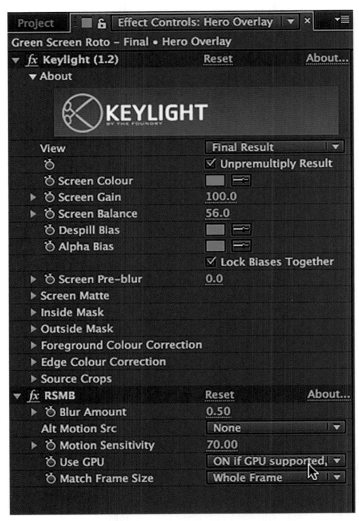

Figure 19.30 *Using the RSMB plug-in from RE:Vision Effects to add natural motion blur back into the composite layers*

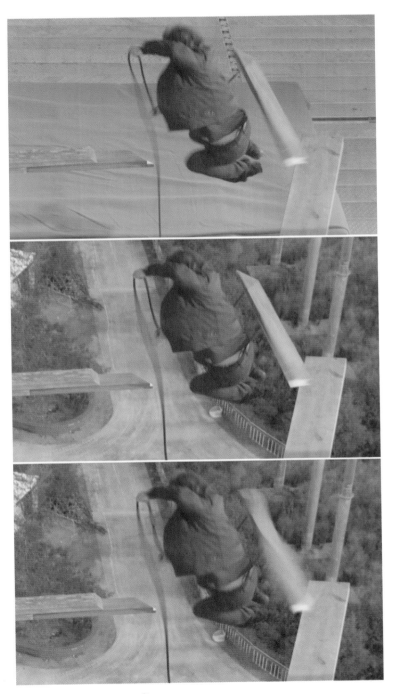

Figure 19.30 (continued)

Where to Learn More?

Products used or mentioned in this chapter:

- **Adobe After Effects:** creative.adobe.com
- **RSMB Pro (Reel Smart Motion Blur Pro):** www.revisionfx.com/products/rsmb/

Image and footage credits:

- **iStockphoto:** www.istockphoto.com
- **Hollywood Camera Work:** www.hollywoodcamerawork.us/trackingplates.html
- *The Courier* **(Films In Motion):** www.imdb.com/title/tt0995845/
- **Jeff Foster's Blog:** www.PixelPainter.com

You can find a complete list of references and suggested continued reading/learning from this chapter in Appendix A.

Products and Services Mentioned in This Book

Table A.1 is a compilation of all products and services mentioned in this book, listed alphabetically. Table A.2 lists all the studios, companies, and individuals who generously allowed their work to be shown in this book.

Table A.1 Products and Services

Product/Service	URL	Products Referenced
2d3 Ltd.	www.2d3.com	boujou three
Adobe Systems Incorporated	creative.adobe.com	After Effects, Photoshop, Premiere Pro, Creative Cloud
Apple Inc.	www.apple.com/final-cut-pro/	Final Cut Pro X
Avid Technology Inc.	www.avid.com	Avid Media Composer Adrenaline HD
Blackmagic Design	www.blackmagicdesign.com	BMD Cinema Camera, Pocket Cinema Camera, UltraStudio 4K, UltraScope, DaVinci Resolve
Boris FX	www.borisfx.com	Continuum Complete
Borrow Lenses	www.borrowlenses.com	Pro Lens Rental
BuyLighting.com	www.buylighting.com	Compact fluorescent light bulbs
Canon USA	www.usa.canon.com/cusa/consumer/products/cameras/slr_cameras/eos_60d	DSLRs
CineMeter App	www.adamwilt.com/cinemeter/	Digital Metering for iPhone/portable devices
CMOCOS	www.cmocos.com	Camera Motion-Control System
Composite Components Company	www.digitalgreenscreen.com	Digital Green/Digital Blue fabrics, paints, lights, and materials
DAZ Productions, Inc.	www.daz3d.com	DAZ Studio 3
Digital Anarchy	www.digitalanarchy.com	Primatte Chromakey 3.0
DSC Laboratories	www.dsclabs.com	ChromaDuMonde Chart
dvGarage, Inc.	www.dvgarage.com	Conduit Suite, dvMatte Pro 3

(*Continued*)

Table A.1 (Continued)

Product/Service	URL	Products Referenced
Fiilex	www.fiilex.com	Fiilex Specular LED Lighting
Full Mental Jacket	www.fullmentaljacket.com	Customized Virtual Set Packages
General Lift LLC	www.general-lift.com	GenuFlex MkIII motion-control system
Grass Valley (Thompson Inc.)	www.grassvalley.com	Broadcast production products
Hollywood Camera Work	www.hollywoodcamerawork.us www.hollywoodcamerawork.us/gs_index.html	Green screen and motion-tracking stock footage, VFX training videos, GreenScreener App for iPad
iStockphoto	www.istockphoto.com	Stock photos, illustrations and video footage
Kino Flo Lighting Systems	www.kinoflo.com	Diva-Lite 400, BarFly 200, BarFly 100, True Match Lamps
Lastolite Limited	www.lastolite.com	Portable Chromakey Collapsible Backgrounds
Leader Instruments Corp	www.leaderusa.com	Waveform monitors
LensProToGo	www.lensprotogo.com	Pro Lens Rentals
Litepanels, Inc.	www.litepanels.com	Litepanels LED lighting systems
Mark Roberts Motion Control	www.mrmoco.com	Milo Motion Control Rigs
Moddler LLC	www.moddler.com	3D printing and modeling
NewTek, Inc.	www.newtek.com	TriCaster STUDIO, LiveSet
OConnor Engineering Laboratories	www.ocon.com	Motion-control fluid head
Panasonic Corporation of North America (Professional Video)	www.panasonic.com/business/provideo/cat_camcorders.asp	P2 solid-state HD camcorders, AG-HPX170, AG-HPX300, AJ-HPX3700 VariCam camcorder
Panavision Inc.	www.panavision.com	Genesis digital camera systems, studio technical and production support services
PhotonCraft	www.photoncraft.com	3D models, virtual sets
Pro Cyc Inc.	www.procyc.com	Modular cyclorama systems
Red Giant Software LLC	www.redgiantsoftware.com	Primatte Keyer Pro 4.0, Magic Bullet Suite
RED Digital Cinema	www.red.com	RED ONE camera
Reflecmedia	www.reflecmedia.com	LiteRing, ChromaFlex, Chromatte, BaseMatte
Re:Visions Effects	www.revisionfx.com/products/rsmb/	RSMB Reel Smart Motion Blur, Twixtor plug-ins
Roscoe Laboratories Inc.	www.rosco.com	DigiComp compositing materials
ScopeBox (divergent media, inc.)	www.scopebox.com	ScopeBox virtual waveform monitor software

Product/Service	URL	Products Referenced
SmallHD	www.smallhd.com/products/ dp7-pro/dp7-pro-oled.html	DP7-PRO OLED Display/Field Monitors
Sony Electronics, Inc. (Pro Video)	pro.sony.com www.sonycreativesoftware. com/vegaspro	PMXEX3 XDCAM and DSRPD170 compact camcorders, Sony Vegas Pro
Strata	www.strata.com	Strata 3D CX Suite
TechnoDolly (Technocrane s.r.o.)	www.technodolly.com	TechnoDolly motion-control crane and camera rig
Telescopic LLC (Techno-Jib)	www.telescopicjib.com	Telescopic motion-control jib arm
Tektronix, Inc.	www.tek.com/waveform-monitor	Waveform monitors
Ultimatte Corporation	www.ultimatte.com	Ultimatte compositing hardware, AdvantEdge compositing software, Ultimatte rt
Virtualsetworks LLC	www.virtualsetworks.com	Pre-rendered 3D virtual set libraries
Vizrt Ltd.	www.vizrt.com	Viz Virtual Studio: 3D virtual sets and studios

Table A.2 Credits for Work Shown in This Book

Studio/Individual	URL	Works Referenced
Academy of Motion Pictures Arts and Sciences (AMPAS)	www.oscars.org www.oscars.org/academy/ buildings/pickford.html	Images, studio reference, technological information, Margaret Herrick Library, Pickford Center for Motion Picture Study
Alex Lindsay (Pixel Corp, Pro Video Coalition)	www.pixelcorps.com www.providecoalition.com	Images, technological information
Barry Andersson	www.barryandersson.com	Author/Producer
Bluescreen LLC (Bob Kertezs)	www.bluescreen.com	Images, technological and historical information
CafeFX	www.imdb.com/ company/co0115302/	Images, studio reference, VFX for HBO's *John Adams* miniseries
Colin Smith (PhotoshopCAFE)	www.photoshopcafe.com	Images, training DVDs
Dan Thompson (Blog: The Long Way Home)	danthompsonsblog.blogspot. com/2009/04/diy-motion-control-rig.html	Technological information for the *DIY Motion Control Rig*
Disney (Disney Store Online)	http://bit.ly/1hqiH9O	Images, studio reference, VFX for *Pete's Dragon* DVD

(Continued)

Table A.2 (Continued)

Studio/Individual	URL	Works Referenced
Films In Motion (*The Courier*)	www.imdb.com/title/tt0995845/	*The Courier* Examples and Project Files
Frieder Hochheim (Kino Flo Incorporated)	www.kinoflo.com	Images, technological information
Full Mental Jacket	www.fullmentaljacket.com	Images, links for global television
HBO (Home Box Office, Inc.)	www.hbo.com	Images, studio reference, VFX for *John Adams* miniseries
Hydralab	www.blog.machinefilm.com	Images, studio reference, VFX for *Machine*
iMatte (Paul Vlahos)	www.imatte.com	Sight Deck
iStockphoto LP	www.istockphoto.com	Images, stock video footage
James Parris	www.papertigerfilms.com	Images, VFX for *Haven*
Jeff Varga (Dead End City – Pilot)	www.vimeo.com/11910694	Images, studio reference, VFX for *Dead End City*
Jonathan Erland (AMPAS, Composite Components Company)	www.oscars.com and www.digitalgreenscreen.com	Images, studio reference, technological and historical information
John Galt (Panavision, JTS white papers)	www.jts2004.org/english/proceedings/Galt.html	Images, technological and historical information
Kanen Flowers/That Studio	www.heropunk.com	Hero Punk (in Production)
KSBY TV	www.ksby.com	Images, studio reference, technological information
Les Perkins (Les Is More Productions)	www.lesismoreproductions.com	Images, studio reference, technological and historical information
MacBreak Studios (Mark Spencer & Steve Martin)	www.pixelcorps.tv/macbreak_studio	Video instruction, tutorials, reviews and information
MGM (Metro-Goldwyn-Mayer Studios Inc.)	www.mgm.com	Images (public domain), studio reference, VFX for *The Thief Of Bagdad, Ben-Hur*
Paul Kalbach, Artichoke Productions	www.artichokeproductions.com	Procution Studio, Green Screen, RED EPIC, SteadiCam
Per Holmes (Hollywood Camera Work)	www.hollywoodcamerawork.us	Images, technological information, stock video footage downloads, training DVDs
Pixel Corps (Alex Lindsay)	www.pixelcorps.com	Online VFX Community
PixelPainter (Jeff Foster, author)	www.pixelpainter.com	Blog, videos, book updates, example downloads
Ripple Training	www.rippletraining.com	FCP X Video Training
RKO Pictures	www.rko.com	Images (public domain), studio reference, VFX for *Flying Down To Rio*

Studio/Individual	URL	Works Referenced
Terry Wieser (Ventura Technology Development Center)	www.tdctraining.com	Images and stock video, studio reference, technological information, studio facilities
Tim Dobbert (DVD: *Matchmoving Advance Production Techniques*)	www.thegnomonworkshop.com/store/product/345/Matchmoving-AdvancedProduction-Techniques	Technological information, matchmoving training DVD
Timothy Hines (Pendragon Pictures)	www.pendragonpictures.com	Images, studio reference, VFX for *The War of the Worlds*
Universal Studios	www.universalstudios.com	Images (public domain), studio reference, VFX for *The Invisible Man*
VASST (Douglas Spotted Eagle)	www.vasst.com/store/training-dvds.aspx	Video Editing Training for Sony Vegas Pro
Ventural Technology Development Center (VTDC)	www.tdctraining.com	Filmmaking and Video Production Training Center
Victor Milt (NanoSoftLight)	www.victormilt.com	Images, technological information, instructional information for the Milt NanoSoftLight
Warner Bros. Entertainment Inc.	www.warnerbros.com	Images (public domain), studio reference, VFX for *The Old Man And The Sea*

About the Companion Website

The companion website www.focalpress.com/cw/foster includes almost 2 gigabytes of HD video footage and movie clips, images, and After Effects project files. The files are organized by chapter. Within each chapter you will find several files, and in some cases, folders with completed movies to preview.

Most folders contain Photoshop .psd files and/or After Effects .aep project files with images and movie clips. Some folders have a secondary folder with the final rendered or composited movies. Most After Effects projects provide both a completed composition and one that is ready for you to re-create. This allows you to reverse-engineer more complicated projects to better understand how the process works.

The After Effects projects assume that the source files are located within the hierarchy of the folder the project file resides in. For best results, download the website content onto your own C:\ drive or Mac desktop. If space is not available, you can reload the necessary files once you are in the program. Copying the folders to your hard drive will allow you to save the work you do in each project.

System Requirements

This book was written with Adobe Photoshop CS6/CC and After Effects CS6/CC, in addition to other software applications and third-party plug-ins. Newer versions of the software and/or plug-ins may be available at the time of print. Since the differences between these versions and the latest releases are minor, it will not affect your learning experience.

If you do not own Adobe Photoshop, After Effects, Final Cut Pro X, or any of the other software applications or plug-ins listed throughout this book, in many cases free trials are available through the software developers. Adobe offers fully functional trials of Photoshop and After Effects at creative.adobe.com. Please refer to Appendix A or the quick reference sections at the end of each chapter for links to products referenced throughout the book.

QuickTime is also required to view or use many of the video clips used in the projects on the disc. If you don't already have QuickTime installed on your computer, you may download it at www.apple.com/quicktime/download.

Index

Note: Page numbers in **bold** are for figures.